AMERICA THE BEAUTIFUL

A photographic journey from coast to coast

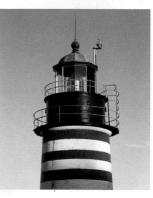

Publications International, Ltd.

TABLE OF CONTENTS

MAINE

Acadia National Park

Situated off the coast of Maine, Acadia National Park covers nearly half of Mount Desert Island. Originally named Isles des Monts Deserts by explorer Samuel de Champlain in 1604, the island also boasts the towns of Bar Harbor, Southwest Harbor, Mount Desert, and Tremont. From the coastline, you can see the island's barren mountaintops, sheared off by ancient glaciers.

The spectacular scenery that is **Acadia National Park** includes 26 mountains. Its rugged terrain and dramatic coastline make for some memorable sights.

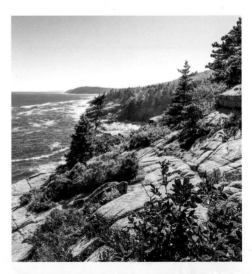

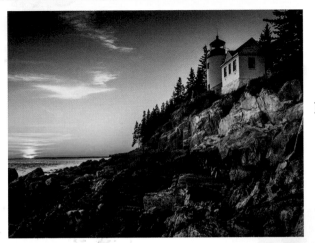

Bass Harbor Head Light, built in 1858, marks the entrance to Bass Harbor on the southwest side of Mount Desert Island.

Jordan Pond is one of Acadia's many features formed by glaciers. The pond is bordered by Penobscot Mountain on the west and by two mountains known as "The Bubbles" to the northeast.

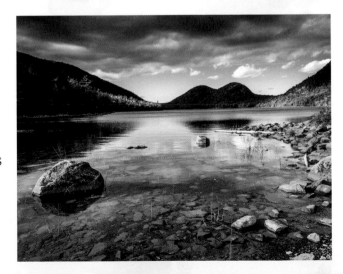

Acadia's spruce and fir forests and stands of maple, beech, and oak fill with the songs of hundreds of species of breeding birds. Its tide pools crawl with anemones, mussels, and sea stars. Wildlife is abundant throughout Acadia.

Boothbay Harbor

Boothbay Harbor, which lies along Maine's mid-coast, is a great place for watching whales and puffins, canoeing, kayaking, hiking, biking, mackerel fishing, and camping. The picturesque harbor is exactly how many people envision the state: Fishers haul in lobster traps, and masts gently rock in the distance. You can cruise to Monhegan Island or see sites such as the Maine Resources Aquarium; the Maine Maritime Museum; or Burnt Island Light.

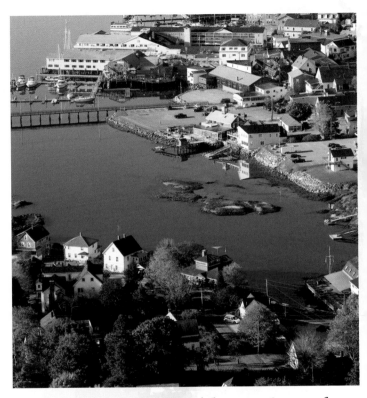

The rugged **Boothbay Harbor** area is one of Maine's most beautiful destinations. You can rent cove-side cottages, dine in fine restaurants, and browse quaint waterfront shops.

Penobscot Bay

Penobscot Bay lies just southwest of Maine's Acadia National Park and is perfect for those who want to explore the real outdoors. Choose among recreational sports such as sailing, fishing, or hunting. The nearby towns of Camden, Bar Harbor, and Castine provide for more relaxing pursuits of fine dining, charming shopping, and admiring local art.

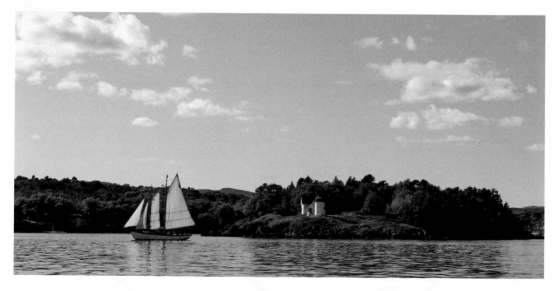

The rocky shoreline of **Penobscot Bay** harbors quaint Maine towns with an authentic Down East feel.

Penobscot Narrows Bridge and Observatory

The Penobscot Narrows Bridge has the distinction of being home to the Penobscot Narrows Observatory, making it the only observatory bridge in the United States. From the observatory found in the west tower of the bridge, visitors can get a good view of the Penobscot River and other sights of coastal Maine—one nearby site is the historic Fort Knox.

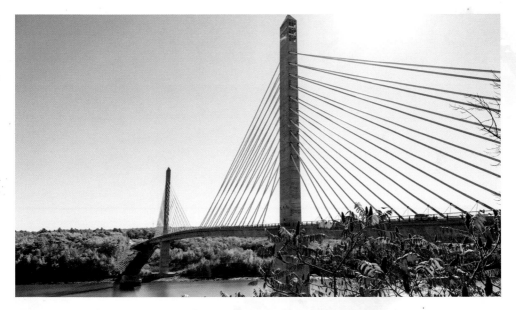

The **Penobscot Narrows Bridge** opened in 2006, replacing an older bridge.

Portland Head Light

The Portland Head Light has marked the entrance to the busy harbor of Portland since 1791. It is one of the most beautiful lighthouses in New England, if not the entire country, and is one of the major tourist attractions along the Maine coast. Both the keeper's house and the 80-foot cylindrical tower sit upon a massive point of weathered rock near the entrance to Portland Harbor. The picturesque scene—wild surf, broken rock, immaculate lighthouse—is a favorite of marine oil painters and landscape photographers.

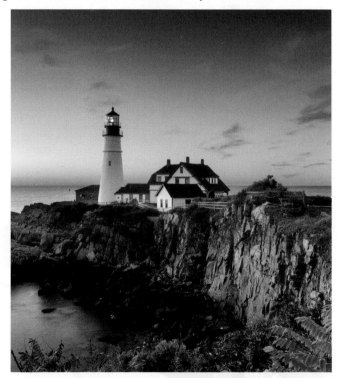

The **Portland Head Light** holds the distinction of being the first lighthouse built by the United States Government (as opposed to a local Colonial authority). It was completed in 1791.

West Quoddy Head Light

Established in 1808, the West Quoddy Head Light in extreme northeastern Maine is one of the nation's oldest and most revered lighthouses. For nearly two centuries it has lit the often-stormy channel between the United States and Canada. The West Quoddy Light is located on a point of land known as West Quoddy Head, just across the long blue-gray channel from the southern shores of New Brunswick, Canada.

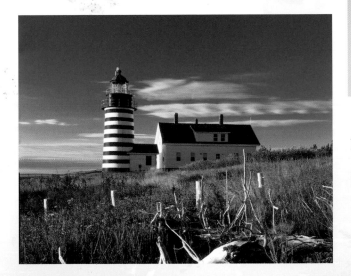

The **West Quoddy Head Light** rises distinctly from the surrounding wildflower-filled fields with parallel red stripes. From a distance, it resembles a barber pole or a gigantic piece of candy.

Baxter State Park

Born into wealth, Percival Baxter—who served as the state's governor for four years in the 1920s—made a project of donating land to the state to form Baxter State Park. He first designated a portion of land for that park while governor. After his tenure in that position, though, he also began to buy parcels of surrounding land and then deed it to the state to become part of the park, all the way through 1962. When he died, he left money to maintain the park that had taken his name in 1931.

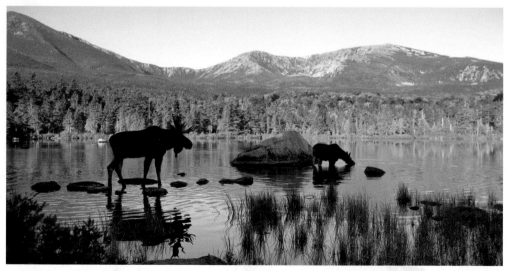

Baxter State Park is a haven for wildlife, featuring moose, deer, otters, muskrat, beavers, wetland birds, and even black bears.

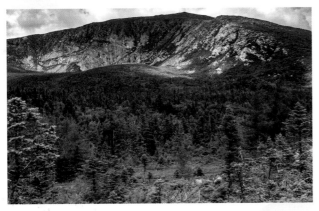

At 5,267 feet, **Mount Katahdin** is the highest point in the state of Maine. The mountain, named by the Penobscot Indians, is found in Baxter State Park.

Explore the wild landscape of **Katahdin Woods and Waters National Monument** in northern Maine. This national monument offers spectacular views of Mount Katahdin.

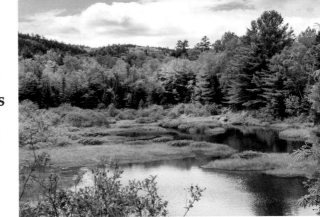

NEW HAMPSHIRE

White Mountain National Forest

New Hampshire's White Mountain National Forest is the heart of the White Mountains. Mount Washington rises fiercely above the dense woodlands to 6,288 feet, which makes it the highest mountain in the northeastern United States. On a clear day, you can see into New Hampshire, Maine, Vermont, Massachusetts, and Canada from its peak.

The vast majority of White Mountain National Forest's 800,000 acres are in New Hampshire, with the eastern edge creeping into Maine. The forest is indisputably nature's domain. It may be an easy drive from urban America, but it seems to be a million miles away.

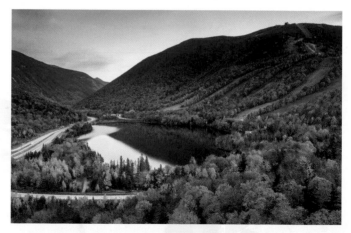

The **White Mountains** in autumn

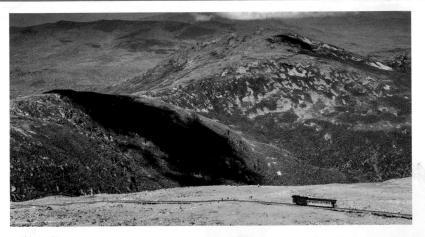

The **Mount Washington Cog Railway**, completed in 1869, carries tourists up Mount Washington in New Hampshire. It is the first mountain-climbing and second steepest cog railway in the world.

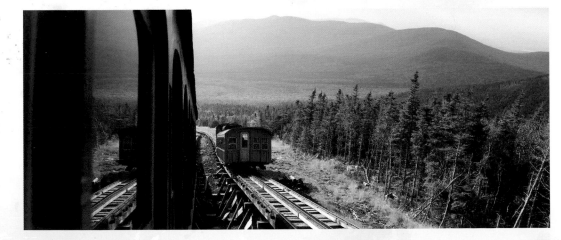

Kancamagus Scenic Byway

Kancamagus Scenic Byway cuts through the heart of White Mountain National Forest, accessing otherwise remote waterfalls, swimming holes, hiking trails, and campgrounds. The highway, which runs from Conway to Lincoln, New Hampshire, is a popular tourist destination during leaf-peeping season due to its many scenic views and locations.

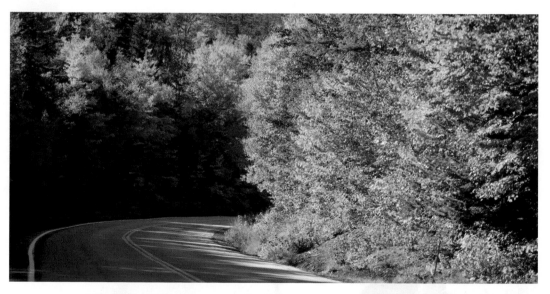

The **Kancamagus Scenic Byway** is an east–west shortcut through the heart of White Mountain National Forest.

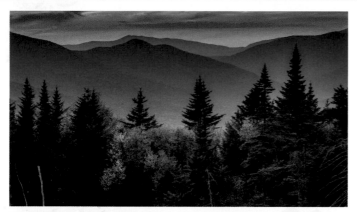

Sunset from
Kancamagus Pass
along the Kancamagus
Scenic Byway

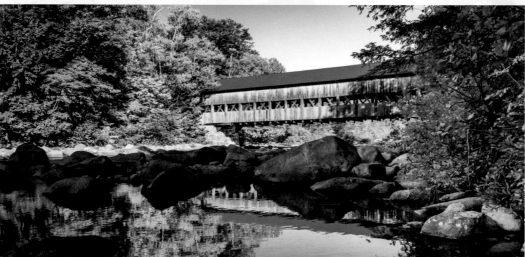

Albany Covered Bridge is along the Kancamagus Highway in
New Hampshire's White Mountain National Forest.

Portsmouth Harbor Lighthouse

Portsmouth Harbor Lighthouse is located within Fort Constitution in New Castle, New Hampshire. The station was first established in 1771. During the Revolutionary War, the lighthouse helped guide local New England privateers who raided British shipping and harassed the king's Navy vessels. Local history also states that folk hero Paul Revere and local militiamen captured the fort in Portsmouth Harbor with the help of the lighthouse keeper. The current tower was built in 1878.

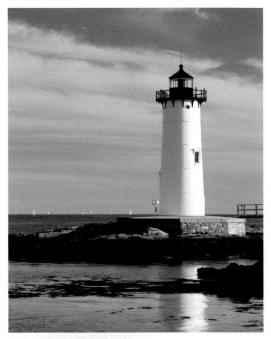

On this bright, sunny day, the cobalt blue waters off Portsmouth, New Hampshire, are filled with recreational sailboats.

Lake Winnipesaukee

At 26 miles long and 15 miles across at its widest point, Lake Winnipesaukee is New Hampshire's largest lake. This glacial phenomenon has been a summer vacation hot spot for more than a century, attracting visitors from all over New England. At Lake Winnipesaukee, you can hike, snowshoe, fish, and scuba dive.

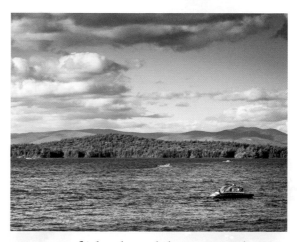

Dozens of islands and the surrounding Ossipee and Sandwich mountain ranges add to **Lake Winnipesaukee's** scenic splendor.

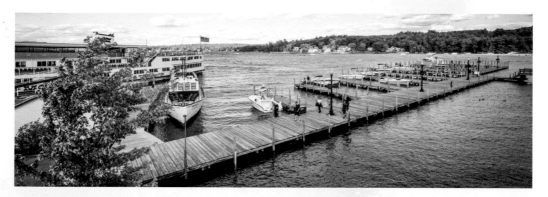

Castle in the Clouds

Named to the National Register of Historic Places in 2018, Castle in the Clouds sits high up in the Ossipee Mountains of New Hampshire. The 16-room mansion was built in 1913–1914 for shoe manufacturer Thomas Plant and his wife, Olivia. The Plants called the estate Lucknow, but it has been known as Castle in the Clouds since it opened to the public in 1959. The house is a fine representative of arts and crafts architecture in New England, expressing the philosophy of living in harmony with nature.

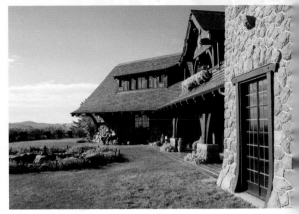

Castle in the Clouds overlooks the Ossipee Mountains and Lake Winnipesaukee. The mountaintop estate encompasses more than 5,000 acres.

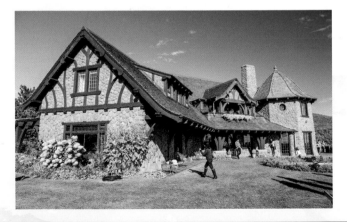

The exterior features a clay tile roof and is constructed of hand-hewn white oak made in shipyards in Maine.

Odiorne Point State Park

This state park includes Odiorne Point, the largest undeveloped stretch of shore on New Hampshire's 18-mile coast. Its spectacular oceanfront is backed by marshes, sand dunes, and dense vegetation. An extensive network of trails, including a paved bike path, winds through the park. There are also picnic areas, a boat launch, and a playground.

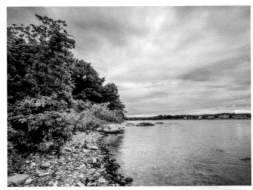

Odiorne Point State Park, in Rye, New Hampshire, offers scenic views of the ocean and rocky shore.

Seacoast Science Center

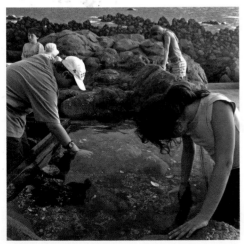

Kids will love visiting the Seacoast Science Center at Odiorne Point State Park to learn about the many creatures they're likely to spot in the tide pools. All kinds of sea urchins, starfish, mollusks, and crabs inhabit the shoreline's intertidal zone, and when the tide is low, there are many opportunities to see them.

Get up close and personal with the mysteries of the ocean at the **Seacoast Science Center's** touch tank, which invites hands-on exploring.

Canterbury Shaker Village

A religious group that originated in England in the 18th century, the Shakers believed in simple living in a community. Canterbury Shaker Village in Canterbury, New Hampshire, was founded in 1792. It declined in the 1900s, and in 1988 became a historic site that offered tours. Today, it contains a museum along with 25 original Shaker buildings amid a beautiful pastoral landscape with gardens, forests, and millponds.

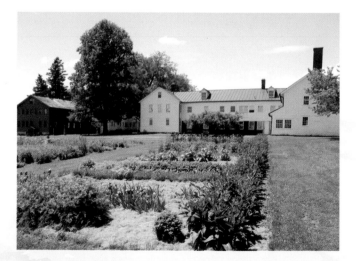

Canterbury Shaker Village was designated a National Historic Landmark in 1993.

Strawbery Banke

Strawbery Banke is a 10-acre living history museum in Portsmouth, New Hampshire. It is the oldest neighborhood in New Hampshire settled by Europeans. The neighborhood's history goes back to 1630, when Englishmen chose this tidal inlet of the Piscataqua River for their first settlement, naming it "Strawbery Banke" after the wild berries growing there. Strawbery Banke offers visitors a glimpse inside the lives of the various people who lived on the Portsmouth waterfront from 1695 to 1954.

Some of the historic buildings in **Strawbery Banke** have been restored and furnished to show particular periods in the past. Costumed interpreters demonstrate cooking, crafts, and skills from the various periods.

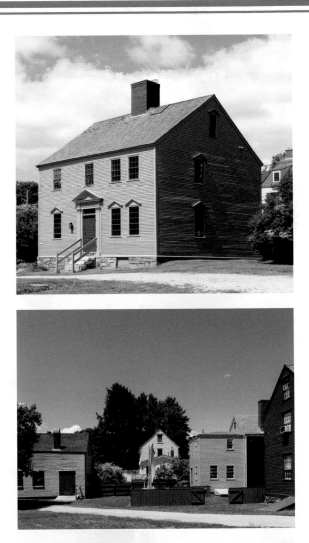

VERMONT

Green Mountains

The Green Mountains of Vermont are full of surprises. The historic range is a great place for caving, hiking, skiing, and gawking at the splendid natural beauty. The 250-mile-long Green Mountains become the Berkshires to the south, in Massachusetts; to the west is Lake Champlain; and to the east are the White Mountains of New Hampshire. The 385,000-acre Green Mountain National Forest is the public's entry to the mountains.

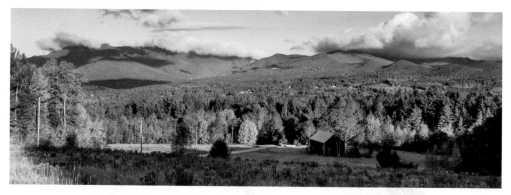

Historic family farms are sprinkled within the dense
forest that sheaths the **Green Mountains**.

The name of the **Green Mountains** resonates through Vermont history: the state's name itself comes from the French for "Green Mountains," and the state's nickname is the "Green Mountain State."

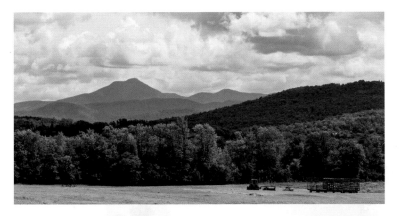

Texas Falls has long been a favorite Green Mountain National Forest attraction.

Lake Champlain

Samuel de Champlain explored so much of New England that it was only fair to name the spectacular Lake Champlain after him. He discovered the lake in 1609 while in the Champlain Valley, which lies between Vermont's Green Mountains and the Adirondack Mountains of New York. Lake Champlain has since served the needs of merchants and mariners, scalawags and soldiers, smugglers and spies, and patriots and traitors. The lake has seen its share of naval conflict, too. In 1814, troops led by U.S. Commodore Thomas McDonough defeated the British Navy in a fierce fight. During the 19th century, canal boats and steamboats carried coal, timber, iron ore, and grain across the lake. Today, industry has given way to recreation.

Lake Champlain has become a year-round playground featuring boating, hiking, skiing, snowshoeing, snowmobiling, ice climbing, and rock climbing. Bicyclists take advantage of the Lake Champlain Bikeways' 35 loops and 10- to 60-mile tours.

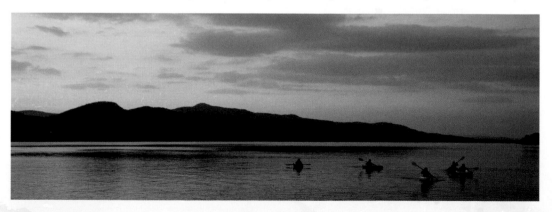

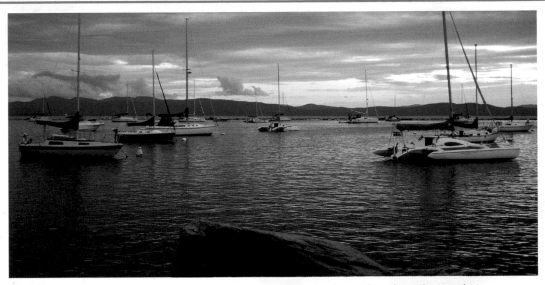

Sailing is one way to enjoy the pristine waters of **Lake Champlain.**

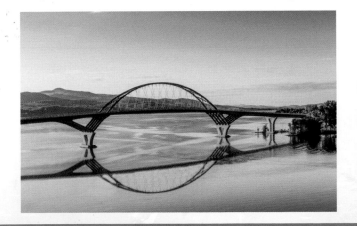

The **Lake Champlain Bridge** traverses Lake Champlain between Chimney Point, Vermont, and Crown Point, New York. The bridge has a total length of 2,200 feet.

Shelburne Museum

The Shelburne Museum, a celebrated Vermont institution where practically everything is featured, takes 45 full acres and 39 buildings to display the museum's collection. Founded in 1947, the museum was created by Electra Havemeyer Webb, daughter of Henry O. Havemeyer, who founded the Domino Sugar Company. With near limitless resources, Webb acquired an eclectic smorgasbord of items over her lifetime; her collection was some 80,000 objects strong at the time of her death in 1960. These and approximately 70,000 additional items are now housed at the Shelburne Museum in the Lake Champlain Valley.

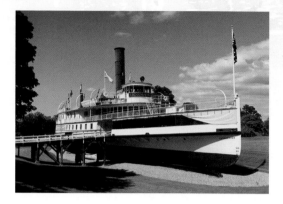

(Above) One of the most revered items at the Shelburne Museum is the steamship *Ticonderoga*. This is no mock-up or reproduction but rather an actual 220-foot-long sidewheel steamer from 1906.

(Right) Shelburne Museum visitors will find Impressionist paintings, historic house interiors from 1790–1950, decorative art, folk art, vintage dolls and dollhouses, toys, carriages, tools, quilts, and Native American artifacts.

Bennington Battle Monument

From the observation deck of this towering 306-foot obelisk, visitors can gaze out on three states: Vermont, Massachusetts, and New York. On August 16, 1777, during the Revolutionary War, militia forces from the fledgling U.S. and the Vermont Republic delivered a resounding defeat to British forces at what became known as the Battle of Bennington. The battle actually took place 10 miles away from Bennington in neighboring Walloomsac, New York. A century later, Vermonters began to plan a monument to memorialize the victory. Begun in 1887, the monument was completed in 1889, becoming and remaining the tallest structure in Vermont.

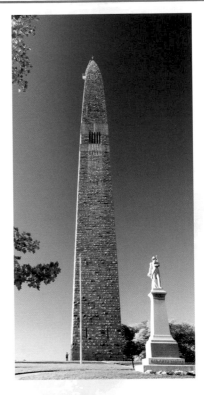

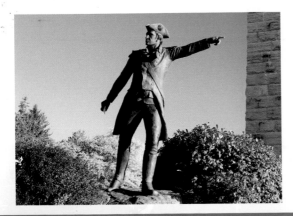

Statues of the battle's military leaders are found around the obelisk, including Brigadier General John Stark of New Hampshire (left) and Colonel Seth Warner of Vermont (above).

Hildene

This beautiful house with its meticulously landscaped grounds is found in Manchester, Vermont. It was built in 1905 by Robert Todd Lincoln, the son of the president, and was owned by various members of the Lincoln family until 1978. Visitors to the house can see an incredible pipe organ that dates to 1908, as well as an observatory built by Robert Lincoln, a carriage barn, and an agricultural center where cheese is made from a herd of goats.

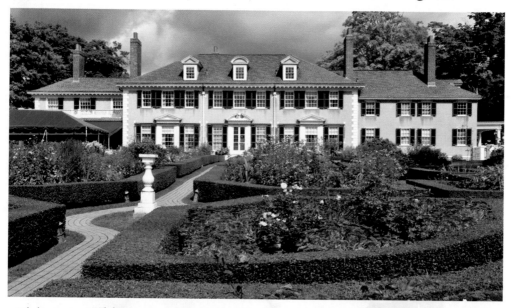

Visitors to **Hildene** can delight in the extensive gardens, including both a formal garden and vegetable gardens, that surround the mansion.

Ben & Jerry's Ice Cream Factory

Vermont's top tourist attraction is Ben & Jerry's Ice Cream Factory in Waterbury. Ben Cohen and Jerry Greenfield began making their ice cream in the neighborhood in 1978; today, they sell their products all over the world. The tour at the Ben & Jerry's Ice Cream Factory offers a glimpse of the ice cream-making process. Be sure to visit the Flavor Graveyard, where colorful tombstones honor dearly departed flavors.

All around the brightly painted **Ben & Jerry's Ice Cream Factory** grounds are unusual items for kids to climb on, as well as a small playground and picnic tables.

MASSACHUSETTS

Freedom Trail

Follow the red brick line along the 2.5-mile Freedom Trail in Boston and take in 300 years of American history. The 16 sites along the trail describe the city's early patriots, their notion of liberty, and the journey to independence.

The idea for the Freedom Trail came in 1958 from William Schofield, an editorial writer for the *Boston Herald-Traveler*. He hatched the idea of creating a marked line that would transform Boston's mazelike streets into something tourists could follow. His campaign succeeded and in-spired other "trails," including Boston's Black Heritage Trail.

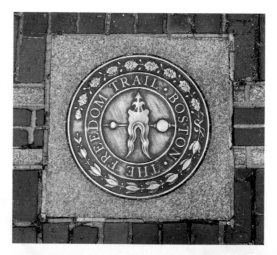

The tour officially begins at the 50-acre Boston Common, which was a British troop encampment during the American Revolution. Other sites along the trail include the Massachusetts State House, Park Street Church, Old South Meeting House, Paul Revere House, and Bunker Hill Monument.

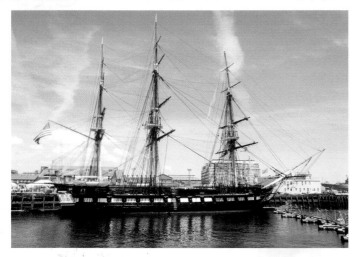

The Freedom Trail ends at the **USS *Constitution***, which became known as "Old Ironsides" during the War of 1812.

The **Old State House** is a stop on the Freedom Trail and the site of the Boston Massacre. Built in 1713, the Old State House was at the center of civic events that sparked the American Revolution. It now serves as a history museum.

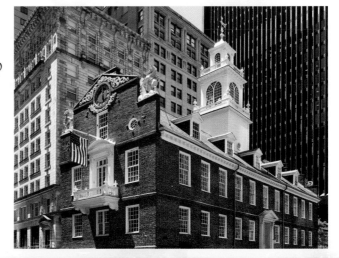

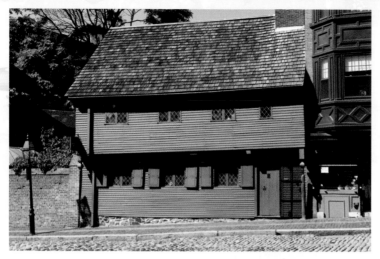

Built around 1680, the **Paul Revere House** is the oldest remaining structure in downtown Boston and the only official Freedom Trail historic site that is a home.

John Hancock, Samuel Adams, and Paul Revere are buried at the **Granary Burying Ground**, a site on the Freedom Trail.

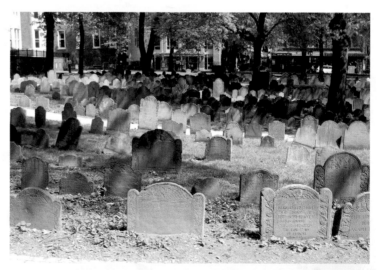

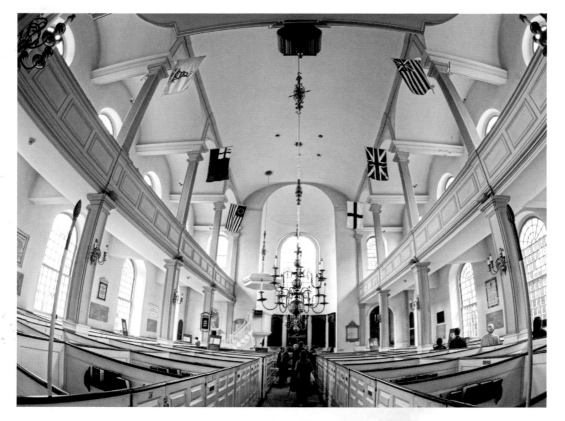

Old North Church is another historic site
along the Freedom Trail in Boston. It was at
Old North Church that Paul Revere hung two
lanterns to warn the people of Boston that
the British were approaching by sea.

Bunker Hill National Monument

In the early morning hours of June 17, 1775, soldiers from Massachusetts, Connecticut, and New Hampshire hastily constructed a fort atop Breed's Hill, an area overlooking the settlement of Charlestown in Boston. By afternoon, British forces stormed the area, and the first major battle of the Revolutionary War was underway. Although most of the fighting took place at Breed's Hill, the confusion and hastiness of the battle led to a slight geographical mix-up, and the battle was named for the higher hill behind Breed's Hill: Bunker Hill.

The **Bunker Hill Monument** now stands on Breed's Hill to commemorate the famous Battle of Bunker Hill. The 221-foot-tall granite obelisk was one of the first monuments in the United States, and was dedicated on June 17, 1843.

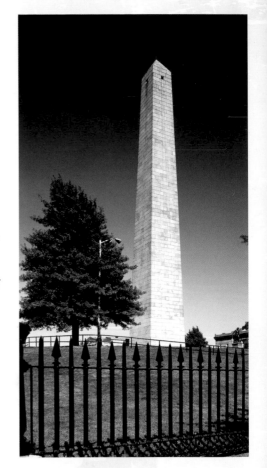

Massachusetts State House

Boston's state capitol building was completed in 1798, and stands on land once owned by founding father—and notable signatory to the Declaration of Independence—John Hancock. Nor was he the only American Revolutionary to be associated with the building, as Paul Revere led the 1795 ceremony in which the cornerstone was laid.

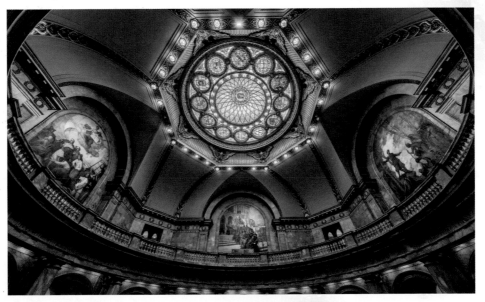

Views of the **Massachusetts State House** interior

Copley Square

Boston's Copley Square is surrounded by iconic Boston landmarks, including Trinity Church, Old South Church, and the Boston Public Library. Copley Square is the finishing point of the Boston Marathon.

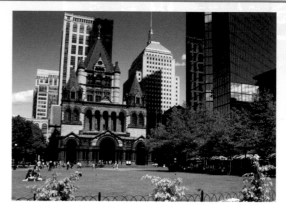

Trinity Church, on Copley Square, was completed in 1877.

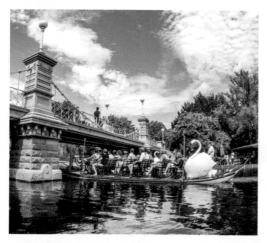

The famous swan boats at **Boston's Public Garden** are especially popular during the spring and summer months.

Boston's Public Garden

A 24-acre garden within a city, Boston's Public Garden has been a favorite among tourists for years. The beautifully landscaped area gives sightseers the chance to rest their tired feet.

Fenway Park

Fenway Park reigns as a temple of baseball, despite the decades of misfortune for its principal occupants, the Boston Red Sox. Built in 1912, Fenway is Major League Baseball's oldest park. The stadium's seating capacity is under 38,000 people, and while the team suffered an 86-year dry spell beginning in 1918, Red Sox fans continued to crowd Fenway. Fans were finally rewarded in 2004 (and again in 2007, 2013, and 2018) when Boston won the World Series. Fenway's atmosphere is magical and not-to-be missed when in Boston.

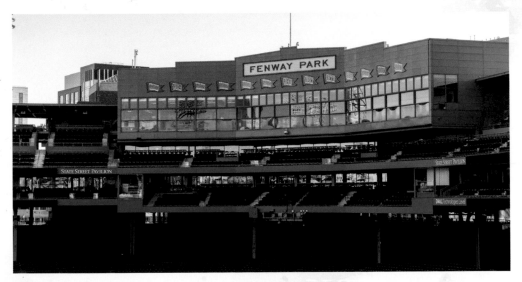

Catching a game at **Fenway Park** is a must for any
fan of America's favorite pastime.

Harvard Square

Harvard Square in Cambridge, Massachusetts, is a great place to go if you want to feel young, hip, and smart. Teeming with Harvard professors, students, and wannabes, "the Square" can give visitors the sense that they are attending Harvard without having to take exams.

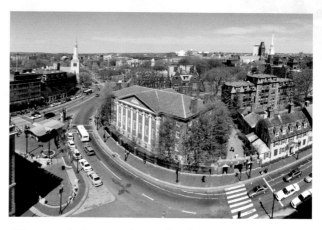

Harvard Square is packed with cafés, shops, and bookstores. A number of Harvard museums are within walking distance of the Square.

Arnold Arboretum

Established in 1872 and planned and designed in collaboration with Frederick Law Olmsted, the Arnold Arboretum is one of the best preserved of Olmsted's landscapes. Founded as a public-private partnership between the City of Boston and Harvard University, the Arboretum's living collection of trees, shrubs, and woody vines is recognized as one of the most comprehensive of its kind in the world.

The **Arnold Arboretum** forms a crucial part of the "Emerald Necklace," a set of parkways and waterways in Boston and nearby Brookline.

Walden Pond

Henry David Thoreau moved to Walden Pond in Concord, Massachusetts, to get a little peace and quiet and to write. He wrote an account of his time there called *Walden; or, Life in the Woods*. In Thoreau's day, the land around the pond was one of the few woods left in the area. Today, Walden Pond is part of Massachusetts's Walden Pond State Reservation, which includes the 61-acre pond plus another 2,680 acres known as "Walden Woods."

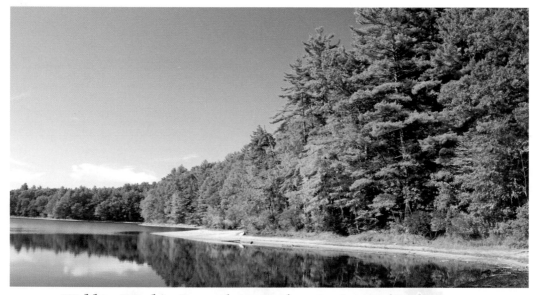

Walden Pond in Concord, Massachusetts, inspired author Henry David Thoreau's most famous work, *Walden*, which is often credited with creating the conservation movement.

Salem

Salem, Massachusetts, calls itself "Witch City" and is so named for that harrowing seven-month period in 1692 when the townspeople put 19 innocent people to death. Today, Salem offers numerous places devoted to witches and their kind.

The **Salem Witch Museum** brings visitors back to early Salem through a dramatic presentation that uses stage sets with life-size figures, lighting, and narration. It also gives visitors an excellent overview of the Salem Witch Trials.

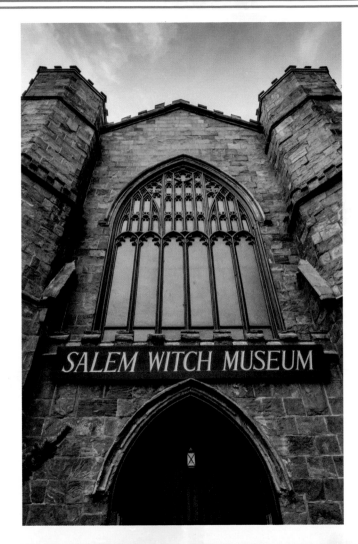

Nantucket

Nantucket is an island south of Cape Cod, Massachusetts. Nantucket was designated a National Historic Landmark in 1966 as the "finest surviving architectural and environmental example of a late 18th- and early 19th-century New England seaport town." There are activities galore (no camping, though), including boat tours, lighthouse viewing, and a whaling museum. Cars were banned on the island in the early 20th century, and bicycles are still the preferred form of transportation.

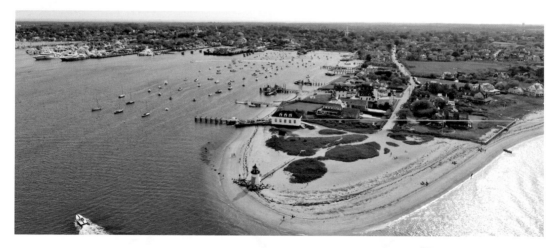

Although not as crowded as nearby Martha's Vineyard,
Nantucket is among the most popular vacation
sites on the northeastern coast.

Brant Point Light

There has been a lighthouse on Brant Point, Massachusetts, at the entrance of Nantucket Harbor, since 1746, making this one of the oldest lighthouse sites in the United States. The scene on the island of Nantucket today is very different from that of over 270 years ago, when there were only windswept hills of sea grass and scrub oak, with sturdy Atlantic whalers and fishing dories resting in the harbor. Today, a myriad of summer homes sit on the gentle hills above the small port, overlooking hundreds of private sailing vessels anchored in the waters below.

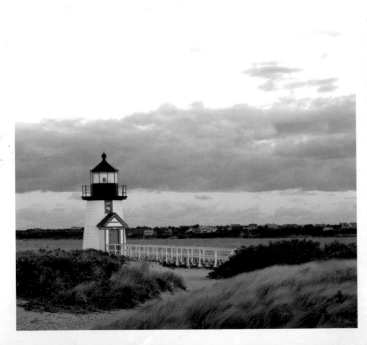

The current lighthouse at Brant Point is the shortest in New England—its light is only 26 feet above sea level. The building is reached by walking over an elevated wooden walkway across a narrow sand spit. The walkway leads to a pile of rocks on which the tiny lighthouse sits.

Martha's Vineyard

Martha's Vineyard, an island off the coast of Massachusetts, provides an old-fashioned beach vacation with pristine beaches, clean salty air, lavish beachfront homes, and rolling farmlands. Its picturesque towns are filled with ice cream shops, sea captains' stately houses, and art galleries.

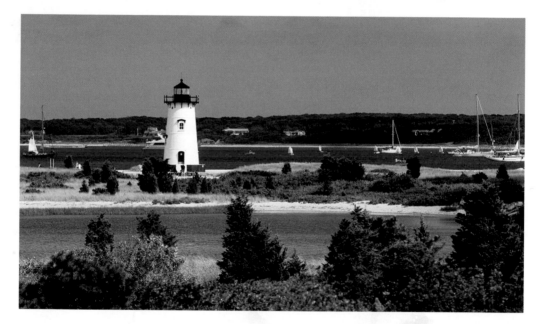

Beaches, boating, kayaking, fine dining, and shopping are among the many things do on **Martha's Vineyard**.

Cape Ann Light

The Cape Ann Light, on Thacher Island, about 40 miles north of Boston, is among the oldest lighthouses on the coast, having first become operational in 1771. Since its earliest days it has been a twin light-house—that is, it is made up of two light-houses separated by about 300 feet on the small rocky island. The two 124-foot granite towers date to 1861. The south tower remains active, producing a flashing red beacon. The north light is operated as a solar-powered amber light, but only as a memorial to mariners past and present.

(Below) Across the waters, rising like a vision from the windswept waters, are the twin lights of Cape Ann.

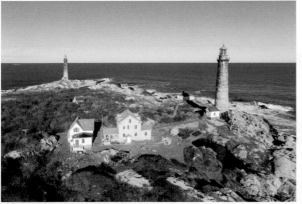

(Left) These two lights on Thacher Island at Cape Ann have stood watch over the seas since 1771. They were among the first lights on the northeastern coast.

Plymouth

In 1620, the *Mayflower* Pilgrims landed in what became Massachusetts. Plymouth Rock marks their traditional landing site. Whether the rock was there at that point is an open question; contemporary documents do not refer to it. Throughout the years, the rock itself has been relocated multiple times. It's also become smaller, as pieces have been chipped off for souvenirs. Plymouth Rock is part of Massachusetts' Pilgrim Memorial State Park, also the home of the National Monument to the Forefathers that was dedicated in 1889.

Plymouth Rock marks the site where the Pilgrims were thought to have landed in 1620. Today, you can see Plymouth Rock at Pilgrim Memorial State Park.

National Monument to the Forefathers

Another monument in Massachusetts's Pilgrim Memorial State Park is the National Monument to the Forefathers. The cornerstone for this large granite statue was laid in 1859, with the completion and dedication taking place in 1888 and 1889. The names of the *Mayflower* Pilgrims are inscribed on

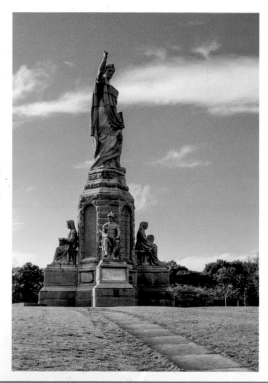

the monument, as are these words: "National Monument to the Forefathers. Erected by a grateful people in remembrance of their labors, sacrifices and sufferings for the cause of civil and religious liberty."

The figures shown on the **National Monument to the Forefathers** are not those of the Pilgrims, but allegorical figures: Faith, which brought the Pilgrims on their journey, stands on the main pedestal. She is surrounded by Morality, Law, Education, and Liberty.

Old Sturbridge Village

Families who want to experience life in times past will be enthralled by Old Sturbridge Village, just an hour's drive west of Boston. The largest outdoor living history museum in the northeast, Old Sturbridge Village brings to life an 1830s New England rural community, down to the smallest details.

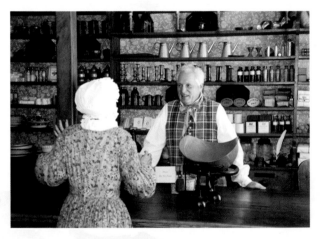

Costumed interpreters demonstrate daily tasks of farmers, blacksmiths, shoemakers, tinsmiths, housewives, and craftspeople at **Old Sturbridge Village**.

The Mount

Edith Wharton was not only a noted American author in the early 20th century, but also a gifted architect. Her country home, the Mount, built in 1902 in Lenox, Massachusetts, reflects her skill at design. Located in the Berkshires, the Mount is a National Historic Landmark and is open to the public.

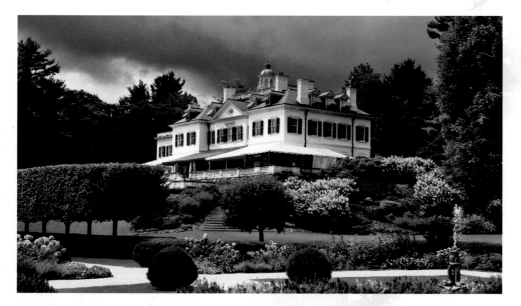

The Mount's main house was inspired by the 17th-century Belton House in England, with additional influences from classical Italian and French architecture.

RHODE ISLAND

Block Island Southeast Light

Fifteen miles beyond Montauk Point, the easternmost spot on Long Island, is Block Island, a 25-square-mile piece of windswept land to the east of Long Island Sound. The Block Island Southeast Light has served as an essential navigational aid for ships cruising into Long Island Sound or proceeding south toward New York City. The local waters are known for their submerged reefs, strong currents, and—because of the close proximity to the North Atlantic—their quickly developing fog banks and storms.

Although the **Block Island Southeast Light** was deactivated in 1990, the entire 2,000-ton building was moved back from the cliffs by 300 feet because of the threat erosion had on the building's stability. The building serves as a museum today.

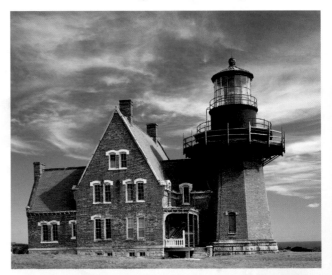

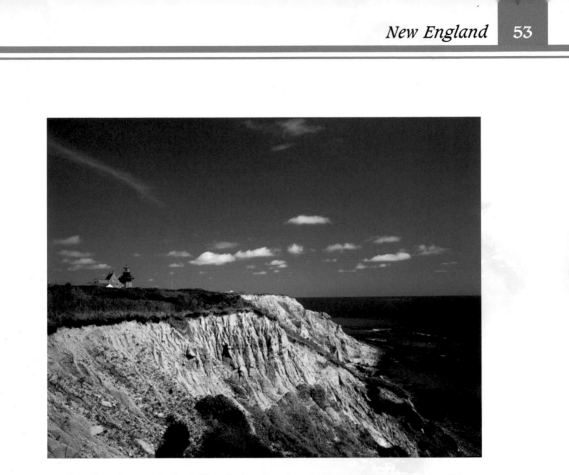

The deeply eroded cliffs of Block Island may be beautiful in this scene, but they pose a very real threat to the stability of the headlands on which the **Block Island Southeast Light** is located.

Benefit Street

If you're touring Providence, Rhode Island, and its antique treasures, the best place to start is Benefit Street, also known as the "Mile of History." Benefit Street was established in 1756 and became home to Providence's well-to-do merchants. Today, almost all the buildings along the "Mile of History" have been restored, giving the street the architectural flavor of colonial times. While many of the building interiors are off-limits to the public, visitors can take in the historical ambience of this collection of homes and businesses.

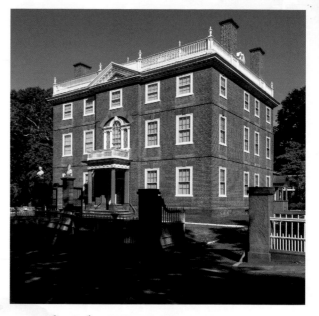

The **John Brown House Museum** is just around the corner from Benefit Street. Providence's John Brown was a politician who completed the mansion in 1788. John Quincy Adams proclaimed the house "the most magnificent and elegant private mansion that I have ever seen on this continent."

Touro Synagogue

Built in 1763 in Newport, Rhode Island, this synagogue is the oldest still standing in the United States. It was built by a Jewish community whose ancestors had come to the area a century earlier in 1658. The building was designated a National Historic Site in 1946.

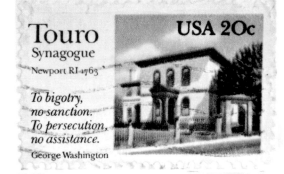

Touro Synagogue
Newport RI 1763

To bigotry, no sanction. To persecution, no assistance.
George Washington

USA 20c

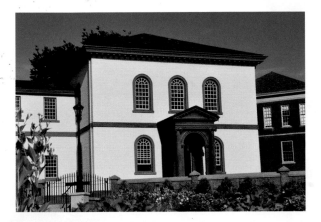

In 1790, George Washington sent a letter to the congregation that is read aloud annually. He wrote in part, "The citizens of the United States of America have a right to applaud them-selves for having given to man-kind examples of an enlarged and liberal policy—a policy worthy of imitation. All possess alike liberty of conscience and immunities of citizenship."

Newport Mansions

Newport is a small city on Aquidneck Island, Rhode Island, in Narragansett Bay. Visitors can explore Newport's spectacular collection of mansions where America's wealthiest families, including the Vanderbilts, Astors, and Dukes, spent leisurely summers. Be sure to see The Breakers, Chateau-sur-Mer, Marble House, the Chepstow mansion, Hunter House, The Elms, and Rosecliff.

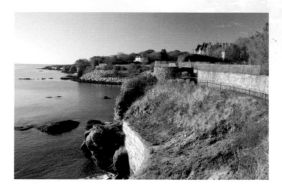

Visitors to the Newport mansions can amble along the famous **Cliff Walk**. The trail along the eastern shore of Newport, Rhode Island, combines the natural beauty of the New England shoreline with the architectural history of Newport's Gilded Age.

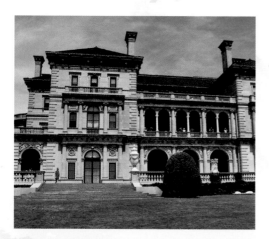

Among the most elaborate of Newport's exquisite mansions is **The Breakers**, Cornelius Vanderbilt II's summer home. Built in 1893–1895, The Breakers was named for the waves that crash into the rocks below the estate.

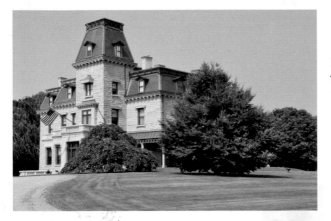

Chateau-sur-Mer was built in 1851 as an Italianate-style villa for China trade merchant William Shepard Wetmore. It is now owned by the Preservation Society of Newport County and is open to the public as a museum.

Rosecliff was built in 1898–1902 as a summer home for silver heiress Theresa Fair Oelrichs in Newport, Rhode Island. The mansion was inspired by the baroque palace Grand Trianon, which is part of Versailles. The mansion's centerpiece is the ballroom, which is the largest in Newport and was decorated with Louis XIV furniture.

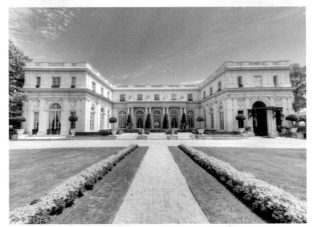

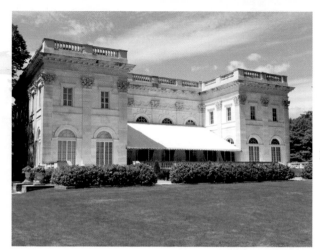

Marble House, built in 1888–1892, was designed for Alva and William Vanderbilt. When Alva divorced William in 1895, she already owned the mansion outright. When she remarried Oliver Belmont in 1896, Alva relocated down the street to Belmont's mansion, Belcourt. After his death in 1908, she reopened Marble House and became active in the women's suffrage movement.

Built in 1881–1883, the **Isaac Bell House** in Newport, Rhode Island, is one of the finest examples of Shingle Style architecture in the United States. The Preservation Society of Newport County bought the house in 1994 and now operates it as a museum.

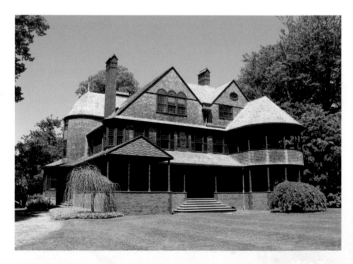

The Elms was constructed in 1899–1901 as a summer home for coal baron Edward Julius Berwind. Its design was inspired the château d'Asnières in France. Like most of Newport's Gilded Age estates, The Elms is constructed with a steel frame with brick partitions and a limestone facade.

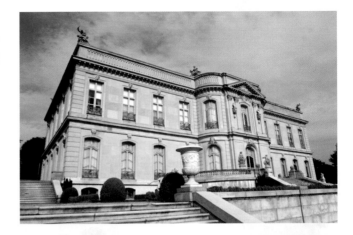

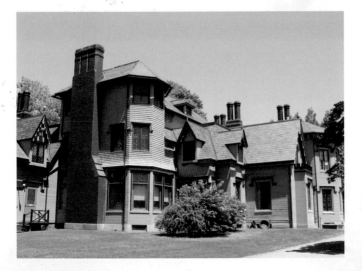

Kingscote is a Gothic Revival mansion in Newport, Rhode Island. It was designed by architect Richard Upjohn and built in 1839. Kingscote was one of the first summer homes built in Newport, and is now a National Historic Landmark.

Beavertail Light

In 1749, a bit more than a century after Roger Williams was exiled from Massachusetts and moved west to form the wilderness outpost of Providence, the Colonial authorities of Rhode Island decided to build a lighthouse on Conanicut Island, near the entrance of Narragansett Bay. The area had become well known for its busy maritime traffic, and a reliable lighthouse was needed on the south end of the island to alert sailors that they were approaching the narrow channels leading to Providence. The Beavertail Light, as it was called, would become New England's third, and America's fourth, light station.

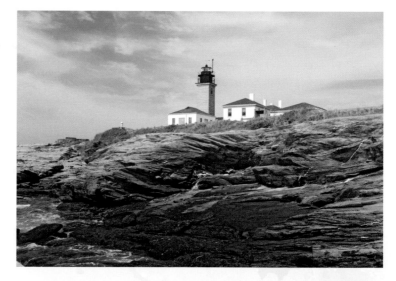

The scenic **Beavertail Light** occupies its own state park. Beavertail State Park, located on Conanicut Island in Narragansett Bay, Rhode Island, offers some of the most beautiful vistas along the New England coastline.

Green Animals Topiary Garden

Lions, tigers, and bears—and just about every other animal you can imagine—are on display at the Green Animals Topiary Garden in Portsmouth, Rhode Island. Eighty topiary displays are available for public viewing.

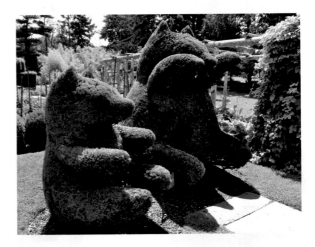

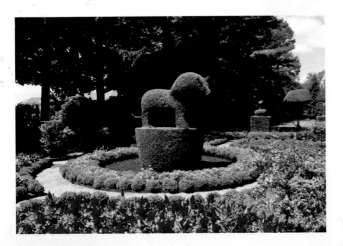

The animals at the **Green Animals Topiary Garden** are sculpted from privet, yew, and boxwood.

CONNECTICUT

Mystic Seaport

Mystic Seaport is one of the nation's leading maritime museums. It was founded in 1929 to preserve seagoing culture. The museum's grounds cover 19 acres in Mystic, Connecticut, and include a recreated New England coastal village, a working shipyard, and artifact storage facilities.

Mystic Seaport expanded in the 1940s. Historic buildings—including the Buckingham-Hall House (a coastal farmhouse), the Nautical Instruments Shop, the Mystic Press Printing Office, and the Boardman School one-room schoolhouse—were moved from their original locations in New England and put together to form Mystic Seaport, a model New England seagoing village. Mystic Seaport became one of the first living museums. It has assembled one of the largest collections of maritime history. The collections include marine paintings, scrimshaw, models, tools, ships plans, film and video recordings, and more than one million photographs. These collections are on display at Mystic Seaport's Collections Research Center storage and preservation facility.

Wooden ship's figureheads featured at the **Mystic Seaport Maritime Museum**

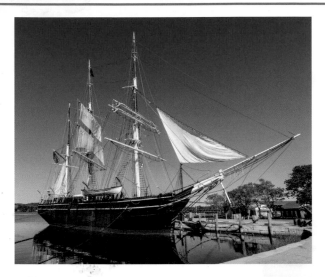

The ***Charles W. Morgan*** is a whaling ship built in 1841. Mystic Seaport acquired the ship in 1941. The ship is among the collection of antique vessels anchored at Mystic Seaport.

The **Buckingham-Hall House** was erected in 1760 in what is now Old Saybrook, Connecticut, by the Buckingham family. The house, which was located near the mouth of the Connecticut River, was purchased by William Hall Jr. in 1833. When construction of a new bridge across the Connecticut River threatened the structure with demolition in 1951, Mystic Seaport agreed to preserve it. It was shipped by barge to Mystic Seaport.

Stonington Borough

The town of Stonington is the oldest borough in Connecticut, settled in 1753 and chartered in 1801. Both the lighthouse and the town represent the history and architecture of an archetypal Connecticut town. The Old Lighthouse Museum is in the restored 30-foot granite tower. The current lighthouse (completed in 1840) was built with salvaged materials from the original lighthouse (built in 1823). The museum's exhibits illustrate the history of this coastal region, which is notable for its beautiful Stonington stoneware.

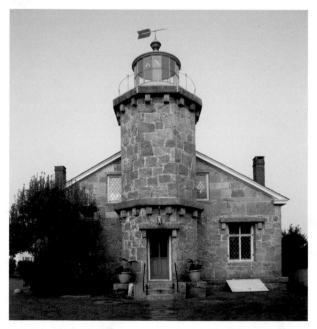

The Stonington Historical Society acquired the lighthouse in 1925 and opened it as a museum in 1927. The **Old Lighthouse Museum** honors the maritime history of this quaint coastal village.

Gillette Castle

What links Lyme, Connecticut, with the figure of Sherlock Holmes? They're joined in the figure of William Gillette, the Connecticut-born actor who played the fictional detective on stage in England and America for more than three decades. (He was the one to introduce the visual of Holmes's curvy pipe.) Gillette also built an elaborate castle that was completed in 1919; the estate even included a 3-mile railroad. It is now a state park, where visitors can picnic, hike, and tour a castle!

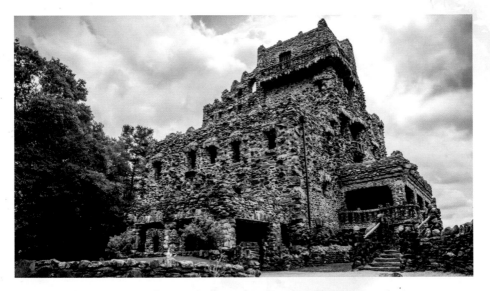

The state of Connecticut acquired **Gillette Castle** in 1943. Since then, visitors have gawked at the castle's stone exterior and admired its interior woodwork.

Connecticut State Capitol

Connecticut's current state capitol building dates to the 1870s. The elaborate building was the design of architect Richard Upjohn, who won a design contest. One of his competitors in that contest, James Batterson, ended up as the building contractor.

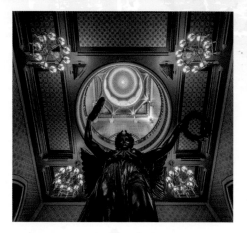

Genius of Connecticut presides over the floor of the rotunda.

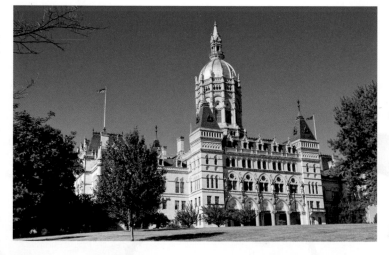

The **Connecticut State Capitol** in Hartford houses both the governor and the general assembly.

Weir Farm National Historic Site

Weir Farm National Historic Site, located in both Ridgefield and Wilton, Connecticut, commemorates the life and work of influential American Impressionist painter J. Alden Weir. Weir Farm National Historic Site is set amidst more than 60 acres of woods, fields, and waterways. Visitors will see why Weir and his friends were inspired by the landscape. Other artists who stayed or lived there include John Singer Sargent, Albert Pinkham Ryder, Childe Hassam, John Twachtman, and Mahonri Young.

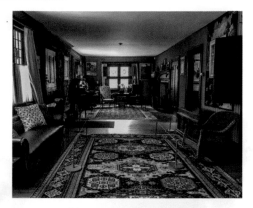

The **Weir House** dates back to the 1780s, but was first occupied by the Weirs in 1882.

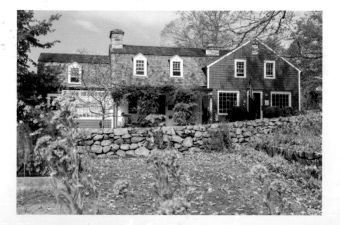

Weir Farm National Historic Site includes historic homes and art studios used by American Impressionist J. Alden Weir and other artists.

Frog Bridge

This whimsical bridge (right) in Willimantic, Connecticut, pays tribute to two disparate phenomena. The spools are monuments to the thread industry that was the backbone of the local economy in the 19th century. The frogs perched atop the spools are reminders of the infamous "Battle of the Frogs" of 1754, when the cries from dying, drought-ravaged bullfrogs seriously alarmed locals during the thick of the French and Indian War.

Cove Island Park

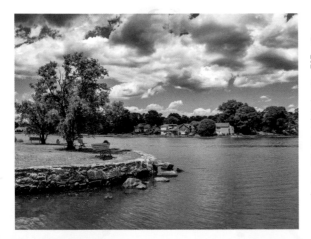

Cove Island Park (left) is an 83-acre park, beach, and recreation area in the Cove section of Stamford, Connecticut, located on Long Island Sound. The park is a popular place for biking, bird–watching, fishing, walking, and kite-flying.

Glass House

In 1948, architect Philip Johnson designed and built his glass house in New Canaan, Connecticut, with walls made entirely of glass. A mere 10.5 feet tall, 56 feet long, and 32 feet wide, the house is basically one glass-enclosed room with kitchen, dining, and sleeping spaces. The glass is held up by black painted steel, and the steel ceiling is also painted black. The Glass House is now owned by the National Trust for Historic Preservation and open to the public.

Interior of Philip Johnson's **Glass House**

Glass House in New Canaan, Connecticut

NEW YORK

Central Park

Central Park is the recreational center of life in Manhattan, New York City. Frederick Law Olmsted and Calvert Vaux designed the park after winning an 1858 design competition. Today, Central Park hosts activities from alfresco dining while listening to the Metropolitan Opera to strolling through formal gardens or exploring the zoo. In the summer, the Public Theater presents a Shakespeare in the Park series. Be sure to see the Bethesda Fountain, the Carousel, the Strawberry Fields memorial to John Lennon, and the Conservatory Garden.

America's first landscaped public park covers 843 acres and is 2.5 miles long and half a mile wide. **Central Park** has a 6.1-mile loop for cars that has parallel paths for horses, joggers, and cyclists during the week, but the park is closed to motorists on weekends.

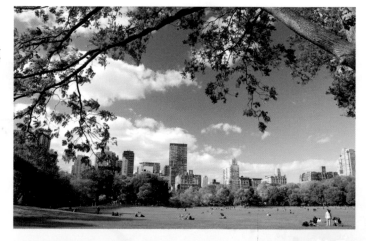

The **Bethesda Fountain**, the focal point of the Bethesda Terrace, is one of the largest fountains in New York, measuring 26 feet high by 96 feet wide. The statue at its center was the only sculpture to have been commissioned as a part of Central Park's original design.

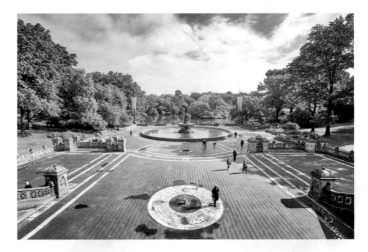

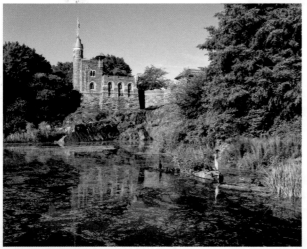

Central Park's **Belvedere Castle** was built in 1865 from schist and granite found naturally in the area. Visitors enjoy viewing Central Park from the site and exploring natural history artifacts. Central Park birdwatchers use the tower to find a closer look at migrating birds.

Statue of Liberty

The Statue of Liberty is one of the must-see sites for any tourist in New York City. Every year, about 4 million people visit the monument, which proudly stands on Liberty Island in New York Harbor. Lady Liberty stands more than 151 feet high but reaches greater heights thanks to the 65-foot-high foundation and the 89-foot-high granite pedestal.

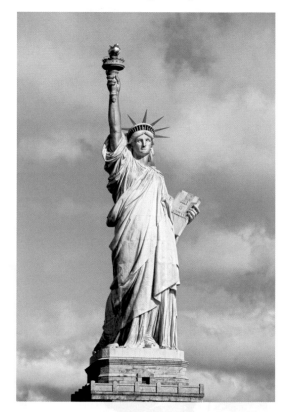

A gift from France to the United States, the statue was designed by Frederic Auguste Bartholdi, who was awarded a U.S. patent for his design in 1879. The monument was built by famed Eiffel Tower engineer Gustave Eiffel, and was officially dedicated on October 28, 1886.

The robed statue carries a torch in her right hand and a tablet in her left, and a broken chain lies at her feet. Representing Libertas, the Roman goddess of liberty, the monument is seen throughout the world as a symbol of freedom.

Ellis Island

On January 1, 1892, Ellis Island opened as an immigration station. Over the next six decades, it acted as the busiest immigration station in the United States, admitting 12 million immigrants to pursue their shot at the American Dream. It closed in 1954, becoming a part of Statue of Liberty National Monument in 1965. Today, it is administered by the National Park Service. Visitors can take a ferry to the island from Manhattan or Jersey City and see the Ellis Island Museum.

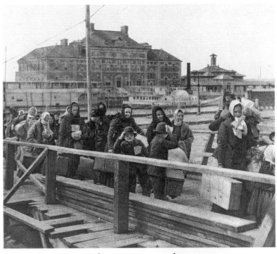

Immigrants coming to
Ellis Island in 1902

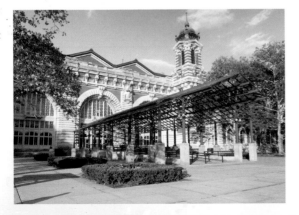

Ellis Island National Museum of Immigration has three floors of exhibits documenting immigrants' experiences at Ellis Island, as well as the general history of immigration to the United States.

The High Line

The High Line, also known as High Line Park, is a 1.45-mile-long elevated linear park, greenway, and rail trail. It was created on a former New York Central Railroad line on the west side of Manhattan in New York City. Since opening in 2009, the High Line has become an icon in contemporary landscape architecture, urban design, and ecology.

The High Line's design is a collaboration between landscape architecture firm James Corner Field Operations (Project Lead), the architecture firm Diller Scofidio + Renfro, and landscape architect Piet Oudolf.

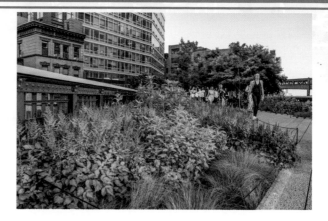

The High Line's vegetation was chosen to pay homage to the wild plants that already grew on the abandoned elevated rail tracks since the trains stopped running. The species were chosen for their hardiness, sustainability, and variation, with a focus on native species.

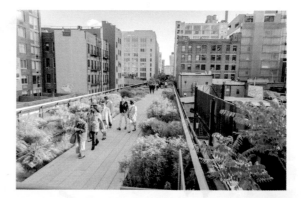

Washington Square Arch

George Washington was inaugurated as the first president of the United States in 1789. A century later, to celebrate the inauguration, the Washington Square Arch was built in New York City. Modeled on Paris's *Arc de Triomphe*, the Arch was completed in 1892. In 1918, two sculptures of Washington were added to the monument, one showing him as Commander-in-Chief and the other as president. The latter was sculpted by A. Stirling Calder, the father of sculptor Alexander Calder. The carving of the statues was done by the Piccirilli Brothers.

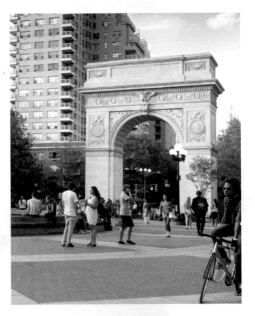

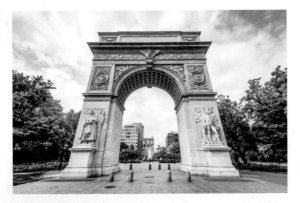

Washington Square Park
is well-known for its arch, honoring George Washington, the man for whom the park is named, and its fountain, which is a popular meeting spot.

Rockefeller Center

Midtown Manhattan's Rockefeller Center is a complex of 19 commercial buildings a few blocks south of Central Park. The center is a shopping mall, an art deco icon, and a winter wonderland. The center of the complex is 30 Rockefeller Plaza, a 70-story building that towers above the skating rink and the adjacent central plaza.

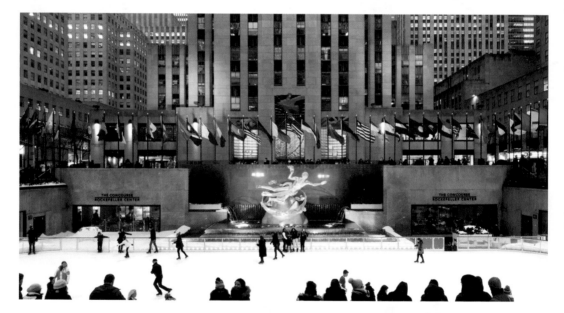

Rockefeller Center is the only place on Earth where you can nurse a cocktail and watch ice-skaters twirl beneath a big, golden statue of Prometheus.

Radio City Music Hall

The "Showplace of the Nation" opened in 1927. At the time, the art deco building had the world's largest indoor auditorium. Still impressive today, the massive auditorium can seat close to 6,000 people. The building is part of Rockefeller Center. As famous as the music hall are the Rockettes, the precision dance troupe who have been knocking out audiences since 1932.

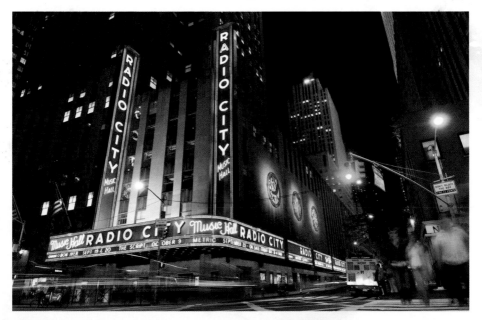

Radio City Music Hall has been endangered financially over the years, but people have rallied to its cause. It became a city landmark in 1978.

Empire State Building

On a clear day, you can see 80 miles from the observation deck of the Empire State Building, all the way to Massachusetts, Connecticut, New Jersey, or Pennsylvania. Of course you can also see much of New York, the Empire State. Each year almost four million tourists walk through the building's chrome-and-marble lobby and stand in line to ride an express elevator to the top. The building overlooks such landmarks as Rockefeller Center, the United Nations, Central Park, the Statue of Liberty, and the Chrysler Building, which is another art deco building.

When it comes to urban views of the world, the **Empire State Building** is preeminent, because of its height and proximity to the dazzling New York City skyline.

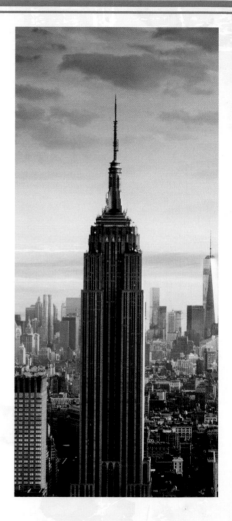

St. Patrick's Cathedral

St. Patrick's Cathedral lies in New York City across from Rockefeller Center. Technically, the cathedral was completed in 1879 after 20 years of construction. But the cathedral is the seat of the Archbishop of New York, so an archbishop's house and the rectory were added between 1882 and 1884. The cathedral's dramatic spires were completed in the 1880s, as well. Later, the great rose window and immense bronze doors on the Fifth Avenue side were added.

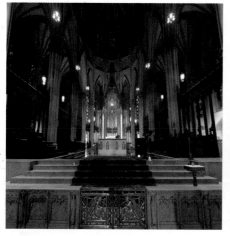

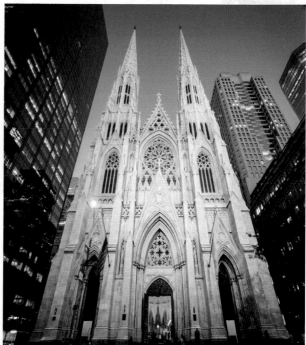

More than 5.5 million visitors come to admire **St. Patrick's Cathedral** each year.

National September 11 Memorial & Museum

The deadly terrorist attacks on September 11, 2001, killed thousands, shocked the nation, and left the city of New York altered forever. Where the Twin Towers of the World Trade Center once stood, there are now two massive reflecting pools, part of the National September 11 Memorial & Museum. Great waterfalls pour into the pools, with the victims' names inscribed around them.

Public discussion about a memorial began soon after the attacks, with construction following in 2006. The Memorial Plaza opened in September 2011, exactly ten years after the attacks. Family members of the victims were able to view the site on the 11th, with the site opening to the public a day later. The museum, which opened a few years later in 2014, includes physical artifacts from the tragedy, audio and video recordings, and photographs of the victims.

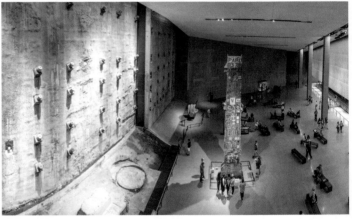

Foundation Hall in the museum contains the **Last Column**. This beam from the South Tower was removed in 2002, closing out the recovery period. During that recovery period, workers left tributes and photographs on the column, which are preserved at the museum.

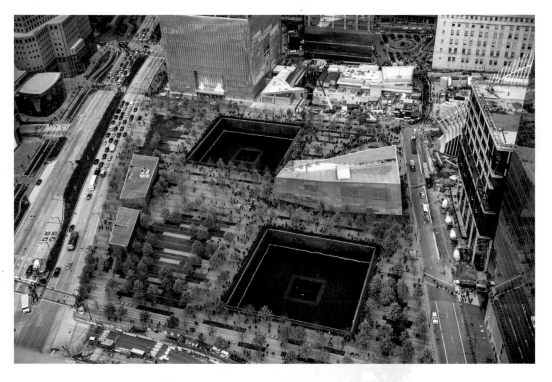

The waterfalls that pour into the pools are the largest
man–made waterfalls in the United States.

Times Square

New York City's Times Square is a blaring, electrifying, exhilarating, intoxicating, spotlit "crossroads of the world." Times Square welcomes more than 30 million visitors annually to its stores, hotels, restaurants, theaters, and attractions. The first electric billboard went up in 1917, and Times Square has been synonymous with glitz ever since. While as crowded and crazy as ever, Times Square today is also tourist- and family-friendly.

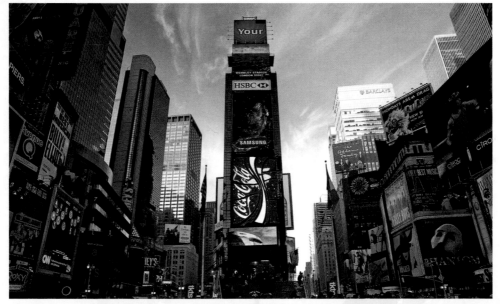

Dazzling neon signs and advertisements have made **Times Square** a New York City icon.

Solomon R. Guggenheim Museum

Viewed from Fifth Avenue, the exterior of the Solomon R. Guggenheim Museum is an inverted cone with wide bands rising upward. Inside, the museum contains an atrium and a spiral ramp where visitors view artwork from a perspective that can be dizzying. The museum has works by Kandinsky, Klee, Calder, Picasso, Rousseau, and many more.

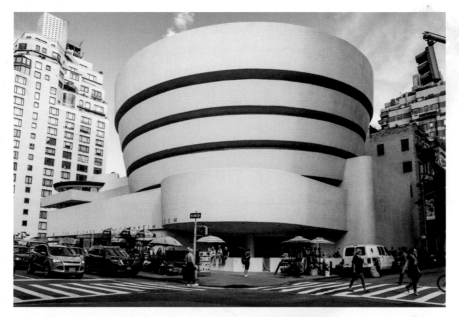

The **Guggenheim Museum** in New York City is known for both its collections and its adventurous architecture.

Brooklyn Bridge

The Brooklyn Bridge opened on May 24, 1883, linking what would become the boroughs of Brooklyn and Manhattan in New York City. It was an engineering accomplishment of mythic proportions. In its day, the Brooklyn Bridge was the longest suspension bridge in the world, with the length of the main span measuring 1,595 feet.

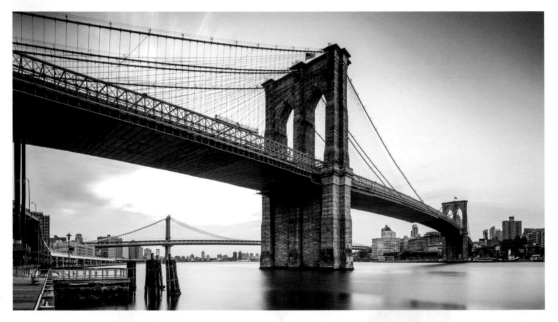

The **Brooklyn Bridge**, designed by architect John Augustus Roebling, towers over New York City's East River.

The heart of the **Lower East Side Tenement Museum** is a historic tenement that was home to an estimated 7,000 people from over 20 nations between 1863 and 1935.

African Burial Ground National Monument is the oldest and largest known excavated burial ground in North America for both free and enslaved Africans. The monument recognizes the historic role slavery played in building New York City.

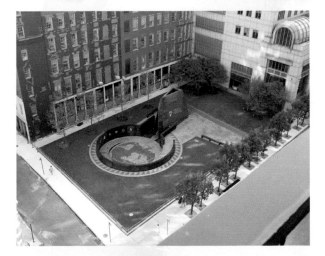

Boldt Castle

George C. Boldt loved his wife Louise so much that he decided to memorialize his devotion by presenting her with a dream castle on Heart Island. For four splendid years, the Boldts and their children summered on Heart Island as the castle's construction advanced. The family marveled at the 6-story, 120-room bulk of the structure. Its mass was offset by ornate trim and flourishing Italian gardens. Unfortunately, in 1904, just as the castle was nearing completion, Louise died suddenly.

With his beloved wife taken from him, a heartbroken Boldt ordered the castle's construction halted, and he never again set foot on the island. The castle stood vacant for decades. Then, in 1977, the Thousand Islands Bridge Authority acquired the property. It maintains Boldt Castle as a tourist attraction. Today, the castle's sad story is powerful enough to bring tears to the eyes of some visitors.

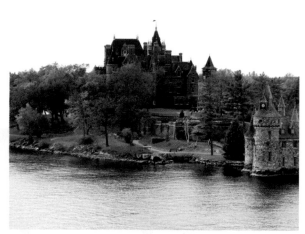

Boldt Castle sits on Heart Island in the Saint Lawrence River. The island is within the Thousand Islands archipelago, which stretches from New York to Canada.

Bannerman Castle

Located on an island once declared off limits to the public are the remains of Bannerman Castle. Francis Bannerman, a wealthy Scot and munitions dealer, designed buildings for an arsenal on the island. He also had a castle built where he and his wife, Helen, could spend the summers. The buildings featured turrets in the style of a Scottish castle. The castle and arsenal eventually fell into disrepair, and an explosion of some of the ammunitions destroyed part of the buildings. The state of New York eventually purchased the buildings and the island.

Bannerman Castle was built in 1901 on the 6.5-acre Pollepel Island in the Hudson River in New York. Today, boat and kayak tours allow tourists to visit the island and the castle ruins.

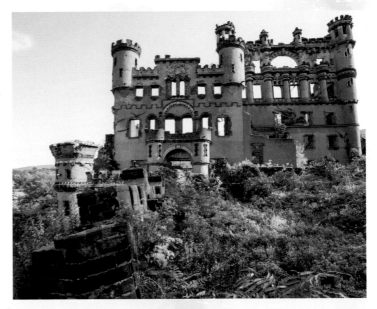

Darwin D. Martin House

The Darwin D. Martin House Complex in New York is ranked as one of Frank Lloyd Wright's most ambitious and important projects created in his Prairie School design. It wasn't just a home that Wright built for the Martin family, but a series of connecting buildings including two family residences, a conservatory, and a carriage house. The complex totals more than 29,000 square feet and is on the National Register of Historic Places.

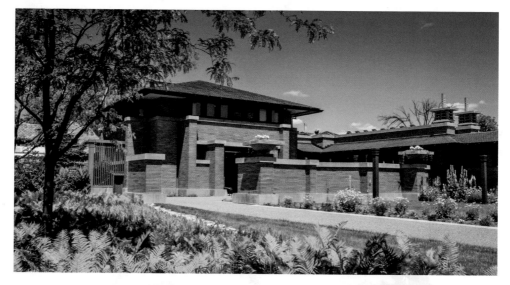

Frank Lloyd Wright's **Darwin D. Martin House** in Buffalo, New York

Olana Estate

An unusual blend of Victorian and Middle Eastern styles, the Olana Estate in New York almost met the wrecking ball when one of the original owner's descendants planned to sell it to developers. A story in *Life* magazine about the mansion, along with a keen interest by art historian David Huntington, saved the estate, which is now a National Historic Landmark.

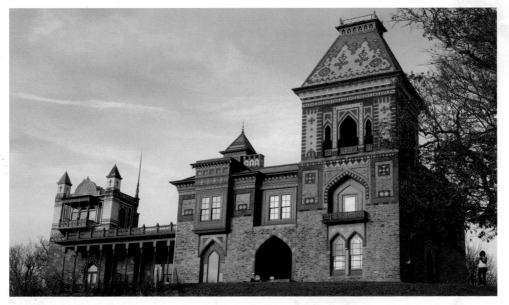

The **Olana Estate** in Greenport, New York, was designed by architect Calvert Vaux and built in 1870–1872.

Montauk Point Lighthouse

East of Fire Island, east of the Hamptons, and east of every other geographic point on Long Island is Montauk Point. There, more than 100 miles from New York City, is one of the first points of land that mariners have historically observed as they sailed to that great capital of maritime commerce. Built in 1797 by architect John McComb, the 78-foot tower at Montauk Point rises from a grassy headland to overlook the gray-blue Atlantic. Given its location on tall bluffs above the surf line, Montauk Point is one of the most scenic lighthouses in North America.

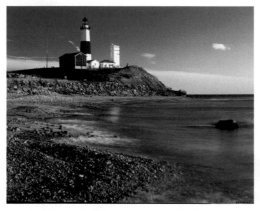

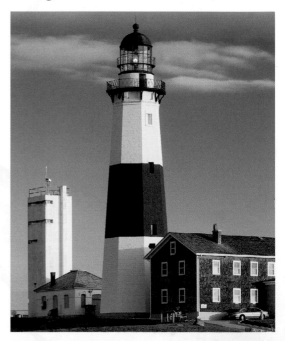

The **Montauk Point Light** was the first public works project completed by the U.S. government, the first lighthouse constructed in New York, and the fourth oldest active lighthouse in the nation.

Fire Island

Fire Island is the largest of the barrier islands that parallel the southern edge of Long Island. Though it stretches for more than 30 miles along the coast, not far from New York City, it still offers a tranquil setting that has made it a special place for getting away. Its beaches have official designation as a National Seashore. There's a national park featuring an eight-mile wilderness preserve in the middle, Smith Point County Park on the east side, and Robert Moses State Park on the west.

Fire Island National Seashore preserves rare maritime forests.

Selkirk Light

One of the earliest lighthouses in the Great Lakes region was built at Selkirk Point near Pulaski, New York, on Lake Ontario. The Selkirk Light, near the mouth of the Salmon River, is one of the prettiest small lighthouses in the Great Lakes area. It was built in 1838 of native fieldstone and secured with white cement, which produced a compact two-story structure resembling a sturdy New England farmhouse. This unique light is privately owned and is available to the public for short-term rentals.

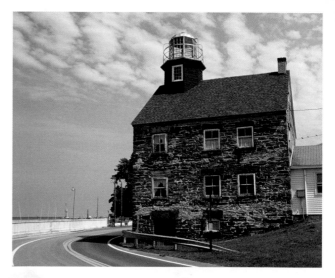

With its weathered gray and black rock, pitched slate-covered roof, and short, red tower, the **Selkirk Light** resembles something from a Norman Rockwell painting.

Niagara Falls

Niagara Falls is the best-known group of waterfalls in North America and quite possibly the world. Tourists have flocked here for more than a century, to take in the overpowering sights and sounds of water in motion as it courses over ancient rock. Niagara Falls is where Lake Erie drains into the Niagara River, Lake Ontario, and beyond. It actually consists of three splendid waterfalls on the Niagara River: American Falls and Bridal Veil Falls in New York, and Horseshoe Falls in southeastern Ontario, Canada. More than six million cubic feet of water pour over these three falls every minute, making for the most powerful group of waterfalls in North America.

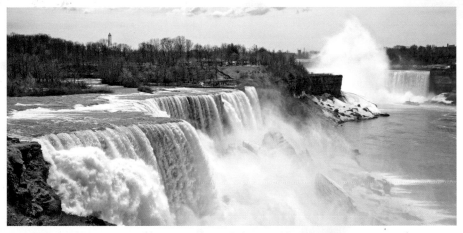

The **Niagara Falls** were born about 10,000 years ago when a slow-moving glacier dammed the river's route and forced it over the low point in the area, a north facing cliff.

NEW JERSEY

Atlantic City Boardwalk

Just off the mainland of southeastern New Jersey lies Absecon Island, whose marshes and sandy beaches lay undisturbed until 1854. Then the Camden and Atlantic Railroad Line was built there, and Atlantic City was born. Unfortunately, the hordes of vacationers dragged volumes of sand through too many marbled lobbies.

In 1870, Alexander Boardman, a railroad conductor, proposed constructing a wooden walkway to sift out the sand, thus creating the Atlantic City Boardwalk. It is more than 4 miles long and 60 feet wide and features steel pilings and 40-foot steel beams. The Boardwalk helped make Atlantic City an attractive host city.

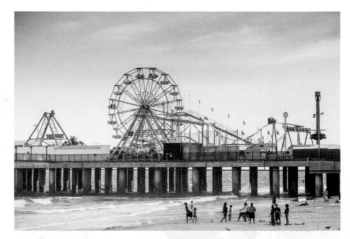

Navesink Light

In 1609, English explorer Captain Henry Hudson came upon the mouth of the great river that now bears his name. Before he entered the mouth of the river, Hudson took note of the unusual hills along the northern coast of what we call New Jersey.

In 1828, the federal government built a light station on the commanding 200-foot New Jersey hills that Hudson had first surveyed. To help distinguish the Navesink Light from others to the north and south, officials erected two octagonal towers, which were separated by a distance of about 320 feet.

The Navesink Lights were rebuilt in 1862. The south tower was given a square shape, while the north tower was octagonal. Centered between them was a fortress-like building, with huge flanking walls extending to either tower. In 1898 the north Navesink tower was decommissioned, and the south tower became the first lighthouse in the U.S. to use an electrically powered lighting device. The south tower continued serving mariners until 1953, when it was also decommissioned.

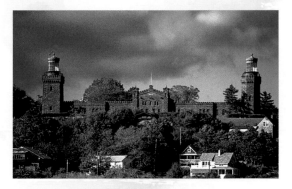

The **Navesink Light** was adopted as the official symbol of the American Army Corps of Engineers, who constructed it in 1862.

Cape May

Cape May is a peninsula at the southernmost tip of New Jersey; it's also the nation's oldest seaside resort. Whalers settled Cape May in the 17th century, and today it's a magnet for visitors from New Jersey, New York, and eastern Pennsylvania. Cape May is the gateway to the 30 miles of sandy Atlantic Ocean beaches along the Jersey Cape that connect the resort towns of Ocean City, Sea Isle City, Avalon, Stone Harbor, and the Wildwoods. You'll find plenty of attractions here, including picturesque gardens and Early-American museums. You can also charter fishing boats, rent speedboats, kayak, or parasail.

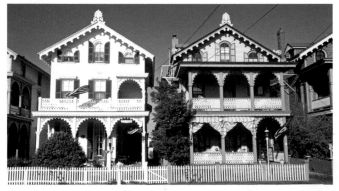

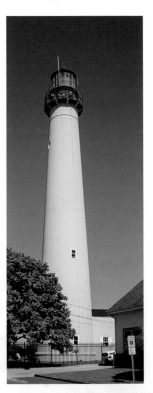

Because a fire swept **Cape May** in 1878, it was rebuilt in the Victorian style of the day, setting the architectural tone for what remains a charming, old-fashioned resort. The **Cape May Lighthouse** (right) towers 157 feet above the picturesque peninsula.

Thomas Edison National Historical Park

The Thomas Edison National Historical Park preserves the home and laboratory of America's greatest inventor in West Orange, New Jersey. With his teams of scientists and technicians, Edison perfected his phonograph and developed motion pictures, a nickel-iron-alkaline storage battery, and many other devices and technologies. Edison earned 1,093 U.S. patents in his lifetime, most for inventions that came from his West Orange laboratory complex.

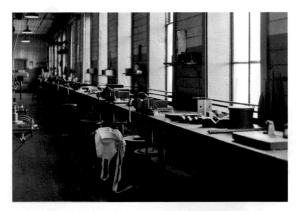

(Above) Laboratory at the **Thomas Edison National Historical Park**

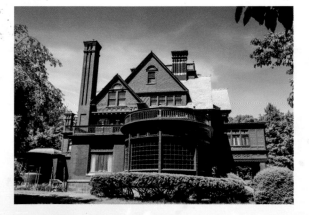

(Left) The national park preserves **Glenmont**, the estate of Thomas and Mina Edison, in the Llewellyn Park neighborhood of West Orange, New Jersey. The home and laboratory were designed by architect Henry Hudson Holly.

Paterson Great Falls

America's first planned industrial city was established in Paterson, New Jersey, centered around the Great Falls of the Passaic River. The area was first inhabited by the Lenni Lenape, followed by Dutch settlers in the 17th century. In 1792, the area was transformed by Alexander Hamilton's vision of creating a strong industrial system in the United States. Hamilton and the "Society for Establishing Usefull Manufacturers" (S.U.M.) purchased 700 acres of land above and below the Great Falls and established the city of Paterson, named for New Jersey Governor William Paterson, in 1792. Cotton and silk fabrics, textile machinery, steam locomotives, continuous rolls of paper, and airplane engines have all been manufactured here.

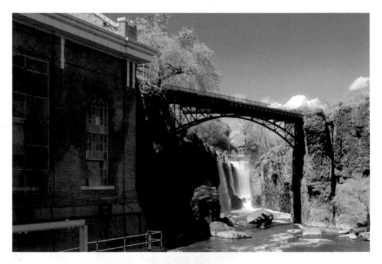

Paterson pioneered methods for harnessing water power for industrial use. **Paterson Great Falls National Historical Park** was dedicated in 2011. It protects the Great Falls of the Passaic River and the surrounding historic district.

New Jersey Pine Barrens

New Jersey Pinelands National Reserve, better known as the Pine Barrens, comprises impenetrable bogs and marshes with forests of low pine and oak, sporadic stands of cedar, and hardwood swamps. Under the barrens, the Kirkwood-Cohansey aquifer contains more than 17 trillion gallons of water—its acidity seeps into the barrens' bogs and swamps and stains the water a tea color. Tourists love hiking, biking, boating, picking cranberries, and visiting the historic villages of Batsto and Double Trouble.

(Above) The 1.1-million-acre **New Jersey Pinelands National Reserve** is about the size of Glacier National Park in Montana.

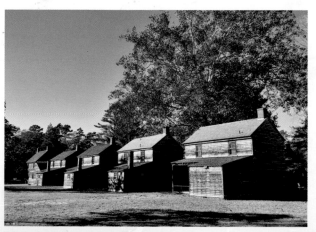

(Left) Fall foliage at the historic **Basto village** in the New Jersey Pine Barrens

DELAWARE

First State National Historical Park

Delaware is famous as the first state to ratify the Constitution. First State National Historical Park consists of seven different sites in Delaware: Beaver Valley, Fort Christina, Old Swedes Church, New Castle Court House, the Green (Dover), John Dickinson Plantation, and Ryves Holt House. The park covers the history of Colonial Delaware and the role it played leading up to American Independence. It also tells the story of early Dutch, Swedish, Finnish, and English settlers.

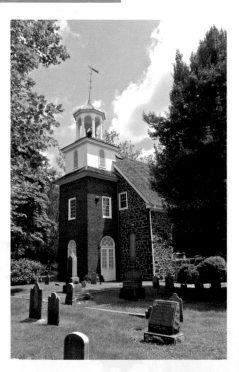

Swedish and Finnish settlers completed what is now called the **Old Swedes Church** in Wilmington in 1699. Much of the original church stands today. The church has preserved records of early settlers and many are buried at its graveyard.

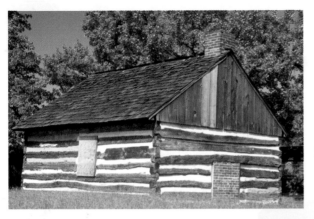

Fort Christina preserves the original site where Swedish and Finnish settlers landed in 1638 and built the colony of New Sweden. The park includes a reconstructed Swedish log cabin.

The **Ryves Holt House** was built in 1665 in Lewes, Delaware, by early Dutch settlers. The house was purchased in 1723 by its namesake, Ryves Holt, who served as the first Chief Justice of Delaware from 1745 until his death in 1763.

Winterthur Gardens and Enchanted Woods

Many people visit Winterthur, the lavish former home of Henry Francis du Pont in northern Delaware, to see its collection of art and antiques and its elaborate formal gardens. Most popular with families, however, is its Enchanted Woods, a three-acre fairytale garden. Children delight in the legend that fairies brought broken stones, old columns, crumbling millstones, and cast-off balustrades to this hilltop area to create a magical place.

A stone house in the garden

Visit **Winterthur,** the former home of Henry Francis du Pont, to see its collection of American decorative arts and meander through its 60-acre garden.

Greenbank Mill

At Greenbank Mills & Philips Farm, visitors can see history come alive again. Visitors to the site can tour the mill in action, as well as viewing various "living history" demonstrations on gardening and using herbs to dye fabric. The farm is even home to a flock of heritage sheep.

Greenbank Mill is listed on the National Register of Historic Places.

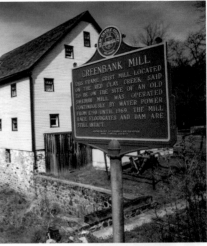

Greenbank Mill was built on the site in 1790 and expanded in 1812. When the mill was gutted due to a fire in 1969, restoration work commenced.

PENNSYLVANIA

Duquesne Incline

One of the best ways to see Pittsburgh, Pennsylvania, is by taking the Duquesne Incline, which, since 1877, has provided public transportation to the top of Mount Washington, a steep hill on the city's south side. Take the incline at night and go to the observation deck overlooking downtown Pittsburgh's Golden Triangle. Fifteen major bridges span the waters of the Allegheny and Monongahela rivers as they flow together to become the Ohio River. You'll be rewarded by the view and will land in the middle of Pittsburgh's Restaurant Row.

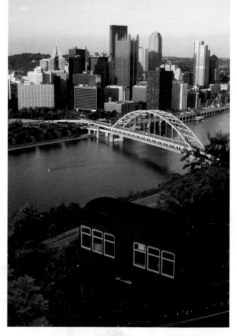

Opposite Mount Washington, going north across the rivers, is the Andy Warhol Museum, the Carnegie Science Center, PNC Park, and Heinz Field. While you're on the north side of the rivers, check out the National Aviary. It's a warm refuge on a chilly Pittsburgh day.

Philadelphia's Old City

The heart of Philadelphia is its Old City neighborhood, where the metropolis began. And the heart of Old City is Elfreth's Alley, the oldest residential street in America, where people have lived since 1702. Three hundred years ago, traders and merchants lived in the Georgian- and Federal-style buildings on the narrow street. Blacksmith Jeremiah Elfreth owned most of the property along the alley and rented his houses to shipbuilders, sea captains, and landlubbers such as pewter smiths.

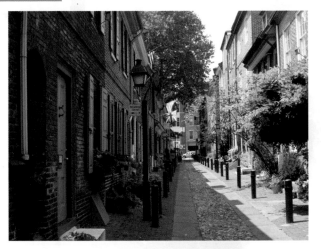

Elfreth's Alley in Philadelphia's Old City is the oldest residential street in America.

Today, Old City is a vibrant neighborhood that is filled with theater companies, art galleries, restaurants, shops, and bars. Christ Church, the Betsy Ross House, and Independence Hall are a short stroll away. Architecture fans should head to Elfreth's Alley Museum, which offers guided tours of homes that were built between 1710 and 1825.

Independence National Historical Park

Independence Hall, which is part of a 45-acre park (along with 20 or so other buildings), is where America's independence was born. Once called the Pennsylvania State House, this simple building in Philadelphia's Center City saw the foundations of the Declaration of Independence laid and brought to fruition.

The comely two-story redbrick building now has a steeple with a clock in it. But long ago, that steeple housed the 2,080-pound Liberty Bell. It chimed often (supposedly annoying the neighbors), but most notably, it was rung on July 8, 1776, to announce the first public reading of the Declaration of Independence. Now the bell is perhaps best known for its cracks—and its silence. The bell no longer hangs in the Independence Hall steeple because it has its own home on the park grounds.

The Independence National Historical Park covers three large city blocks. Follow the paths (quaint alleys) to the many historical buildings and fascinating sites, such as Ben Franklin's final resting place in the Christ Church graveyard. It's hallowed ground you're walking on, so take your time, and try to see as much as you can. It's a visit you'll always remember.

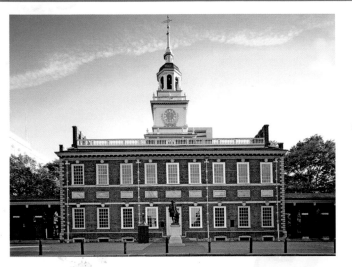

Construction on the Pennsylvania State House, now called **Independence Hall**, began in 1732 and was completed 21 years later.

This memorial in **Washington Square**, erected in 1954, contains the remains of an unknown Revolutionary War soldier who died in the fight for independence. An eternal flame honors the high price paid by soldiers in the name of freedom.

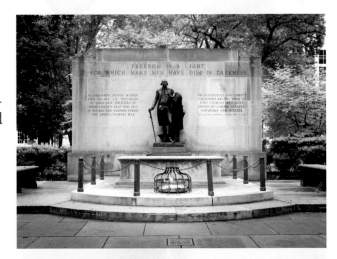

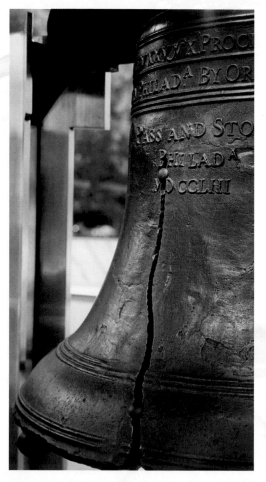

(Left) The **Liberty Bell** is now displayed in a glass chamber at the Liberty Bell Center, part of Independence National Historical Park.

(Below) This room in **Congress Hall** is where the U.S. House of Representatives met from 1790 to 1800. John Adams was sworn in as the nation's second president here on March 4, 1797.

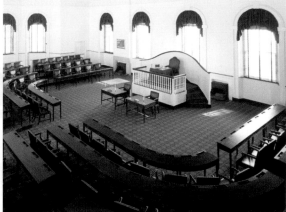

Gettysburg

Gettysburg, Pennsylvania, was the site of one of the most pivotal battles of the Civil War. The clash during the first three days of July 1863 led to the eventual defeat of the Confederacy.

Gettysburg will forever be remembered as the place where General George Gordon Meade's Union forces turned back the Confederate Army of General Robert E. Lee, and as the location where President Abraham Lincoln gave his famous address four months later.

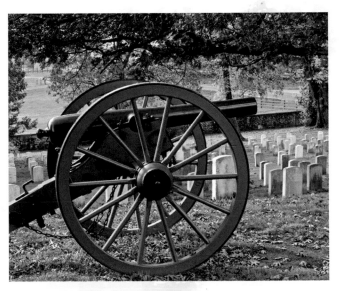

Gettysburg includes the 6,000-acre battlefield and its more than 1,400 markers and monuments, the national park, the adjacent borough, and the next-door Eisenhower National Historic Site.

A visit to **Gettysburg** is well worth the trip to see the now-peaceful hills and fields where the tide of the Civil War changed.

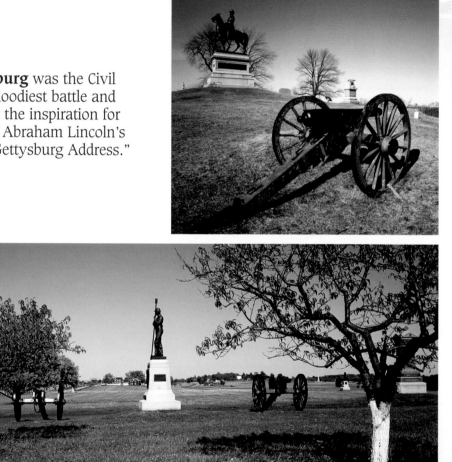

Gettysburg was the Civil War's bloodiest battle and was also the inspiration for President Abraham Lincoln's famous "Gettysburg Address."

Pennsylvania State Memorial

The Pennsylvania State Memorial is the largest monument in Gettysburg National Military Park. The 110-foot-tall monument commemorates the thousands of Pennsylvanian soldiers who fought in the famed Battle of Gettysburg in July 1863. It is constructed of North Carolina granite, and topped with a bronze figure representing Nike, the goddess of victory and peace. The metal used to create the statue of Nike was reclaimed from melted-down Civil War cannons.

The stone arches are flanked by bronze statues of Civil War historical figures, including President Abraham Lincoln, Pennsylvania Governor Andrew Curtain, and six generals who fought in the Battle of Gettysburg.

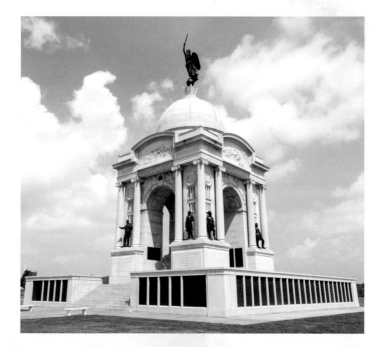

Fallingwater

Frank Lloyd Wright is probably the most famous American architect, and his most renowned building is a house in Mill Run, Pennsylvania, called Fallingwater. Wright designed the house in 1935 for Mr. and Mrs. Edgar J. Kaufmann of Pittsburgh. It was completed in 1939.

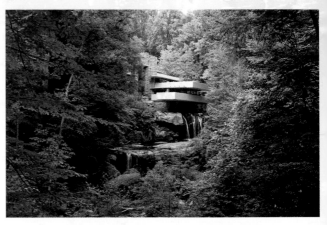

The unique balconies of **Fallingwater** seem to float over the falls.

The location for the building was inspired by Edgar Kaufmann's love for the waterfall on Bear Run, the stream that runs through these serene woods. Wright also recognized the beauty of the location, and immediately visualized a house with cantilevered balconies on the rock bank over the waterfall.

Fallingwater became the gem of Wright's organic architecture school. A 1991 survey of the American Institute of Architects members judged it the all-time-best work of American architecture.

Today Fallingwater is open to the public and contains the original Wright-designed furnishings and the Kaufmanns' superb modern and Japanese art collections. There are the exterior views of the place, which suggest that art and nature are not so far apart.

Allegheny National Forest

Established as a national forest in 1923, Allegheny National Forest in northwestern Pennsylvania contains tracts of old-growth forest. As well as hiking, it offers boating, fishing, and hunting. The forest had been heavily logged before becoming federal land. Black cherry and maple trees now thrive there.

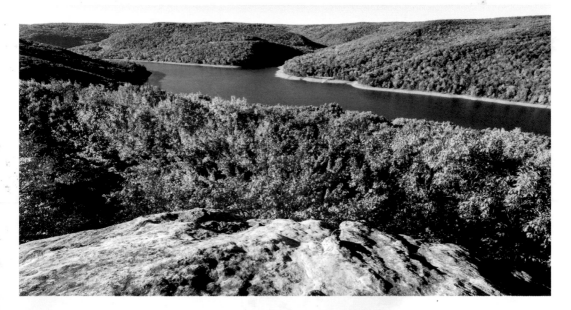

This autumn shot showcases the natural beauty of **Allegheny National Forest**.

Pennsylvania Dutch Country

As you drive through this peaceful realm, you'll pass classic barns and silos, horse-drawn buggies, wooden covered bridges, and a pretty patchwork of farm fields and villages. You might even see girls in bonnets and boys in hats walking to their one-room schoolhouse. You won't see them in cars, of course, and some Amish children aren't even allowed to have bicycles because their elders fear they might venture too far from home. That's just one of the many things that sets apart the Pennsylvania Dutch Country.

Plan to stop at one of the region's pretzel bakeries, such as the Sturgis Pretzel House in Lititz, which has been baking the snack since 1861. Here you can make your pretzels and eat them right out of the stone oven.

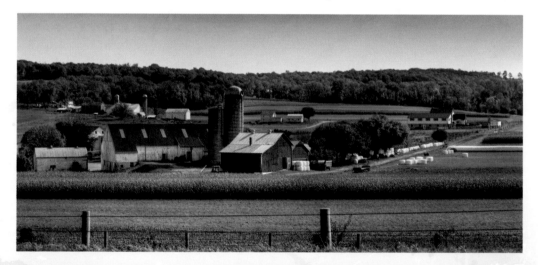

Horse-drawn carriages are a common sight in **Pennsylvania Dutch Country** (Lancaster County). The area draws many visitors, curious to see a way of life that doesn't include modern conveniences.

You can purchase regional foods, flowers, and Amish crafts at **Lancaster Central Market**, the oldest publicly owned, continuously operating farmer's market, which dates back to the 1730s.

Pennsylvania State Capitol

Pennsylvania had had several capitals before settling on Harrisburg, and the current state capitol building was the third one built in that city. Construction took place between 1902 and 1906. The building was designed by Joseph Huston in the Beaux-Arts style. The results were beautiful, with President Theodore Roosevelt saying at its dedication that it was, "the handsomest building I ever saw." Artwork and architecture throughout was often done by Pennsylvanians, including the stained-glass dome shown here that tops the Supreme Court chamber.

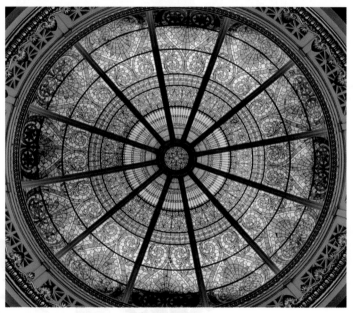

The Capitol building is home to Pennsylvania's Senate, House of Representatives, and Supreme Court.

Flight 93 National Memorial

On September 11, 2001, forty people aboard hijacked United Airlines Flight 93 were determined to wrest control of their plane from the hijackers. Without their intervention, the plane would have caused untold devastation to its intended target, believed to be the U.S. Capitol. The plane crashed in an open field in Somerset County, Pennsylvania, killing all on board. Congress passed a bill approving the establishment of a memorial in 2002, with the first phase of the memorial dedicated on September 10, 2011. The visitor's center was completed in 2015.

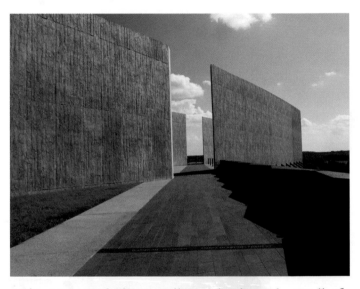

The Memorial Plaza Walkway leads to the Wall of Names at the **Flight 93 National Memorial** in Stoystown, Pennsylvania. The wall is aligned with the plane's flight path.

MARYLAND

Baltimore Inner Harbor

The showpiece of Baltimore, Maryland, is its fantastic Inner Harbor. Not long ago, the city's harbor could have served as urban decay's exhibit A. Then, beginning in the early 1960s, a succession of city administrations focused on rehabilitating the old waterfront. They succeeded beyond anyone's wildest dreams, luring many top-notch attractions. These include the National Aquarium, the Maryland Science Center, the Port Discovery Children's Museum, the Historic Ships in Baltimore Museum, the Civil War-era USS *Constellation*, and much more. Another mustsee is the Top of the World Observation Level on the 27th floor of Baltimore's World Trade Center.

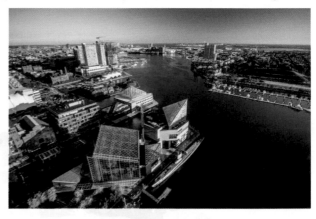

Baltimore Inner Harbor

Annapolis

Annapolis, Maryland, is known as the sailing capital of America and home to the U.S. Naval Academy. Sailing is definitely a favorite pastime for Annapolis residents, and many major national and international sailing events, as well as weekly racing events for the locals, take place in the bay. Schooners, sailing sloops, and cruise boats offer a variety of trips, narrated tours, and even Sunday brunch. You can also take a guided kayak tour of downtown Annapolis or paddle alone on the many creeks that feed the bay.

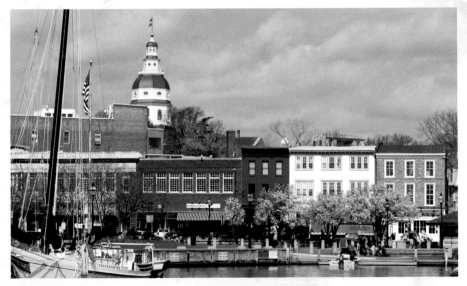

Annapolis Harbor is a fascinating place for families to explore and is sure to spark the imagination of fledgling sailors.

Thomas Point Light

The light at Thomas Point Shoals, located near Annapolis, Maryland, is one of the more unusual-looking lighthouses in America. The Thomas Point Light is perched on a wrought-iron platform in the middle of Chesapeake Bay. The light's base was created with a type of construction that secures the building to the ocean floor, allowing it to sit surrounded by water. The light indicates the presence of the treacherous shoals upon which Thomas Point Light is located.

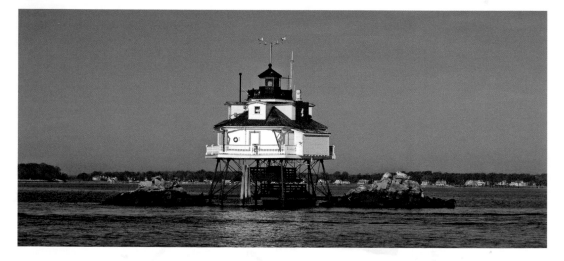

In former times, beginning in 1825, the Thomas Point Lighthouse was located onshore. In 1875, a new **Thomas Point Light** was moved to its present position off shore, where it was found to be more useful.

Chesapeake Bay

Chesapeake Bay, the largest estuary in North America, is shared by Maryland, Virginia, and Delaware. The bay stretches almost 200 miles from the Susquehanna River to the Atlantic Ocean and ranges from four miles wide to 30 miles wide. The beautiful bay was once the valley of the Susquehanna River, which helps explain why the bay is surprisingly shallow—most of it is less than six feet deep. The bay area today is a feast of art exhibitions, waterfront festivals, regattas and races, sportfishing contests, and boat shows.

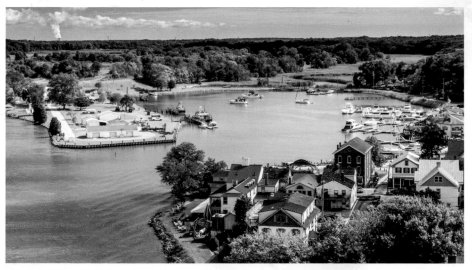

Recent conservation and restoration efforts have benefited **Chesapeake Bay**. The devastating pollution of the bay's waters has remained a threat since the 1970s but no longer greatly detracts from its natural beauty.

Brookside Gardens

Brookside Gardens are public gardens found within Wheaton Regional Park, in Silver Spring, Maryland. The Gardens were founded in 1969 and named for the winding brooks and streams that surround the public display garden. The 50-acre property features several gardens that are all easily viewed from walking trails, benches, and shady gazebos.

Smaller gardens include a Japanese teahouse and landscape, an aquatic garden, a rose garden, and an azalea garden.

Capital Wheel

Capital Wheel is found at Maryland's National Harbor along the Potomac River. In fact, it sits on a pier that extends into the river itself.

(Right) Maryland's **Capital Wheel** stands 180 feet high.

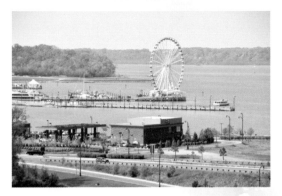

Awakening Sculpture

In a classic bit of American weirdness, *The Awakening*, a 70-foot-long by 17-foot-high "screaming" sculpture by J. Seward Johnson Jr., was moved from its Hains Point, Washington, D.C., home to Oxen Hill, Maryland, in 2008. The aluminum behemoth whose wildly contorted facial expressions suggest a perpetually bad day, had struggled at Hains Point in his half-buried state since 1980, when it was

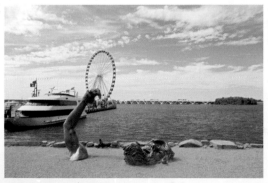

created as part of a public art exhibition. Eventually, the sculpture was loaned to the National Park Service, which maintained stewardship of the statue until it was sold to billionaire developer Milton Peterson for the hefty price of $750,000. Peterson saw fit to provide the grumpy giant with new "digs" on a faux beach at National Harbor, Maryland.

Assateague Island

Off the coasts of Maryland and Virginia is an island with white sand beaches sparkling in the sunshine. Assateague Island is 37 miles long and is populated with wild horses that have galloped along the beach since the 1600s.

The surf is gentle, and stripers, bluefish, weakfish, and kingfish are plentiful. Assateague Island is a barrier island, so it has an ocean side, a bay side, and an interior. The center of the island is a bird-watcher's paradise of ponds and marshes, home to wintering snow geese,

Tree swallows stop on Assateague Island to feed on bayberries during their southward migrations.

green-winged teal, northern pintail, American wigeon, bufflehead, red-breasted merganser, bald eagles, ospreys, red-tailed hawks, kestrels, and merlins.

Three stunning public parks share the island's 39,727 acres: Maryland's Assateague State Park, Assateague Island National Seashore, and Chincoteague National Wildlife Refuge.

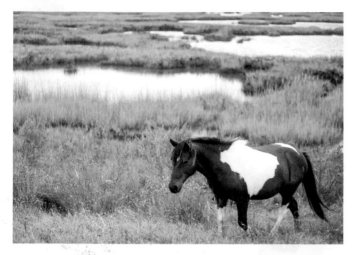

Assateague Island's horses are descendants of domestic horses that reverted back to the wild. They are only about 12 to 13 hands tall— the size of ponies.

Great egret in flight at Assateague Island National Seashore

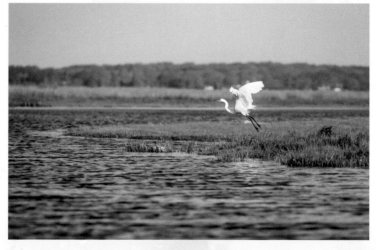

WASHINGTON, D.C.

National Mall

The National Mall in Washington, D.C., is one of the world's great public places. Its 146 acres of renowned monuments, impressive institutions, and grand government offices draw visitors from across the country and around the world.

By strict definition, "the Mall" means the greensward and adjacent buildings from the Washington Monument to the U.S. Capitol. But the broader area of the National Mall includes dozens of world-class museums, memorials, gardens, and other features worth exploring.

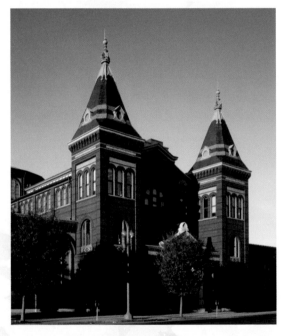

The Smithsonian Institution offers eleven museums and galleries on the National Mall. The Mall's **Smithsonian Institution Building** ("The Castle"), completed in 1855, serves as its visitor center.

Attractions at the National Mall and the surrounding area include:

- World War I and World War II memorials
- Constitution Gardens
- National Gallery of Art
- Martin Luther King Jr. Memorial
- Korean War and Vietnam Veterans memorials
- Franklin Delano Roosevelt Memorial
- Washington Monument
- Lincoln Memorial
- Thomas Jefferson Memorial

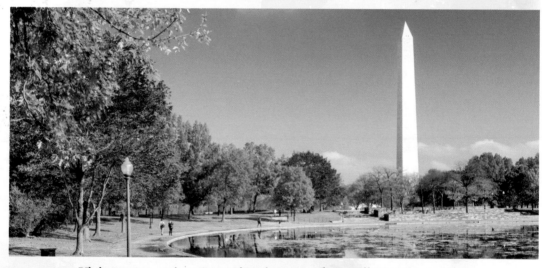

Visitors can enjoy **Constitution Gardens** all year long. The park is home to a wide array of urban wildlife.

U.S. Capitol

The U.S. Capitol is an icon of 19th-century neoclassical architecture that houses the country's legislative branches and stands as a symbol of the United States. The building's cornerstone was laid on September 18, 1793, and it's been burnt, rebuilt, expanded, and restored since then. The design of the current grounds dates to the late 1800s. They were worked on by famed landscape architect Frederick Law Olmsted.

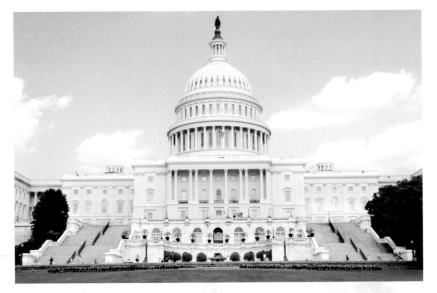

The Senate meets in the north wing, while the House of Representatives meets in the south.

Washington Monument

As early as 1783, proposals for a monument to honor the country's first president were considered. But disagreements over design and political power struggles served to delay construction. Finally, in 1848, the cornerstone was laid and work began on architect Robert Mills's obelisk design. Lack of funding and the onset of the Civil War halted construction once again, and it took another 36 years before the capstone was set in 1884. The monument was dedicated on February 21, 1885, and at last—on October 9, 1888—the Washington Monument was open, receiving an average of 55,000 visitors a month in its first year.

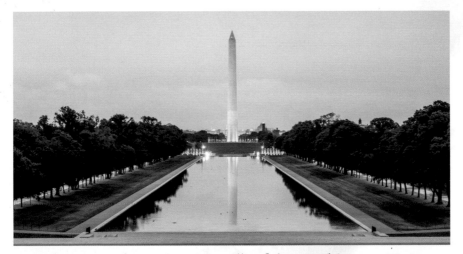

The east and west interior walls of the **Washington Monument** contain almost 200 commemorative stones, donated by cities, states, foreign governments, and various organizations.

Thomas Jefferson Memorial

In 1934, one of the country's most influential presidents, Franklin Delano Roosevelt, suggested that a memorial be built for another influential president he greatly admired: Thomas Jefferson. Known as a writer, philosopher, diplomat, and Renaissance man, Jefferson left behind a legacy of political ideas and actions that have passed the test of time. FDR felt that Jefferson, as the main drafter of the Declaration of Independence, first U.S. Secretary of State, and third U.S. president, deserved a monument of recognition. Congress agreed and appropriated $3 million for the project.

Construction began in 1938 in West Potomac Park on the shore of the Potomac River Tidal Basin. Jefferson himself was a fan of neoclassical architecture, and is often credited with introducing the design to the United States. So memorial designer John Russell Pope modeled the building after the Pantheon in Rome, with marble Ionic columns surrounding a circular colonnade. Inside the memorial stands a 19-foot-tall bronze statue of Jefferson, sculpted by Rudulph Evans.

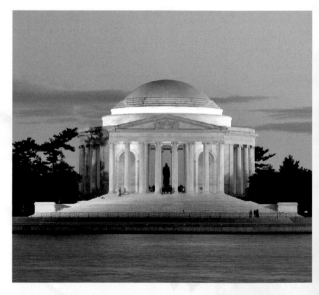

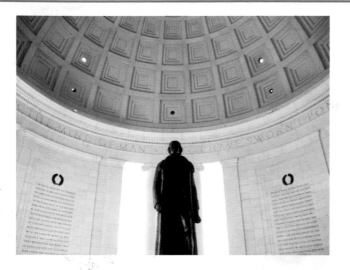

A statue of Jefferson stands at the center of the rotunda under the dome, and the surrounding walls are inscribed with words from his most lasting and eloquent writings, including personal letters and the Declaration of Independence.

Situated on the shore of the Tidal Basin among some of Washington, D.C.'s famous blossoming cherry trees, the **Thomas Jefferson Memorial**, with its graceful dome, is a striking site.

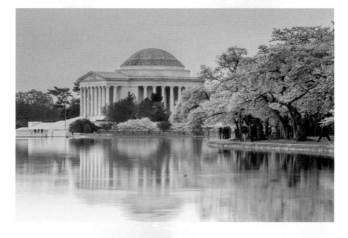

Franklin Delano Roosevelt Memorial

America's longest-serving president is honored with a memorial that sprawls over 7.5 acres, or 326,700 square feet. It consists of four open-air rooms, each depicting one of his four terms in office. Waterfalls and pools unify the memorial and evoke different events from the tumultuous times that Roosevelt oversaw during his presidency. More than twenty quotations are found around the site.

Landscape architect Lawrence Halprin was chosen to design the memorial in 1974; however, because of funding delays, the memorial was not dedicated until 1997.

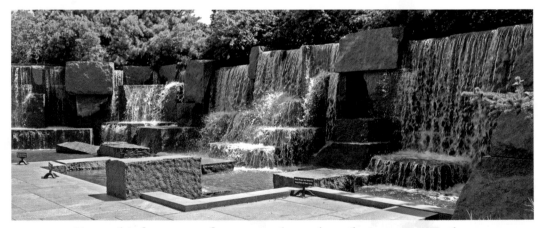

From the first water feature, a sharp drop that represents the initial economic crash of the Great Depression, the waterfalls become more complex as visitors walk through the memorial.

FDR is shown with his dog Fala. FDR's pose, and whether he should be depicted in a wheelchair, was a matter of controversy. The memorial is not only about the man, but also the tumultuous times, most notably the Great Depression and World War II, through which he guided the nation.

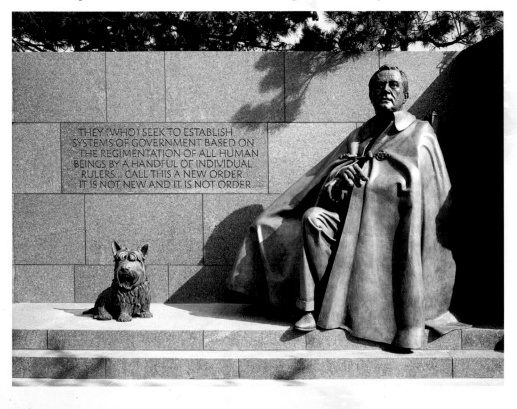

THEY (WHO) SEEK TO ESTABLISH SYSTEMS OF GOVERNMENT BASED ON THE REGIMENTATION OF ALL HUMAN BEINGS BY A HANDFUL OF INDIVIDUAL RULERS... CALL THIS A NEW ORDER. IT IS NOT NEW AND IT IS NOT ORDER

Lincoln Memorial

The Lincoln Memorial leads visitors to contemplate what Lincoln accomplished and what he stood for. No poet or biographer has expressed this as well as Lincoln himself in his addresses at his second inauguration and at Gettysburg. Both speeches are carved into the memorial's walls. The base of the Lincoln Memorial covers roughly the same area as a football field. The statue measures 19 feet wide by 19 feet tall—its size was sharply increased when sculptor Daniel Chester French realized it would be overwhelmed by the memorial building's size. The building has 36 Doric columns, one for each state during Lincoln's presidency.

The **Lincoln Memorial** has come to symbolize freedom, democracy, national unity, and social justice.

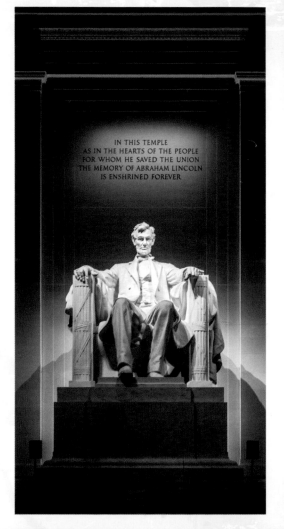

IN THIS TEMPLE
AS IN THE HEARTS OF THE PEOPLE
FOR WHOM HE SAVED THE UNION
THE MEMORY OF ABRAHAM LINCOLN
IS ENSHRINED FOREVER

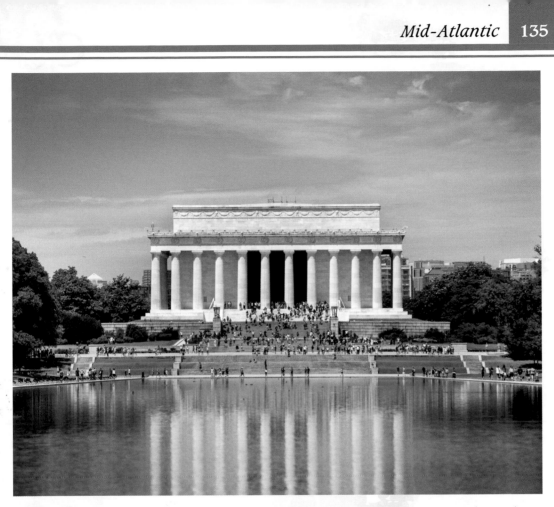

In 1963, Martin Luther King Jr. delivered his "I Have a Dream" speech on the steps of the **Lincoln Memorial**. In 2003, forty years later, an inscription about that speech was added to the step on which King stood when he gave the speech.

Vietnam Veterans Memorial

As one of the most visited memorials in Washington, D.C.—second only to the Lincoln Memorial—it is surprising to learn that the Vietnam Veterans Memorial was not well received when it was dedicated on November 13, 1982. Artist Maya Lin's design was considered too unconventional and plain to be a war memorial, with one critic calling it a "black gash of shame."

The simple design consists of two walls, each 246-foot-9-inch long, which are sunk into the ground and meet together in a V shape. Lin's vision was to create a memorial that symbolized a healing wound, to reflect the pain and recovery the country experienced after the war. Today, the Vietnam Veterans Memorial is no longer seen as a "black gash of shame," but rather as a shrine and place of reflection and respect.

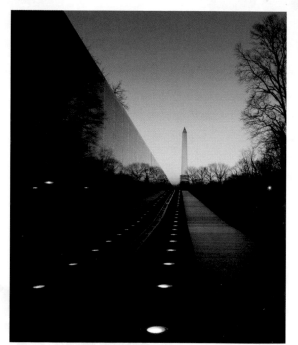

In 2007, decades after the original criticism for being too "plain" and "unconventional," the memorial was recognized on the American Institute of Architects' "List of America's Favorite Architecture."

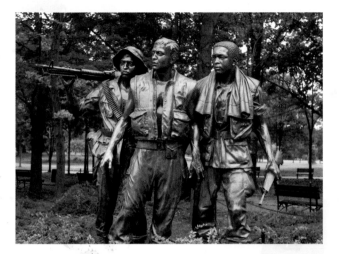

(Left) As a compromise to those who felt the memorial was too basic, a bronze sculpture, created by Frederick Hart, was added a short distance from the wall. Called *The Three Servicemen*, the traditionally styled sculpture features three soldiers who appear to gaze at the names of their fallen friends on the wall.

(Right) Visitors often leave items at the wall for sentimental reasons. More than 400,000 items have been left since the memorial's dedication. These have included everything from flags, medals, letters, and photos to cans of beer, roller skates, and even a motorcycle.

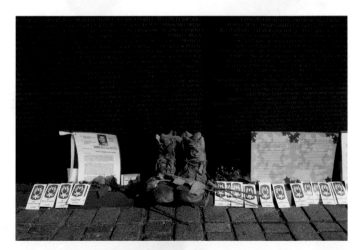

National Museum of African American History and Culture

One of the museums of the Smithsonian Institution, the National Museum of African American History and Culture opened in September 2016. The idea for a museum had been under discussion for at least a century—a group of African American Civil War veterans brought up the idea in 1915. Renewed interest in the 1980s and 1990s brought the idea to the forefront, and the museum broke ground in 2012. Certain exhibits were placed as the museum was built, for example, a segregated railroad passenger car.

The museum highlights historical artifacts having to do with slavery, segregation, and the Civil Rights movement, as well as the many contributions made by African Americans to American culture.

Washington National Cathedral

Pierre L'Enfant, Washington, D.C.'s first city planner, conceived of a national church in 1791. However, it took some time for L'Enfant's vision to come to pass. The foundation was laid in 1907, but the grand structure with more than 250 angels and more than 100 gargoyles was not finished for 83 years. The National Cathedral has been a focal point for spiritual life in the nation's capital since it opened in 1912. Every president has attended services here while in office. Many people have gathered at the church to mourn the passing of leaders or mark momentous events in world history.

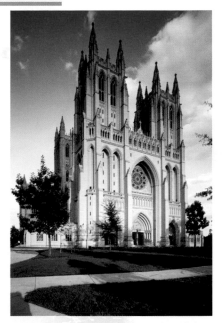

The **National Cathedral** in Washington, D.C., is the sixth-largest cathedral in the world.

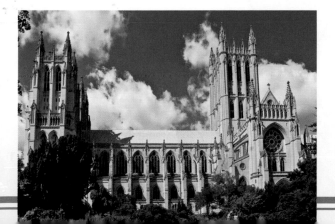

VIRGINIA

Arlington National Cemetery

Nearly four million visitors come to Arlington National Cemetery each year. Most come to pay respect to the leaders interred here or to thank the more than 300,000 people buried here, many of whom were soldiers killed in the line of duty. The original 200 acres were designated as a military cemetery on June 15, 1864. Soldiers and veterans from every war the United States has fought, from the Revolutionary War to the war in Iraq, are buried here (those who died prior to the Civil War were reinterred in Arlington after 1900).

The Tomb of the Unknowns contains the remains of service members from both World Wars and the conflict in Korea. (The Vietnam veteran who had been buried here was identified in 1998, and his body was returned to his family.) The Tomb is guarded 24 hours a day.

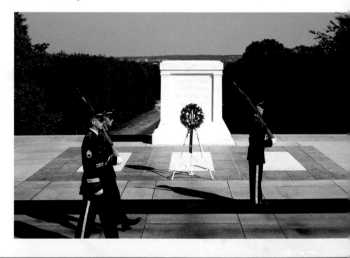

United States Marine Corps War Memorial

One of the most iconic moments of World War II is captured in sculpture at the United States Marine Corps War Memorial. Sculptor Felix de Weldon used the famous photo of Marines raising a U.S. flag on Mount Suribachi as his inspiration for the statue, which is also commonly known as the Iwo Jima Memorial. The memorial honors not only those who lost their lives during WWII, but all Marines who have died serving the country since the Marine Corps began in 1775.

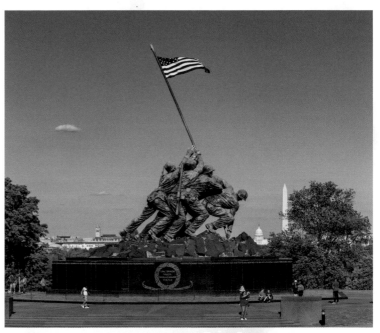

In 1961, President John F. Kennedy declared that the U.S. flag should continually fly over the **United States Marine Corps War Memorial**. Since then, the flag has flown 24 hours a day, 365 days a year on the 60-foot flagpole at the site.

Monticello

Monticello, the Virginia home of American founder Thomas Jefferson, is a Roman neoclassical masterpiece. Jefferson moved onto the property in 1770, but the mansion was not completed until 1809, after Jefferson's second term as president. The house was the centerpiece of Jefferson's plantation, which totaled 5,000 acres at its peak. About 130 slaves worked the land, tended livestock, cooked, and cleaned there during Jefferson's life.

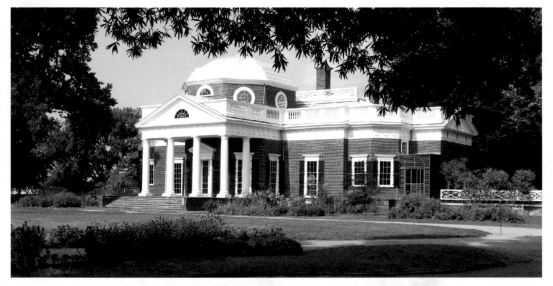

Jefferson's **Monticello** features east- and west-facing porticos that bookend an entrance hall and parlor. The 43-room mansion has 13 skylights, including one over Jefferson's bed.

Mount Vernon

Mount Vernon was home to George Washington, the first president of the United States. The Virginia land was given to George Washington's great-grandfather in 1674, and it remained in the family for seven generations. Washington spent five years at Mount Vernon as a child and later lived there as an adult with his wife, Martha. The plantation grew to 8,000 acres while Washington served as commander in chief during the Revolutionary War. The estate is now 500 acres, 50 of which are open to the public.

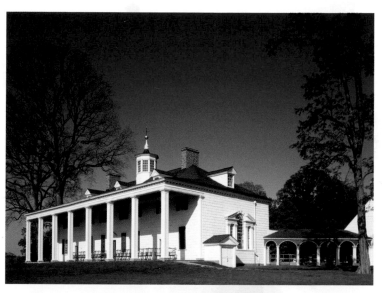

Although Washington was best known as a military and political leader, he also designed and built many of the structures at **Mount Vernon**, including the famed mansion with its distinctive two-story portico.

Virginia Beach

Virginia Beach is a modern magnet for outdoors buffs—namely surfers, anglers, golfers, and boaters. The city is a favorite getaway with attractions ranging from amusement parks and miniature golf courses to historic sites and vibrant art. The beach is a wide, sandy strip on the central Atlantic coast, fronted by a three-mile boardwalk and oceanfront resorts with all the trimmings.

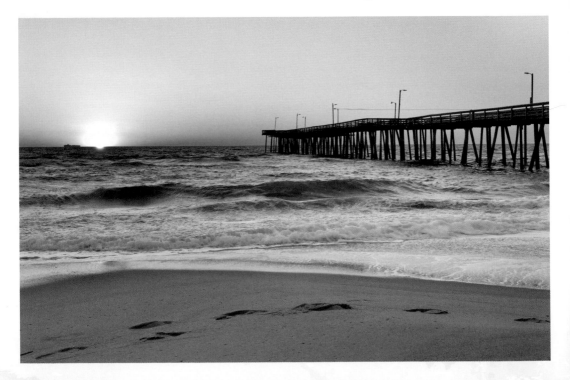

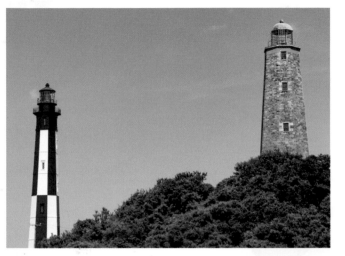

The original **Cape Henry Lighthouse** (built in 1792) at Fort Story in Virginia Beach was the first lighthouse structure authorized, completed, and lighted by the federal government. While the old lighthouse still stands, a new lighthouse was added in 1878.

The **Cape Henry Memorial Cross** at Fort Story commemorates where the first Europeans—a party that included Captain John Smith—made landfall on April 26, 1607.

Shenandoah National Park

Shenandoah National Park spans 199,100 acres and rises to 4,051 feet at Hawksbill Mountain, one of two peaks more than 4,000 feet high. It boasts 500 miles of hiking and climbing trails, including 101 miles of the Appalachian Trail. The park is uplifted over the Virginia Piedmont on the east and the Shenandoah Valley on its west. Some of the most satisfying hikes in America are found here.

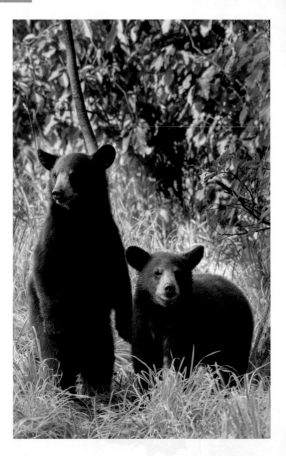

More than 50 species of mammal inhabit Shenandoah, from the big brown bat to striped and spotted skunks, and from tiny moles, voles, and shrews to bobcats, bears, coyotes, and cougars. Most famed of the park's animals are its **American black bears**. One of the densest populations of black bears in the United States takes refuge here.

(Right) **Dark Hollow Falls** in Shenandoah National Park

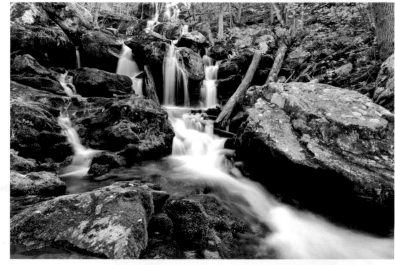

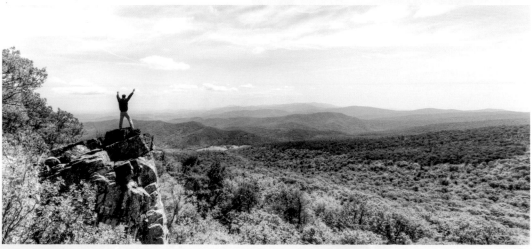

Colonial Williamsburg

Williamsburg, Jamestown, and Yorktown make up Virginia's Historic Triangle. Known as Colonial Williamsburg, the area is the world's largest, and possibly greatest, living-history museum. Nowhere else is more care taken to create, recreate, and maintain a semblance of pre-Revolutionary life in the United States than here. Actors wear period clothing and interact with each other and the visiting public to simulate life in Williamsburg during the 17th century. Today's 301-acre colonial village consists of 88 original buildings that were restored or repaired and nearly 500 buildings and outbuildings that were reconstructed.

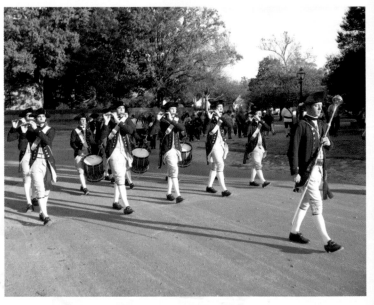

Today the **Colonial Williamsburg Fifes and Drums** are boys and girls ages 10 to 18 who carry on the tradition of military music.

Jamestown

Most Americans are familiar with the story of the settlers of Jamestown from their school days: the 1607 settlement was the first permanent English settlement in what later became the United States. Virginia's Historic Jamestowne, part of Colonial National Historical Park, offers tours about the site's history.

A statue of Captain John Smith

A statue of Pocahontas

Chincoteague Island

Chincoteague was once a tiny, rarely-visited fishing village on the island of the same name, but a 1961 Hollywood movie changed that forever. *Misty of Chincoteague*, based on a children's book by Marguerite Henry, introduced the world to its serene beauty. Billed as Virginia's only resort island, Chincoteague offers plenty of unspoiled nature. In addition to biking, hiking, boating, clamming, and a waterpark for kids young and old, one of the most breathtaking sights is the famed Chincoteague wild ponies.

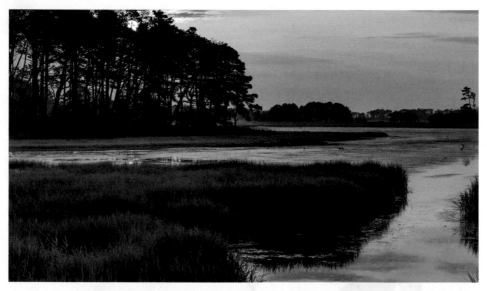

Chincoteague National Wildlife Refuge

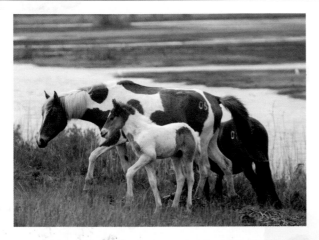

A local legend claims the island's ponies descend from shipwreck survivors who swam ashore. The more plausible explanation is that they descend from horses brought to the island by mainland owners in the late 1600s to avoid fencing laws and livestock taxes.

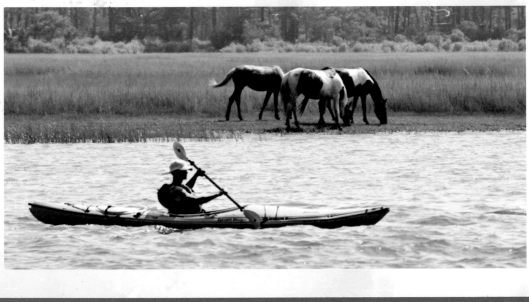

Shenandoah Valley

Shenandoah Valley stretches from Harpers Ferry, West Virginia, to Roanoke and Salem, Virginia. Visit the valley in the spring or fall to see the fabulous blossoming flowers or autumn leaf displays. More than 500 miles of trails wind through the valley, including part of the Appalachian Trail.

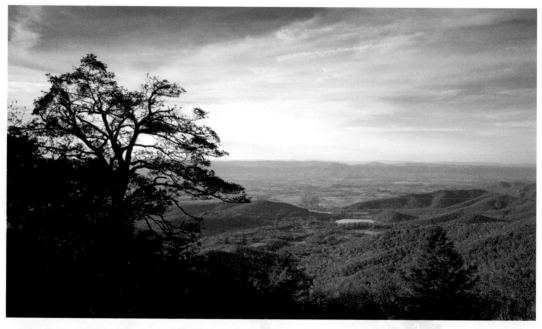

Skyline Drive runs along the crest of the Blue Ridge, providing 75 overlooks and magnificent vistas of forests, mountains, and the Shenandoah Valley.

WEST VIRGINIA

New River Gorge Bridge

The New River Gorge Bridge was added to the National Register of Historic Places in 2013. Its 1977 completion was an engineering challenge; the bridge is found in the Appalachian Mountains and is one of the highest bridges open to vehicles in the world. It cut the travel time across the gorge from an arduous 45 minutes on mountain roads to an easy minute across the bridge.

The **New River Gorge Bridge** is one of the most photographed places in West Virginia.

Harpers Ferry

The town of Harpers Ferry, West Virginia, at the confluence of the Shenandoah and Potomac rivers, is best known for abolitionist John Brown's raid on an arsenal in 1859. He believed that with the weapons stored there, the slaves could fight for their own freedom. When the Civil War ended, Harpers Ferry became a focal point during Reconstruction. The town made many early attempts at integrating former slaves into society. This included the 1867 establishment of Storer College, one of the first integrated schools in the United States.

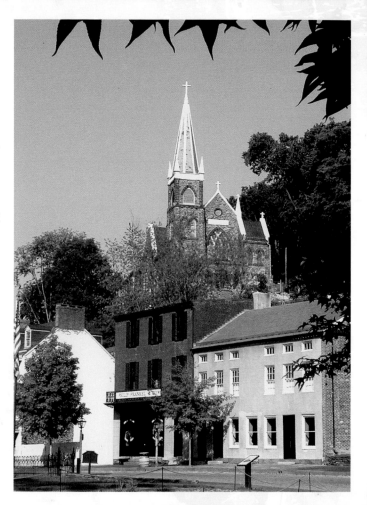

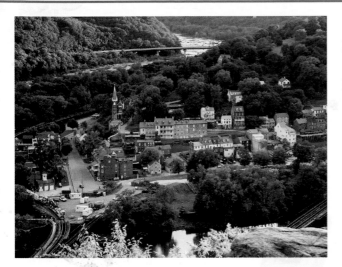

Harpers Ferry, West Virginia, is a small but historically important town at the confluence of the Potomac and Shenandoah rivers. The town has a population just below 300.

In **Harpers Ferry** you can stroll the picturesque streets, visit museums, or hike the trails and battlefields.

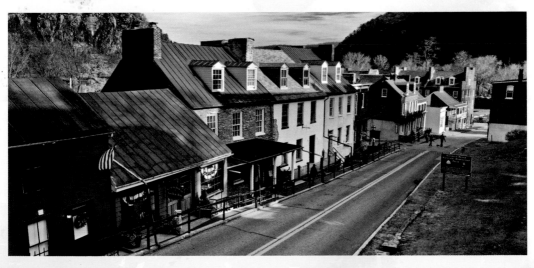

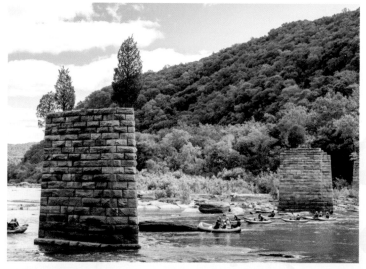

Now designated **Harpers Ferry National Historical Park**, the West Virginia town and surrounding areas create a popular way station for hikers traveling the Appalachian Trail. Harpers Ferry offers historical re-creations, but visitors also come to raft, hike, fish, and explore.

Glade Creek Grist Mill

Visitors to Babcock State Park in Clifftop, West Virginia, can hike, camp, and rent watercraft, as one might expect at a state park. They can also visit a working mill, the Glade Creek Grist Mill, which pays tribute to West Virginia's past—and they can even buy corn meal and flour made at the mill!

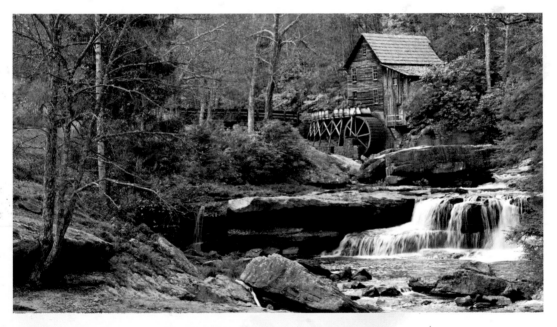

Glade Creek Grist Mill was built in 1976, in the location of a previous mill. It salvaged parts from three other mills.

Monongahela National Forest

Monongahela National Forest in West Virginia is one of the largest tracts of protected Eastern woodlands. This makes it a hub for outdoorspeople of all stripes—anglers, hikers, mountain bikers, and paddlers. The forest's extensive network of backcountry trails will get you around a landscape dotted with highland bogs and dense thickets of blueberries. Black bears, foxes, beavers, woodchucks, opossums, and mink are among the mammals found in Monongahela. There are also dozens of types of fish in the streams and 75 types of trees rooted in the forest's fertile soil.

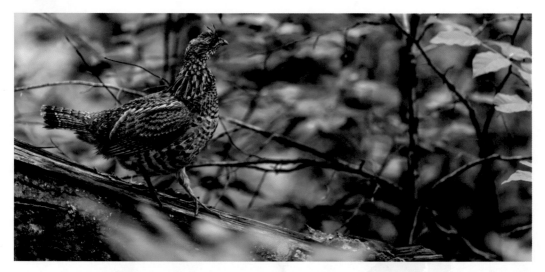

There are more than 200 feathered species in the skies and the treetops of **Monongahela National Forest**.

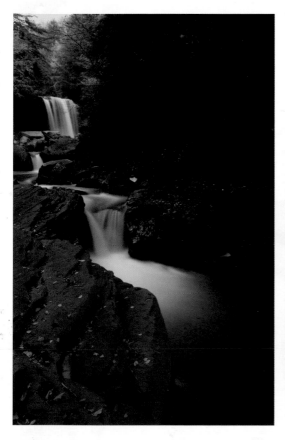

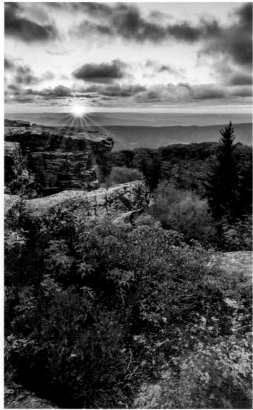

Douglas Falls
in Monongahela
National Forest

**Monongahela
National Forest** covers
919,000 rugged acres.

KENTUCKY

Kentucky Derby

It's called "the most exciting two minutes in sports" and features 20 world-class athletes culled from a field of more than 30,000. The athletes in question are three-year-old thoroughbred horses. The winner covers the 1.25-mile track at Churchill Downs in Louisville, Kentucky, in just about two minutes at a gallop averaging almost 40 miles per hour. Run every May since 1875, the Derby is a raucous party, a long-standing tradition, and a vibrant pageant.

Derby Day in 1901

The first "jewel" of the three races collectively known as the Triple Crown, the **Kentucky Derby** is no ordinary sporting event. More than 150,000 people attend the Derby each year.

Mammoth Cave

Mammoth Cave, the world's longest known cave system, is hidden beneath the forested hills of southern Kentucky. There are more than 360 miles of its underground passages on five different levels. Mammoth Cave is made up of limestone, which dissolves when water seeps through the ground. As the water works its way downward, the limestone erodes, forming the honeycomb of underground passageways, amphitheaters, and rooms that make up Mammoth Cave. Mammoth Cave National Park preserves the cave system and a part of the Green River valley.

The dazzling array of stalagmites, stalactites, and columns of **Mammoth Cave** are the product of water seeping downward for many millennia.

Louisville Water Tower

In the 1830s and 1840s, Kentuckians suffered greatly from epidemics of typhoid and cholera. Louisville's 1860 Water Tower helped solve that problem. The beauty of its Greek-style architecture helped reconcile doubtful residents to its construction; the link between cholera and typhoid and polluted water was not then fully understood by the public. It holds the distinction of being the oldest ornamental water tower in the U.S.

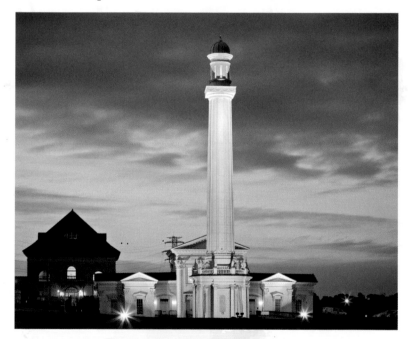

The water tower was added to the National Register of Historic Places in 1971, and the Louisville WaterWorks Museum opened on the property in 2014.

TENNESSEE

Beale Street

Beale Street, in Memphis, Tennessee, is truly a multisensory experience. Pots of gumbo and red beans and rice simmer at every corner, but the smells and tastes of Beale Street are just side dishes. The main course is the music played at the neon-and-brick clubs.

Memphis touts itself as the "Birthplace of Rock 'n' Roll," and it's got a strong case for the title. In the mid-1950s, Memphis's blues legacy fused with country music, creating a new sound that found fans across the country. Beale Street has remained the heart and soul of music in Memphis.

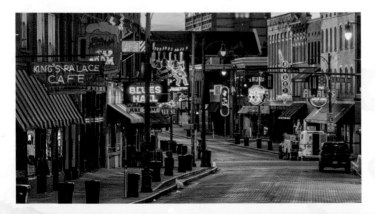

In the early 20th century, **Beale Street** was one of the busiest markets in the South. In the 1980s, Beale Street was redeveloped into an open-air, pedestrian-only center for music and nightlife.

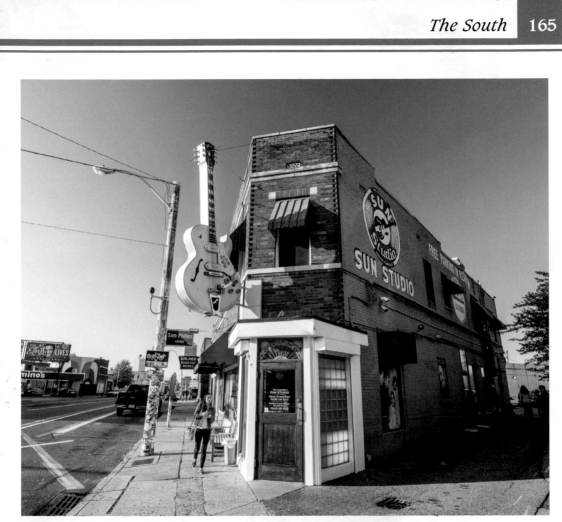

Memphis is home to **Sun Records**, the label that signed
Elvis Presley to his first recording contract in 1954.

Grand Ole Opry

The Grand Ole Opry in Nashville, Tennessee, is a cultural phenomenon. At its heart, it's a radio program that showcases American country music. In fact, it's the longest-running live radio program in the United States.

But country music is just the starting point. The Opry is the centerpiece of Opryland, a comprehensive resort and convention center that offers everything from golf to shopping to, of course, country music.

Shows at the **Grand Ole Opry** are magical to the performers and audience alike.

Graceland

Elvis Presley bought Graceland mansion in Memphis, Tennessee's Whitehaven neighborhood in 1957 when he was just 22 years old. He paid $102,500 for the property, an 18-room mansion on nearly 14 acres of country estate surrounded by towering oak trees. The home's interior has been preserved as it was at the time of Elvis's death in 1977. Graceland is now on the National Register of Historic Places, and it has become a magnet for Elvis fans everywhere.

Remembrance Garden

More than a quarter-century after his death, **Graceland** attracts upward of 750,000 fans a year—a testament to Elvis's lasting popularity.

Great Smoky Mountains National Park

Shrouded in thick forest along the border of Tennessee and North Carolina, the Great Smoky Mountains are the United States' highest range east of South Dakota's Black Hills. Established in 1934, Great Smoky Mountains National Park is consistently the most visited park in the system. The park often feels like a vestige of an ancient era when trees ruled the planet. Today, more than 100 species of trees and 1,300 varieties of flowering plants grow in the park. The respiration of all this plant life produces the gauzy haze that gives the mountains their "smoky" name.

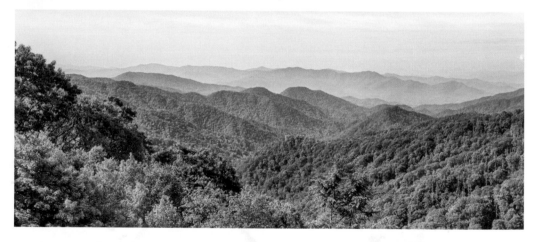

Great Smoky Mountains National Park, which covers 810 square miles, has so many types of forest vegetation that it has been designated an International Biosphere Reserve. About half of this large, lush forest comprises virgin growth that dates back to well before colonial times.

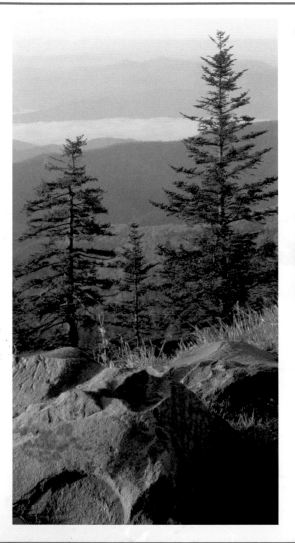

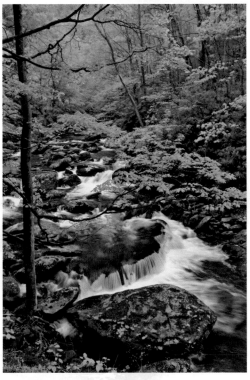

The Great Smoky Mountains have been called "the land of moving water." Part of the reason for this is the 55–85 inches of rain the area receives annually, which feeds dozens of cold, clear creeks and rivers.

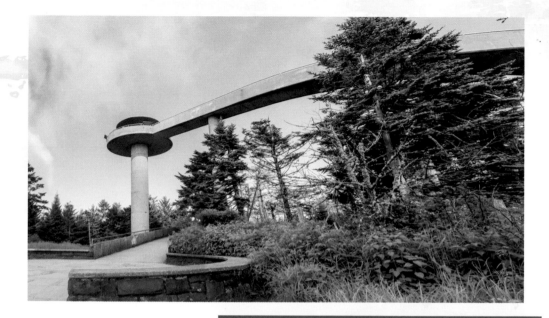

The park's highest point is the 6,643-foot peak of **Clingmans Dome**. On clear days, you can see as far as 100 miles from the top of its observation tower.

What to see at Great Smoky Mountains:
Cades Cove; Clingmans Dome; Mount LeConte; Newfound Gap; Cataloochee; Fontana Dam; Mountain Farm Museum and Mingus Mill; Balsam Mountain; Chimney Tops

What to do at Great Smoky Mountains:
Hiking; Backpacking; Horseback riding; Fishing; Bicycling; Camping

NORTH CAROLINA

Blue Ridge Parkway

"America's Favorite Drive" glides along the ridgetops of the southern Appalachian mountainside. The peaks are more than 6,000 feet above sea level, offering remarkable views of the verdant fields and country towns far below.

The **Blue Ridge Parkway** winds 469 miles from Shenandoah National Park to Great Smoky Mountains National Park.

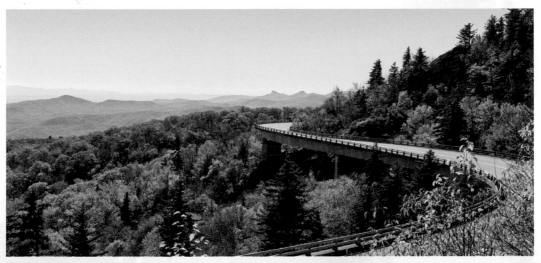

Shackleford Banks

Known for the feral horses that roam the land and waters with no help from man, Shackleford Banks is a stunning part of the Cape Lookout National Seashore and a popular island destination for nature and animal lovers. In addition to the horses, the island offers a variety of sea life, including loggerhead turtles that nest there in the summer.

Shackleford Banks, a barrier island off the coast of North Carolina, is home to more than 100 feral horses.

Roanoke Island

English colonists arrived on Roanoke Island, off the coast of North Carolina, in 1587, but disappeared in 1590. The mystery of the Lost Colony of Roanoke remains unsolved. Modern Roanoke Island is home to a historic park that tells this story and others through living-history demonstrations, a replica of a 16th-century sailing ship, and an interactive museum. Boardwalks and nature trails reveal native wildflowers and protected maritime forest. An outdoor pavilion hosts a performing arts series.

Elizabeth II, docked at Manteo Harbor on Roanoke Island, is a composite design modeled after the original *Elizabeth*, one of the ships that sailed to the New World in 1585.

Cape Hatteras

Cape Hatteras is a largely untamed string of barrier islands about 70 miles long. The dunes, marshes, and woodlands that mark the thin strand of land between North Carolina's coastal sounds and the Atlantic Ocean are a diverse ecosystem defined by the wind and sea. Nearly 400 species of birds have been seen in the Cape Hatteras area.

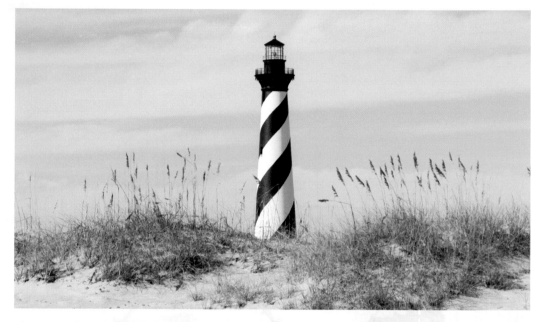

The 208-foot-tall **Cape Hatteras Lighthouse** is the tallest in the United States.

Biltmore Estate

The Biltmore mansion is the centerpiece of an immaculate 8,000-acre estate that includes lush gardens, active vineyards, and a luxury inn. It was the vision of George W. Vanderbilt. In the late 1880s, he purchased 125,000 acres in the Blue Ridge Mountains near Asheville, North Carolina, where he built the 250-room French Renaissance château.

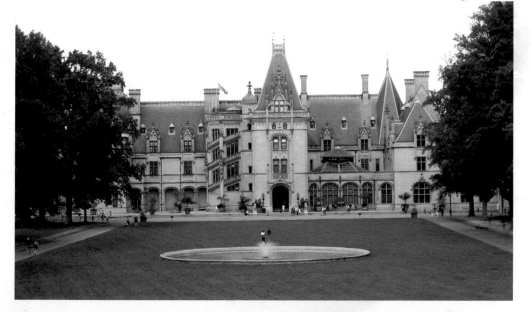

Originally the country retreat of the Vanderbilt family, **Biltmore** has evolved into a swanky tourist attraction.

SOUTH CAROLINA

Myrtle Beach

South Carolina's Grand Strand, Myrtle Beach, has been a favorite sun-and-sand destination for more than a century. The beach is named for the numerous wax myrtle trees growing along the shore. The popular Myrtle Beach Boardwalk is home to its 187-foot-tall SkyWheel Ferris wheel.

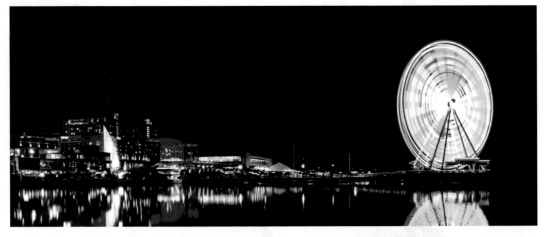

More than 1.5 million LED lights on the **Myrtle Beach SkyWheel** provide a beautiful display at night.

Hilton Head Island

Hilton Head Island is one of the premier destinations in the Southeast. The barrier island's pristine natural environment is balanced with the graceful aesthetics of some of the finest resorts and golf courses. About 2.5 million tourists visit Hilton Head Island each year for the lush scenery, posh resorts, great golf, fresh coastal air, and beautiful sunsets.

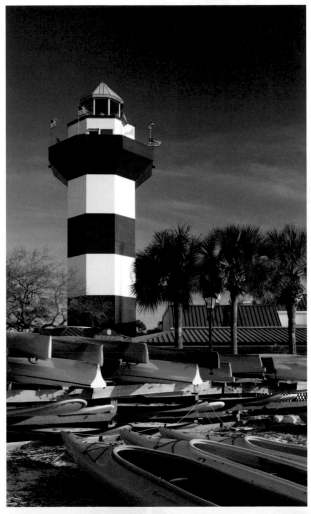

Hilton Head Island, a foot-shape barrier island off the South Carolina coast, is one of the top beach getaway spots in the Southeast.

Charleston

Charleston, South Carolina, is a beautifully preserved city full of antebellum mansions, quaint cobblestone alleys, and carefully preserved historic buildings. After the Civil War devastated the community, residents were so poor that they could not afford to rebuild, so the city simply adapted its old buildings, unknowingly protecting them as historical treasures for future generations to appreciate.

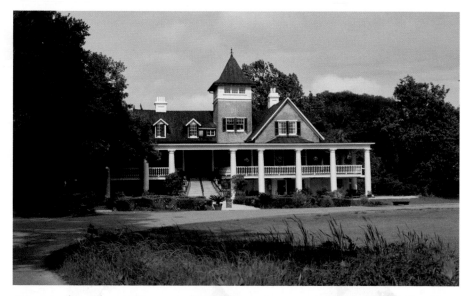

Magnolia Plantation and Gardens is a great example of Charleston's preservation. You can tour the home and take the Nature Train tour to see the plantation's many animals, including alligators.

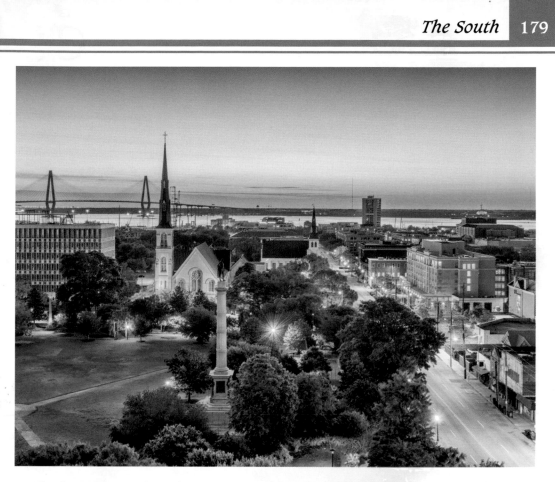

Charleston's **Marion Square** was once called Citadel Green, as the military school The Citadel was once located there, and members of the South Carolina State Arsenal could be seen marching there. Today, you're more likely to see people gathering for a farmer's market or an arts festival.

Congaree National Park

South Carolina's rivers once were bordered by more than one million acres of old-growth bottomland hardwood forests, which, in fact, blanketed almost 30 million acres across the Southeast. Now almost all of the old growth forest that's left in the United States is preserved by Congaree National Park. Congaree contains a majestic and complex combination of hardwood floodplain forest, vast forest canopy, swamp, and uplands area.

The 22,200-acre park is one of the globe's best remaining examples of a mature forested southern floodplain.

What to see at Congaree:
Cedar Creek; Congaree River; Boardwalk Trail; Congaree River Blue Trail

What to do at Congaree:
Boating; Hiking; Fishing; Camping; Canoeing; Kayaking

Drayton Hall

Drayton Hall is a plantation house in Charleston, South Carolina. John Drayton Sr. had the mansion built in the 1740s on land where rice was grown and dozens of slaves worked and lived. Seven generations of Draytons lived in the home. The National Trust for Historic Preservation acquired Drayton Hall in 1974 and opened it for public tours in 1977.

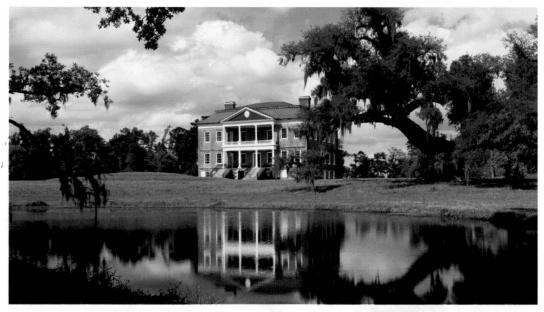

The two-story brick house's design was said to be inspired by English-Georgian architecture as well as Renaissance architect Andrea Palladio.

GEORGIA

Jekyll Island

Jekyll Island is Georgia's smallest barrier island and lies off the coast midway between Savannah, Georgia, and Jacksonville, Florida. Jekyll Island was a popular destination for the country's rich and powerful and is now a favorite among those looking for a relaxing beach getaway.

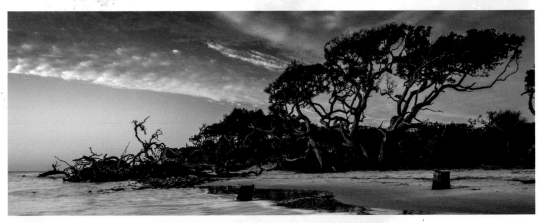

Jekyll Island is one of Georgia's so-called Golden Isles, along with St. Simons Island, Sea Island, and Little St. Simons Island.

Savannah

Savannah, Georgia, is America's first planned city. General James Edward Oglethorpe (who had previously founded the colony of Georgia) founded Savannah in 1733. He designed his new capital as a series of neighborhoods centered around 24 squares. His layout remains intact today. Each square has a distinctive architecture, history, and folklore.

Chippewa Square is at the center of the downtown historic district. A statue of General Oglethorpe at the square commemorates the founding of Georgia. The square gets its name from the Battle of Chippewa in the War of 1812.

Johnson Square (right), laid out in 1733, was the first square in Savannah. The obelisk honors Revolutionary War hero General Nathanael Greene.

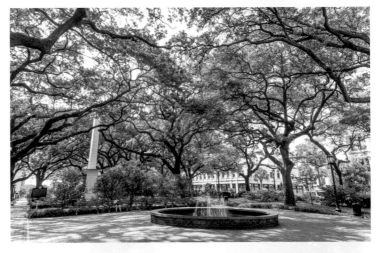

Forsyth Park (below) is an oasis of greenery in Savannah, Georgia.

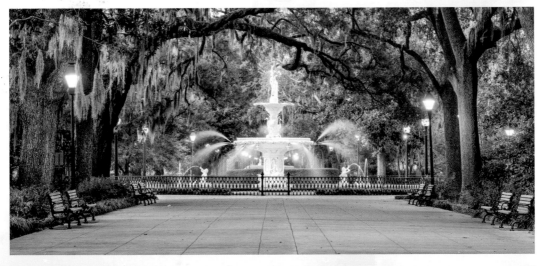

Tybee Island

Eighteen miles east of Savannah, Georgia, is Tybee Island. Visitors to the barrier island encounter bird-filled salt marshes, miles of sand and sun, and a main boulevard lined with enormous oaks and picturesque sabal palms.

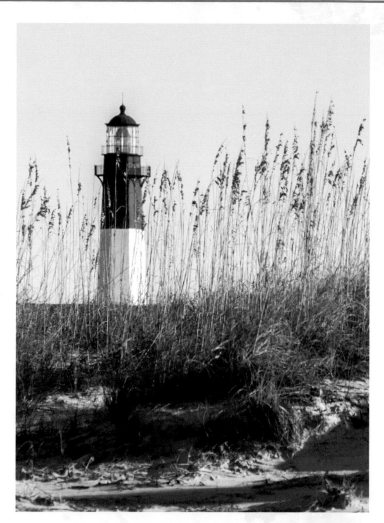

The **Tybee Island Lighthouse** stands watch over a once remote barrier island, which has become one of the most popular summer vacation spots along the entire Georgia seacoast.

Amicalola Falls

A hiker's paradise unfolds at Amicalola Falls State Park in Georgia as 12 miles of trails weave through the picturesque Appalachian Mountains and lead to the Amicalola Watershed and Amicalola Falls. At 729 feet, Amicalola Falls is the tallest waterfall in Georgia and one of the tallest east of the Mississippi River. Its name means "Tumbling Waters" in Cherokee.

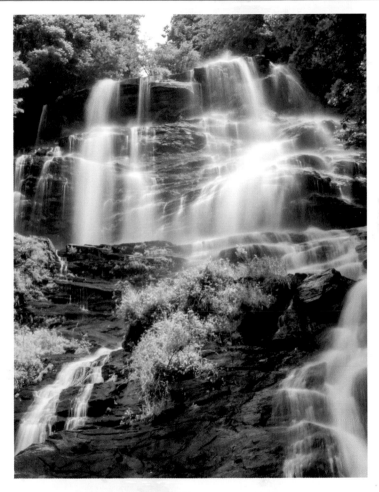

Cumberland Island

Cumberland Island is Georgia's largest and southernmost barrier island. The remote island is 3 miles wide and is ringed by a beach almost 18 miles long. It's covered by acres of marsh, tidal creeks, sand dunes, blinding white sand, and historic ruins and museums that compel admiration and amazement.

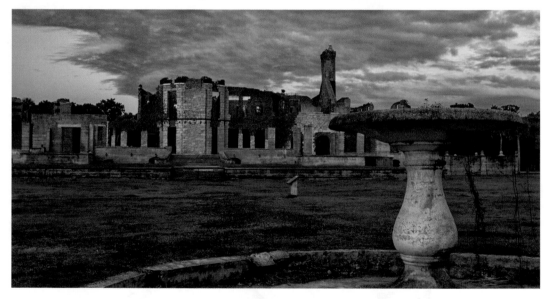

The ruins of the **Dungeness Mansion** (first built in 1884 as a winter home for Thomas Carnegie) are one of the most visited spots on the island.

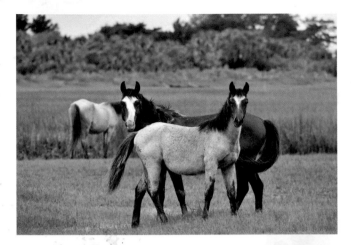

(Left) Cumberland Island is home to some 150 feral horses. These horses were photographed at **Cumberland Island National Seashore**.

(Below) Many of the island's trails cut through maritime forests, under live oak trees draped in Spanish moss, and between stands of saw palmettos.

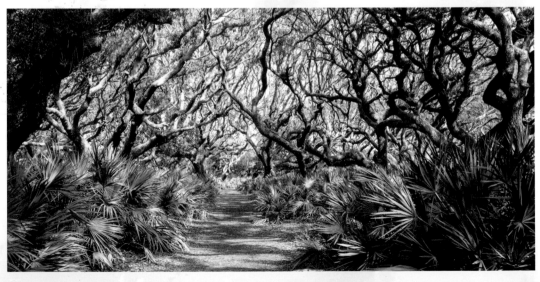

FLORIDA

Everglades National Park

This national treasure at the southern tip of Florida encompasses 1.5 million acres of saw grass marshes, tangled mangrove forests, and fresh and brackish water wetlands. Tram tours and hiking trails are available in areas of the Everglades open to the public. However, this slow-moving "River of Grass" is best explored by boat. At Flamingo Marina you can rent a kayak, a canoe, or a skiff to see an incredible collection of animals up close. Gorgeous fish, turtles, marsh rabbits, manatees, crocodiles, otters, alligators, and hundreds of species of birds inhabit the park. If you are very lucky, you might even spot a rare Florida panther.

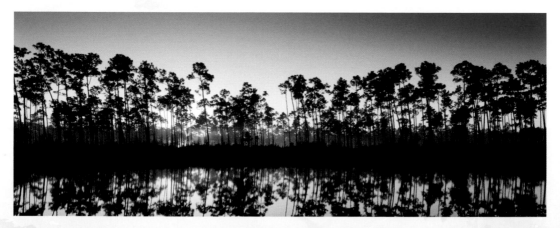

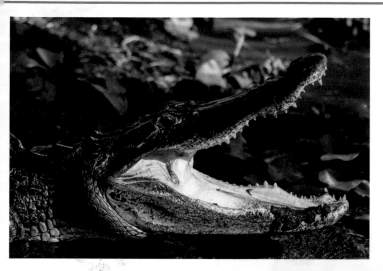

The Florida Everglades is the only place on Earth where crocodiles and alligators native to the U.S. naturally coexist.

High-speed airboats, propelled by fanlike contraptions, are a fun way to tour the swampy marshes of this unique wetland. Many outfitters offer guided airboat tours.

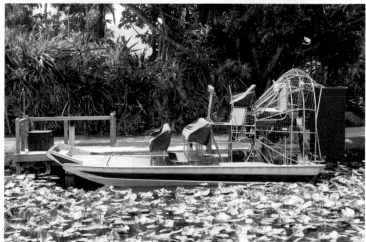

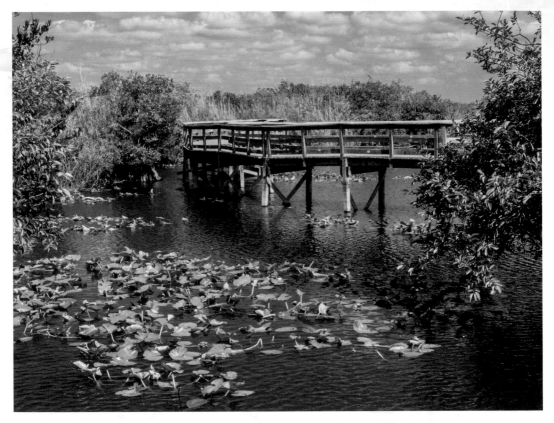

Everglades National Park offers a number of easy boardwalk trails for those who want to explore on foot. **The Anhinga Trail** (above) is one of the park's most dependable areas for wildlife viewing.

What to see at Everglades:
*Shark Valley; Ten Thousand Islands;
Flamingo; Wilderness Waterway*

What to do at Everglades:
*Boating; Kayaking; Fishing; Diving;
Snorkeling; Airboat rides; Canoeing;
Camping; Hiking; Bird-watching*

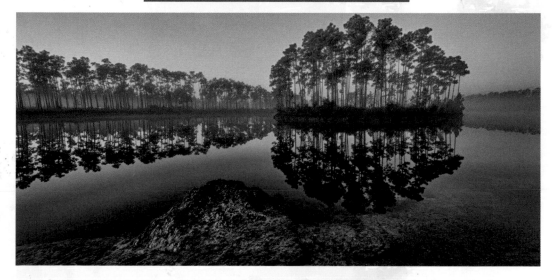

Everglades National Park is justly famed for its walkways, which
are designed to take visitors through differing ecosystems. The result
is a tour of a riotous variety of plant and animal life.

St. Augustine

St. Augustine, Florida, is the oldest permanently inhabited city in the United States. Founded in 1565, it's filled with reminders of its early Spanish history. Walking through the carefully restored Spanish Quarter, you'll see narrow cobblestone streets, the oldest wooden schoolhouse in the country, and Ponce de Leon's Fountain of Youth.

Castillo de San Marcos

The Castillo de San Marcos fortress, built by Spaniards between 1672 and 1695, boasts an impressive moat, a drawbridge, and huge cannons atop which kids can sit. Castillo de San Marcos once helped guard St. Augustine from pirate raids. Later, supporters of the American Revolution were locked away in its dank dungeons.

The walls of **Castillo de San Marcos** are made of a durable substance called coquina (a limestone material composed of broken seashells and coral), which helped the fort remain impenetrable.

Ringling Estate

Circus owner and art collector John Ringling and his wife, Mable, began building their Italian Renaissance-style mansion in Sarasota Bay, Florida, in 1924. The building was named Cà d'Zan, meaning "House of John" in Venetian dialect. A 60-foot tower caps the mansion. The estate also contains the John and Mable Ringling Museum of Art. Their art treasures include more than 10,000 paintings, sculptures, drawings, prints, photographs, and decorative arts. The museum holds the largest private collection of paintings and drawings by Peter Paul Rubens.

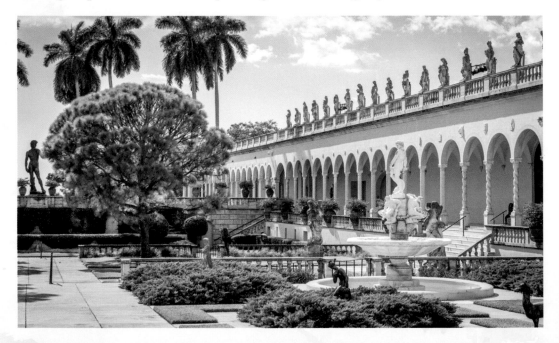

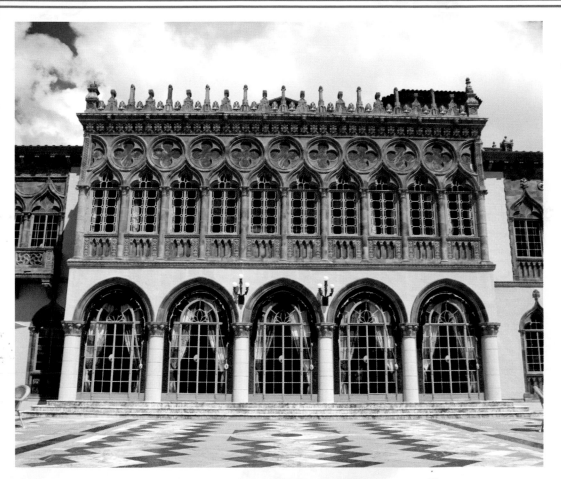

An impressive 8,000-square-foot marble terrace offers
awe-inspiring views of Sarasota Bay.

Dry Tortugas National Park

There's not much "dry" about the Dry Tortugas, an island group a little less than 70 miles west of Key West, Florida. The area derived the first part of its name from the fact that there are no sources of fresh water on the islands. The tortugas part of the name reaches back into history to Spanish explorer Ponce de Leon, who discovered the region in 1513. Despite the hardships of his voyage and the lack of potable water, the adventurer was pleased to be able to keep his ships stocked with sea turtles—in Spanish, *tortugas.*

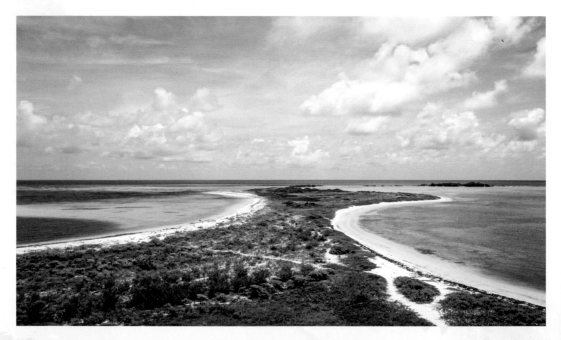

What to see at Dry Tortugas:
*Fort Jefferson; Loggerhead Key;
Bush Key; Hospital Key*

What to do at Dry Tortugas:
*Scuba diving; Snorkeling;
Fishing; Camping*

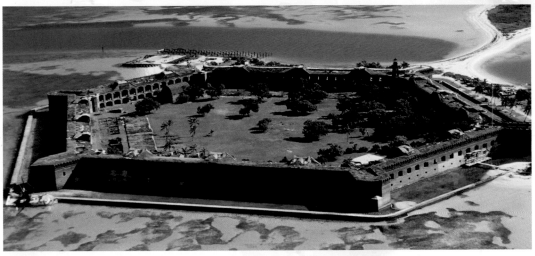

Fort Jefferson (above) was designed as a six-sided, three-tiered fortress and prison with 420 heavy guns facing the sea. At one time as many as 2,000 people occupied the fort.

Key West

Key West has long been famous as one of America's top destinations for fun-and-sun vacations. Key West has retained its charm, remoteness, intriguing history, and natural beauty since the 1920s. Mallory Square hosts the Sunset Celebration each evening, with food vendors, fire-eaters, tightrope walkers, and arts and crafts exhibits.

Located at the southernmost tip of the Florida Keys, **Key West** is home to the southernmost point in the continental United States.

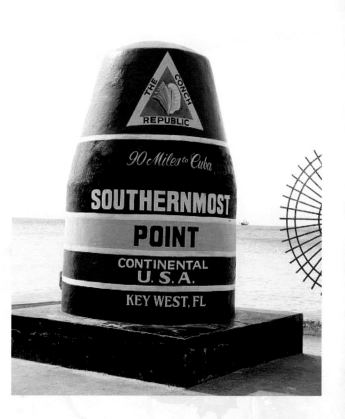

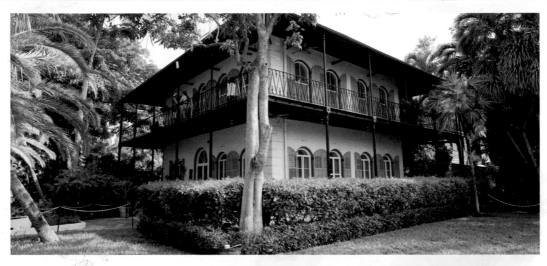

Novelist Ernest Hemingway wrote many of his best works while on the island, and today **Hemingway House** is Key West's top tourist attraction.

Puerto Rico

Cathedral of San Juan Bautista

In 1521, a wood cathedral was built in San Juan, Puerto Rico. When that church was destroyed by a hurricane, the current building was built in 1540. At almost 500 years old, it is the oldest cathedral in the United States.

The cathedral is not just a historic site—it still serves as an active church.

El Yunque National Forest

The El Yunque National Forest in northeastern Puerto Rico is the only tropical rain forest in the U.S. national forest system. At nearly 29,000 acres, it is one of the smallest national forests in size, yet one of the most biologically diverse.

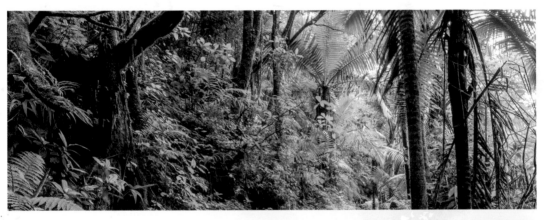

El Yunque National Forest is home to hundreds of animal and plant species, some of which are found only here.

Juan Diego Falls (right) in El Yunque National Forest, Puerto Rico

ALABAMA

U.S. Space and Rocket Center

The U.S. Space and Rocket Center in Huntsville, Alabama, showcases a fascinating and comprehensive collection of rockets, missiles, boosters, and space memorabilia. On display are capsules and space suits used over the years in NASA missions and a mock-up of *Saturn V*, the 363-foot rocket that helped launch astronauts to the moon. There's also a full-size mock-up of a space shuttle and a lunar rover vehicle.

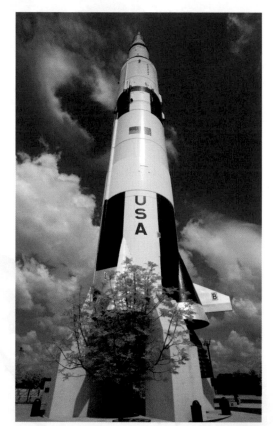

The **U.S. Space and Rocket Center** showcases the hardware used in the space program and houses a multitude of artifacts.

Vulcan Statue

The 56-foot statue of Vulcan in Birmingham, Alabama, is the largest cast-iron statue in the world. Birmingham began as a mining town for coal, limestone, and iron ore, which were forged to make steel. By the 20th century, it was a formidable industrial power. The city's business leaders, seeking to promote Birmingham, had Italian sculptor Giuseppe Moretti create a cast-iron sculpture of Vulcan, the Roman god of fire, volcanoes, and the forge. The sculpture was unveiled at the 1904 St. Louis World's Fair.

When the statue was moved back to Birmingham, its arms were reassembled improperly. The statue was neglected and became a three-dimensional billboard. In 1939, Vulcan was finally moved to his proper place on Birmingham's Red Mountain. Restoration of the statue was completed in 2004, and Vulcan Park reopened for the statue's centennial. Today the statue provides a panoramic view of Birmingham.

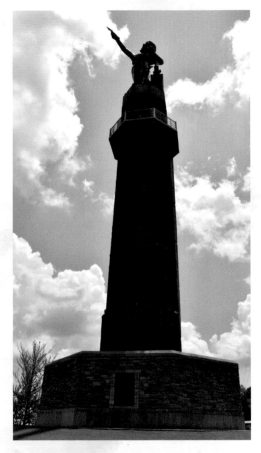

The cast-iron **Vulcan Statue** in Birmingham has been restored to symbolize the town's steel history.

Gulf Coast of Alabama

Alabama's Gulf Coast has 32 miles of white sand beaches and water warm enough to swim in eight months of the year. The towns of Gulf Shores and Orange Beach offer plenty of accommodations lining the shore and family fun such as miniature golf, water parks, marinas, and ice cream parlors.

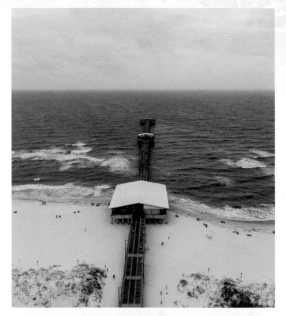

The fine, white sand on the beaches of the **Alabama Gulf Coast** must have inspired the phrase "white sugar sand."

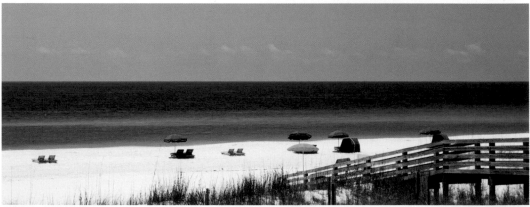

Edmund Pettus Bridge

Built in 1940, the Edmund Pettus Bridge stands in history. On March 7, 1965, peaceful marchers were attempting to cross the bridge on the road to Montgomery, when they were attacked by police. The televised Bloody Sunday attacks were seen worldwide and brought attention to the voting rights movement. The Edmund Pettus Bridge is now a National Historic Landmark and part of the Civil Rights Trail.

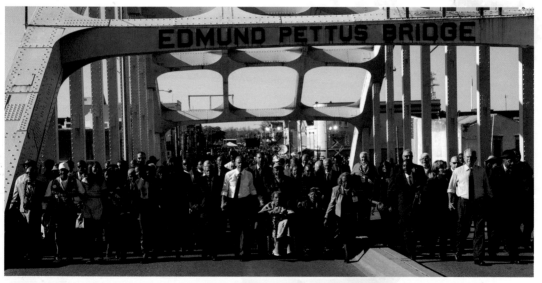

The 50th anniversary of Bloody Sunday was memorialized in 2015 when then-President Obama went to the site, along with former President George W. Bush and marchers like John Lewis and Amelia Boynton Robinson who had been beaten on Bloody Sunday.

MISSISSIPPI

Gulf Islands National Seashore

From above, the Gulf Islands National Seashore looks like a sandy string of pearls off the coasts of Florida and Mississippi. Along the water are miles of snow-white beaches, bayous, saltwater marshes, maritime forests, barrier islands, and nature trails. Of the more than 135,000 acres of national seashore, 80 percent of the park is underwater.

The environment is diverse, but visitors to **Gulf Islands National Seashore** usually focus on the beach. Miles and miles of white powdery sand extend into the sparkling water.

Biloxi Light

In a beautiful town with many wonderful coastal sites to visit—the Gulf Islands National Seashore, the Maritime Museum, the Marine Life Oceanarium—the Biloxi Light stands out. Located about six miles west of the entrance to Biloxi Harbor, the Biloxi Light was built in 1848. The 48-foot conical tower was made of cast iron, with an inner masonry wall of locally fired bricks. One of the unusual facts about the Biloxi Light is that it has had two female lighthouse keepers. Maria Younghans, who held the job from 1867 through 1920, was succeeded by her daughter Miranda, who stayed until 1929.

The **Biloxi Light** has the distinction of being the only lighthouse in the world that is currently—as a result of development—located in the median strip of a busy highway.

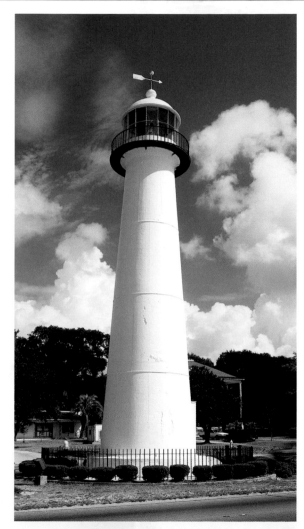

Natchez Trace

Natchez Trace originated thousands of years ago. Deer and bison were the first to tramp along what became the Old Natchez Trace. Then the Choctaw and Chickasaw connected the paths, and the trail became the region's premiere trade route.

Arriving Europeans grasped its potential, and by the late 1700s the Natchez Trace bustled with boaters. They would sell their cargo and flatboats or keelboats for lumber in Natchez or New Orleans and then travel back north to Nashville and beyond. In 1801, the United States signed a treaty with the Choctaw allowing roads to be built along the route.

Natchez Trace, which runs from Mississippi to Tennessee, began as a series of tribal trading routes.

Today, the 444-mile Natchez Trace Parkway is a recreational and scenic drive that runs from Natchez, Mississippi, to just outside Nashville, Tennessee. Adventurers can enjoy hiking trails, archeological sites, scenic overlooks, waterfalls, picnic sites, and campgrounds along the parkway.

Mississippi State Capitol

The Mississippi State Capitol was built in the Beaux-Arts style in 1903. It was the third building to act as the capitol; the second is now a museum. The current building became a National Historic Landmark in 2016.

The chamber of the House of Representatives (right) at the **Mississippi State Capitol**

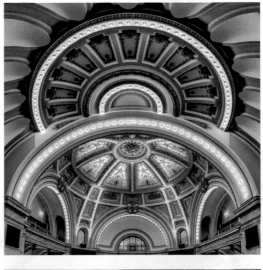

Windsor Ruins

The Windsor Ruins consist of 23 Corinthian columns from the largest antebellum mansion ever built in Mississippi. The Greek Revival house was built for Smith Coffee Daniel II in Claiborne County. The mansion stood from 1861 to 1890, when it was destroyed by fire.

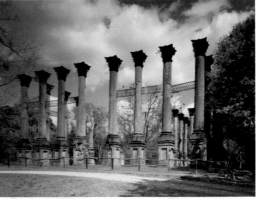

These Corinthian columns are all that remains of the **Windsor Mansion**.

LOUISIANA

Plantation Alley

Louisiana's Great River Road is also known as Plantation Alley. There, 30 antebellum mansions and 10 other ancient properties sit regally on bluffs overlooking the Mississippi River. All are open for tours or have been converted into hotels or bed-and-breakfast inns. Along the Great River Road, they provide a dignified procession of antebellum architecture surrounded by sugarcane fields and pecan groves.

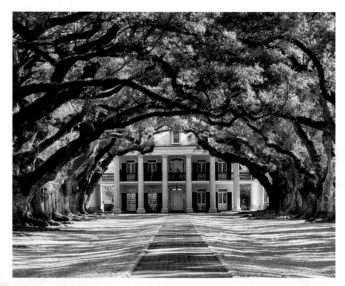

To tour Plantation Alley, start in Baton Rouge, and drive south. Instead of taking I-10 straight to New Orleans, travel along the Mississippi River toward Plaquemine, White Castle, and Donaldsonville.

Oak Alley Plantation is a sweeping columned mansion framed by live oaks. It has been the setting for movies including *Interview with the Vampire* and *Primary Colors*.

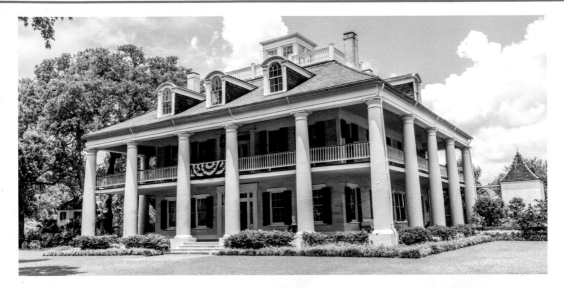

The well-known **Houmas House** (above) in Burnside was once the center of a 20,000-acre sugarcane plantation. This Greek Revival mansion is furnished with antiques.

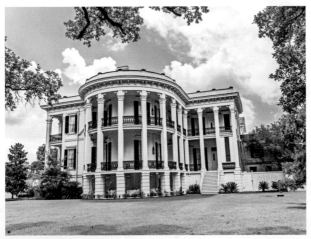

Nottoway (left), a gem of Greek Revival architecture, is one of the largest plantations.

Mardi Gras

Now the biggest annual party in North America, New Orleans's Carnival is an over-the-top street party that typically attracts more than a million people from all over the world. Carnival culminates with Mardi Gras, or Fat Tuesday, the wild event that turns New Orleans into a center of celebration.

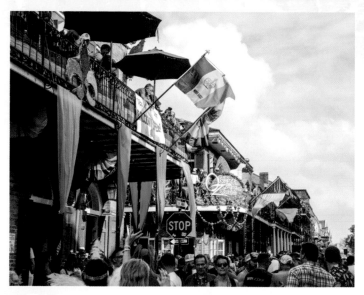

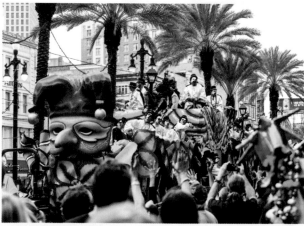

(Above) New Orleans's famous **French Quarter**—in particular, Bourbon Street—becomes a wild party during Carnival.

(Left) The parades are the flamboyant soul of Carnival. Elaborate multicolor floats carry people in ornate costumes.

St. Charles Streetcar Line

The St. Charles Streetcar Line began operations in 1835; at more than 180 years old, it's billed as not only the oldest continuously operating streetcar line in the United States but in the world. Its interiors provide a blast from the past, with mahogany seating instead of modern plastic. The line runs 13 miles along St. Charles Avenue in New Orleans, and those who ride the line the entire way will pass through Uptown New Orleans, the Central Business District, and the Garden District, before the line terminates near the French Quarter.

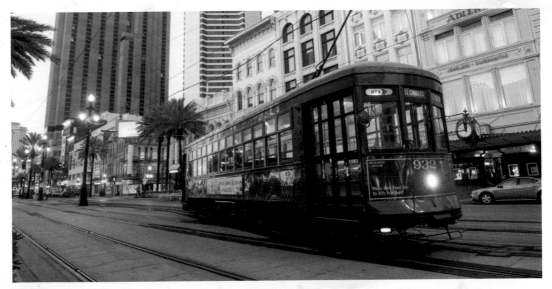

In 2014, the **St. Charles Streetcar Line** received the honor of being designated a National Historic Landmark.

ARKANSAS

Hot Springs National Park

Hot Springs National Park protects 47 different hot springs and their watershed on Hot Springs Mountain, as well as the eight historic bathhouses in the town of Hot Springs, Arkansas. For more than 200 years, vacationers have come to the waters in bathhouse row in hopes of curing all kinds of ills, and tourists can still enjoy a soak in several bathhouses. But there's much more to Hot Springs National Park than a relaxing soak. Favorite recreations include hiking, crystal prospecting, camping in Gulpha Gorge Campground, and driving or hiking up Hot Springs Mountain to enjoy the 40-mile view from Hot Springs Tower.

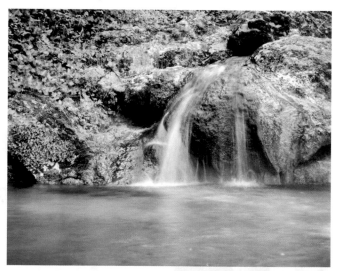

What to see at Hot Springs:
Bathhouse Row; Fordyce Bath-house; Hot Springs Mountain Tower; Sugarloaf Mountain; Music Mountain; North Mountain; West Mountain

What to do at Hot Springs:
Hiking; Horseback riding; Bird-watching; Soaking and bathing

The **Fordyce Bathhouse** on Bathhouse Row is now the park museum and visitor center. Visitors can see stained-glass windows, assorted statuary, and luxurious tubs like the ones in which the aficionados of another age undertook three-week therapy courses of daily hot baths and massages. The Bathhouse Row historic district displays how early visitors enjoyed the park, and the many matchless examples of Gilded Age architecture show how the resort early on earned the title "The American Spa."

Blanchard Springs Caverns

Blanchard Springs Caverns in north-central Arkansas is the jewel of the Ozarks. This three-level cave system has almost every kind of cave formation: from soda straws to bacon formations to rimstone cave pools. The most famous formation in these caverns is the 70-foot-high joined stalagmite-stalactite called the Giant Column.

Visitors can choose from three scenic trails through **Blanchard Springs Caverns**. The easiest is a one-hour trail that is stroller- and wheelchair-accessible, but the most difficult trail takes four hours and involves spelunking. The shimmering **Ghost Room** (left) is a highlight of the Discovery Trail.

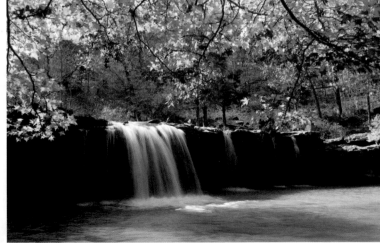

Buffalo National River in northern Arkansas is one of the few remaining undammed rivers in the contiguous United States. The 135-mile river contains both swift-moving rapids and calm pools and flows through the Ozark Mountains.

Enjoy the wide-open serenity of the **Ozark National Forest** in Arkansas. There are campsites and opportunities for fishing, hiking, and watching wildlife.

OHIO

Cincinnati Museum Center

The Cincinnati Museum Center at Union Terminal is an art deco masterwork that attracts visitors from around the world. Union Terminal was an architectural icon since it opened in 1933, but after train travel dwindled, the terminal was declared a National Historic Landmark in 1977 and stood empty for more than a decade. Today the terminal is home to five major Cincinnati cultural organizations: the Cincinnati History Museum, the Duke Energy Children's Museum, the Museum of Natural History & Science, the Robert D. Lindner Family OMNI-MAX Theater, and the Cincinnati Historical Library and Archives.

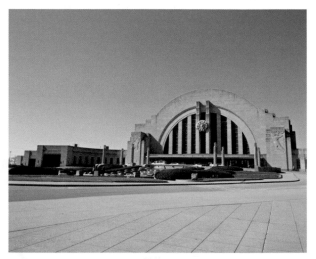

Originally the Union Terminal train station, the building reopened as the **Cincinnati Museum Center** in 1990.

Rock and Roll Hall of Fame

Rock 'n' roll lives on today, more than a half-century after its birth. One reason is Cleveland's Rock and Roll Hall of Fame and Museum. Designed by architect I. M. Pei, the building expresses the raw power of rock music. The geometric and cantilevered forms are often compared to a turntable. The striking building and its 162-foot tower anchor Cleveland's North Coast Harbor.

The hall began operation in 1986 with the ceremonial induction of its first class of rock stars: Chuck Berry, Elvis Presley, Little Richard, Sam Cooke, the Everly Brothers, and Buddy Holly, among others. It holds a collection of rock memorabilia and rarities and features groundbreaking exhibitions.

The **Rock and Roll Hall of Fame** is the world's first museum honoring rock music.

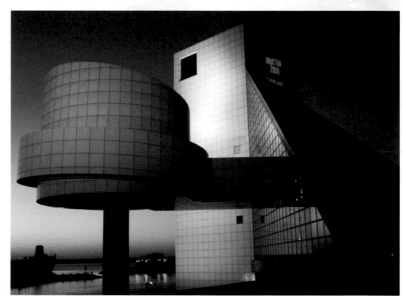

Cuyahoga Valley National Park

Cuyahoga Valley National Park, which lies between Akron and Cleveland in Ohio, may be the park service's most urban-friendly environment. The park preserves 33,000 acres along the Cuyahoga River, called "crooked river" by the Mohawk Indians. The forests, plains, streams, and ravines here contain an astonishing array of fauna and flora, not to mention a variety of recreational opportunities. The park has almost no roads, but you can explore plenty of bike and hiking paths.

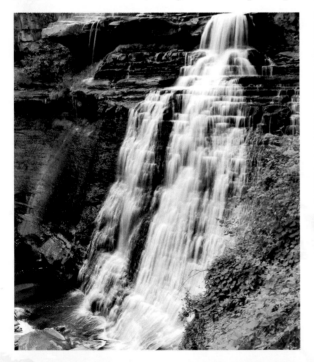

What to see at Cuyahoga:
Cuyahoga River; Ohio & Erie Canalway; Towpath Trail; Frazee House; Cuyahoga Valley Scenic Railway; Brandywine Falls; Beaver Marsh; Blue Hen Falls

What to do at Cuyahoga:
Hiking; Bicycling; Canoeing; Kayaking; Picnicking; Bird-watching; Camping; Fishing; Golfing

(Left) Probably the most-photographed feature of Cuyahoga Valley National Park is the 60-foot-high **Brandywine Falls**.

Perry's Victory and International Peace Memorial

Who was Perry and what did he win? Commodore Oliver Hazard Perry led U.S. naval forces against the British at the Battle of Lake Erie, during the War of 1812. His victory over those forces helped American troops gain control of the lake. A hundred years after the war, the 352-foot monument was constructed, to remember not only the victory but to celebrate the long-standing peace between Britain, Canada, and the United States that followed. The flags of all three countries are flown at the site.

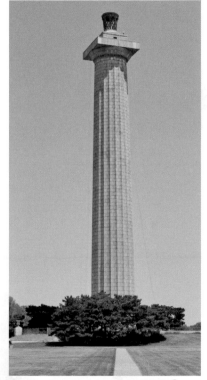

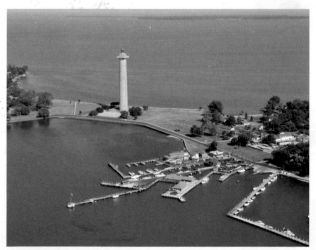

Perry's Victory and International Peace Memorial in Put-In-Bay, Ohio

The monument rises 352 feet over Lake Erie.

INDIANA

Indianapolis 500

Named for the number of miles covered by circling the 2.5-mile track 200 times, the Indianapolis 500 occurs every year at the Indianapolis Motor Speedway, also known as the Brickyard. The race has been held during Memorial Day weekend every year since 1911, with the exception of six years during World Wars I and II. It is one of the longest-standing and richest motorsports events in the world.

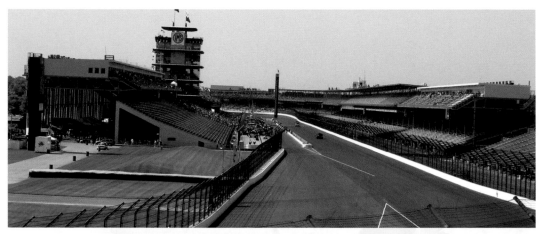

The Indianapolis Motor Speedway, also called the Brickyard, is the famed home of the Indianapolis 500.

Soldiers and Sailors Monument

In the middle of Monument Circle, in the center of the city of Indianapolis, Indiana, rises the 284-foot Soldiers and Sailors Monument. The cornerstone was laid in 1889, with construction continuing until 1901 and the dedication taking place a year later. While it began as a Civil War monument, inscriptions on the monument honor veterans from the Revolutionary War, the War of 1812, and the Mexican-American War as well.

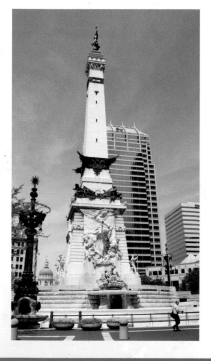

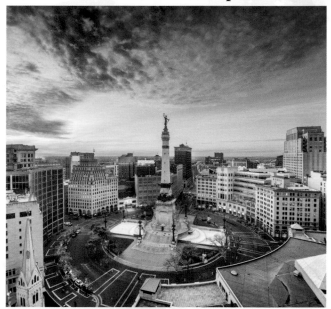

Soldiers and Sailors Monument in Indianapolis

Michigan City Light

The Michigan City Light was designed to serve the busy harbor at Michigan City, an active shipping port for goods produced in central and northern Indiana. Although the Michigan City Light was decommissioned in 1904, local lighthouse aficionados have maintained the site as a museum.

Just a few miles from the Mighigan City Light is the popular **Indiana Dunes National Seashore**, where thousands of visitors throng every summer to enjoy one of the Midwest's greatest attractions.

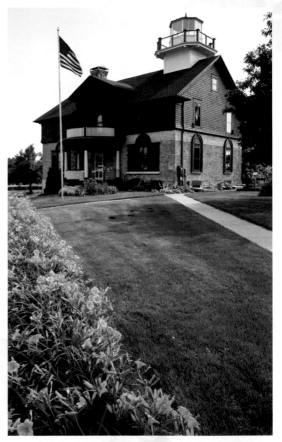

The current **Michigan City Light** was raised in 1858 (the original light had been built in 1837).

Spring Mill State Park

The mill at Spring Mill State Park is just one of many buildings found there in its Pioneer Village. More than twenty buildings show what life was like in the early 1800s, including a sawmill, a tavern, a weaver's shop, and a blacksmith shop.

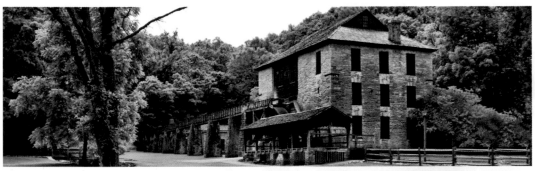

The mill itself dates to 1817.

Brown County State Park

Brown County State Park, located in Southern Indiana, offers many trails for hiking and horseback riding. Visitors can also enjoy fishing or ice fishing on the park's two lakes.

Brown County State Park is the largest state park in Indiana.

MICHIGAN

Isle Royale National Park

Isle Royale, which was carved and compressed by glaciers, is the largest island on Lake Superior. It exists in splendid isolation—you can only get to the island by boat, seaplane, or ferry. Together with numerous smaller islands it makes up Isle Royale National Park, located off of Michigan's Upper Peninsula. There are no roads on the island, but you can choose routes from among the 165 miles of hiking trails. Diving for shipwrecks is another favorite activity—there are more than ten major wrecks below the surface of the lake.

The **Rock Harbor Lighthouse** at the northeast
end of Isle Royale was built in 1855.

What to see at Isle Royale:
Rock Harbor; Siskiwit Bay; Windigo Area

What to do at Isle Royale:
Kayaking and canoeing; Hiking; Camping; Scuba diving; Berry picking

Moose have lived on Isle Royale—the largest island in the world's largest freshwater lake—since the early 1900s.

Mackinac Bridge

The mighty Mackinac Bridge straddles the Straits of Mackinac between Lakes Michigan and Huron to connect Michigan's Upper and Lower Peninsulas. Although residents first discussed the idea of building a bridge as far back as the 1880s, ferry traffic prevailed until the bridge finally opened in 1957. Measured the conventional way, between towers, Mackinac Bridge is the third-longest suspension bridge in the United States.

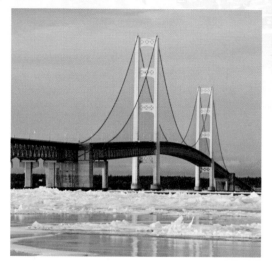

The nearly five-mile-long **Mackinac Bridge** links Michigan's Upper and Lower Peninsulas.

The suspension bridge has a length of more than 26,000 feet.

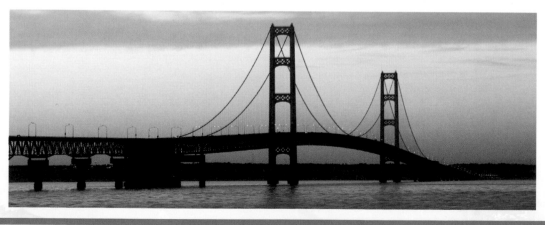

Pictured Rocks National Lakeshore

Pictured Rocks National Lakeshore spans 42 miles of Lake Superior shoreline, covering more than 73,000 acres of Michigan's Upper Peninsula. It is a preserve of spectacular scenery and cascading sand dunes. The most photographed area is the five miles of "perched" dunes and sparse jack pine forests of the Grand Sable Dunes.

Laughing Whitefish Falls
(above) has a dramatic
100-foot drop.

Despite the remote location,
almost 400,000 visitors seek out
Pictured Rocks each year.

WISCONSIN

Milwaukee Art Museum

In 1957, the Milwaukee Art Center opened its Eero Saarinen Building, named after the architect who designed it. The building itself is a work of art. It has a floating cruciform shape with four large wings that cantilever in space. In 2001, the Quadracci Pavilion, designed by Santiago Calatrava, was added to the building. The prominent pavilion has attracted world-wide attention for its light, lacy facade that curves like a sail, despite being built from 20,000 cubic yards of concrete.

The museum's collections include works by Degas, Homer, Monet, O'Keeffe, Picasso, Rodin, Toulouse-La-trec, and Warhol.

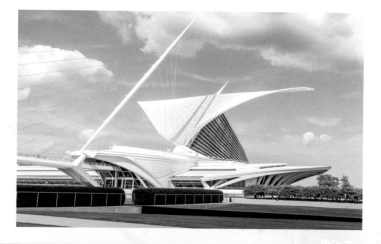

Apostle Islands National Lakeshore

The 21 islands of Apostle Islands National Lakeshore dot the coast of northern Wisconsin just off Bayfield Peninsula. The popular Madeline Island is the largest of the group and the only one that permits commercial growth. Nesting bald eagles at Bay State Park are this island's main attraction. Once past Madeline Island, take in the beauty of the sandscapes, sea caves, and waterfalls of the Lake Superior lakeshore. There are woods of hemlock, white pine, and northern hardwood and pristine old-growth forests on Devils, Raspberry, Outer, and Sand islands.

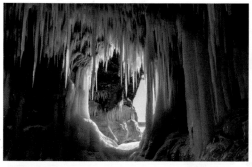

(Above) Winter brings cross-country skiers, ice fishers, and visitors who wish to explore the limestone caves.

During warmer weather, visitors enjoy hiking, picnicking, scuba diving, swimming, hunting, fishing, excursion cruises, kayaking, camping, and sailing.

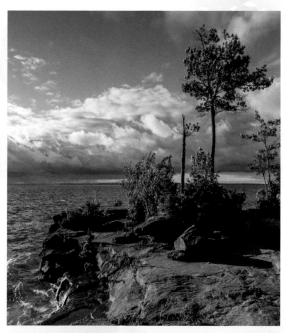

Pabst Mansion

The Pabst Mansion in Milwaukee was the 1892 creation of Frederick Pabst, whose many titles included sea captain, beer baron, real estate mogul, philanthropist, and patron of the arts. The heavy, square architecture was patterned after the 16th-century palaces and fortresses in Flanders, Belgium. With 37 rooms, 12 baths, and 14 fireplaces, the mansion lives up to its name. In its time, the house was a high-tech marvel featuring electricity, plumbing for 9 bathrooms, and 16 thermostats. Today, the Pabst Mansion is called "the Finest Flemish Renaissance Revival Mansion in America."

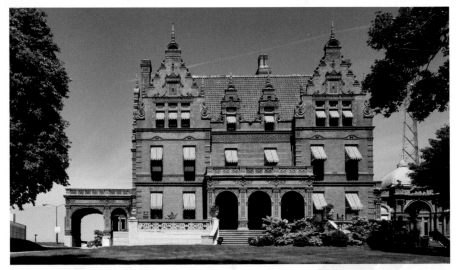

Pabst commissioned Milwaukee architect George Bowman Ferry to design the mansion in 1889. Construction was completed in 1892.

(Right) **Door County**, the long, finger-shape peninsula that separates the main body of Lake Michigan from the city of Green Bay, is known for its quiet beaches, picturesque towns, historic lighthouses, and scenic farms.

(Below) **Taliesin** is regarded as a prime example of Frank Lloyd Wright's organic architecture. The house is located in Spring Green, Wisconsin. On tours you'll see many structures Wright built on the 600-acre estate.

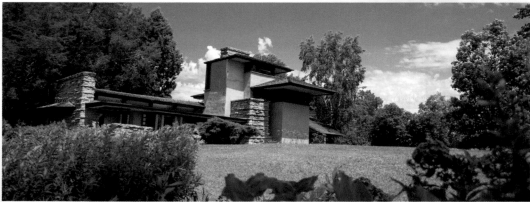

ILLINOIS

Millennium Park

What was once an eyesore of decaying railroad tracks and parking lots near Chicago's lakefront is now a stunning 24.5-acre urban jewel called Millennium Park. Among its major attractions are two pieces of public art: *Cloud Gate* and the *Crown Fountain*. The highly reflective 110-ton polished steel sculpture officially named *Cloud Gate* is affectionately called "The Bean." Visitors can see the park and cityscape reflected in its curves. The *Crown Fountain* is a reflecting pool flanked by two 50-foot towers onto which close-up images of Chicagoans are projected. The faces smile, laugh, and squirt water, much to the delight of onlookers. On warm days, children splash in the shallow water between the two towers.

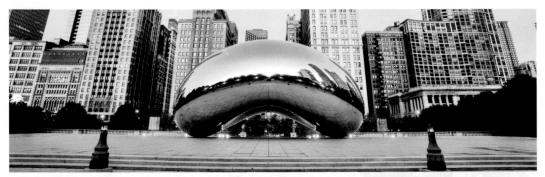

A 12-foot-high arch forms the "gate" in the highly polished **Cloud Gate** sculpture.

Lurie Garden

Located within Chicago's Millennium Park, the Lurie Garden is an urban oasis. The 2.5-acre public garden contains more than 222 types of plants, of which 40 percent are native to North America and 26 percent are native to Illinois. The garden's design pays homage to Chicago's transformation from flat marshland to innovative green city, or *"Urbs in Horto,"* which means "City in a Garden" in Latin.

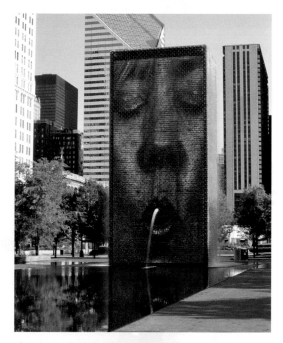

The **Crown Fountain** (above) is made up of glass blocks erected in front of two gigantic video screens. The screens display a continuous loop of faces that smile, laugh, and spray water.

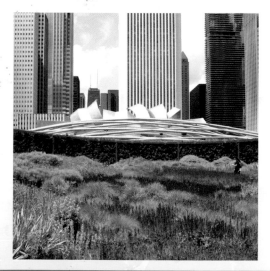

Lurie Garden (left) in Chicago's Millennium Park

Buckingham Fountain

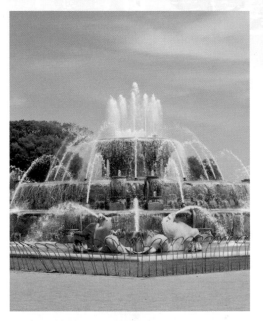

Not far from Lake Michigan and the Chicago River stands a famous Chicago water feature: Buckingham Fountain, found at the center of Grant Park. During the spring, summer, and early fall, visitors can see water and light shows. The Beaux–Arts fountain was unveiled in 1927. In the early days, engineers controlled the fountain and its water shows manually. Today, the water and lights shows are automated.

Four sea horses in the water represent the four states that surround Lake Michigan: Illinois, Wisconsin, Michigan, and Indiana.

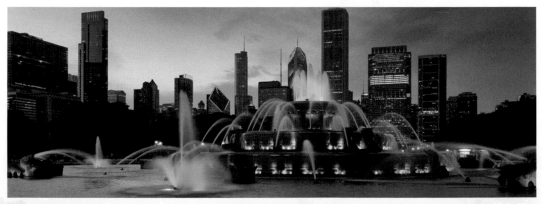

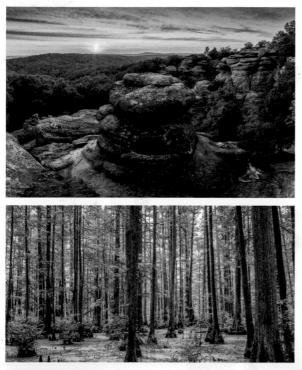

(Top left) **Shawnee National Forest** consists of approximately 280,000 acres in the hills of Southern Illinois. The Garden of the Gods (shown here) is one of several wilderness areas.

(Middle) Located in the southern tip of Illinois, **Cache State River Natural Area** features ancient cypress trees, some at least a millennium old. Canoeing and fishing are popular in this tranquil park.

(Below) Located along the bank of the Illinois River in LaSalle County, **Starved Rock State Park** offers 13 miles of trails, waterfalls, canyon views, and fishing in the Illinois River.

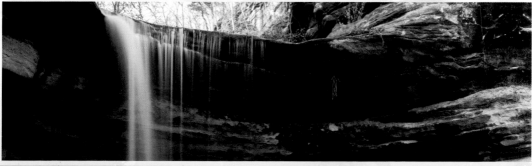

MISSOURI

Kauffman Center for the Performing Arts

A relatively recent addition to Kansas City, Missouri, the Kauffman Center for the performing arts opened in 2011 with a concert headlined by Placido Domingo. It is home to the city's symphony, its lyric opera, and its ballet. One performance venue is named the Muriel Kauffman Theatre. Philanthropist Muriel Kauffman had first proposed the idea for the Center; after her death, her daughter moved the project forward.

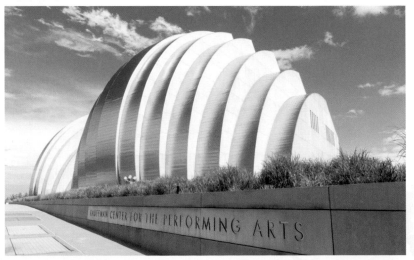

Architect Moshe Safdie designed the project.

Gateway Arch

The Gateway Arch in St. Louis, Missouri, is the focal point of Gateway Arch National Park. The arch was created as monument to western expansion in the United States. It was designed by Finnish-American architect Eero Saarinen in 1947 and completed in 1965. The top of the arch is accessible by two trams—one in each leg—that are made up of eight cylindrical, five-seat compartments.

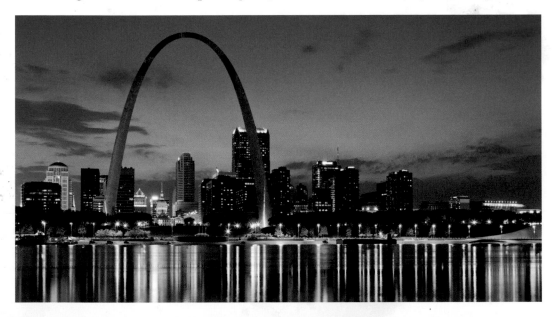

At 630 feet tall, the **Gateway Arch** is the nation's tallest monument and the tallest man-made monument in the Western Hemisphere.

(Left) **Lake of the Ozarks**, Missouri's largest state park, spans more than 17,500 acres. Visitors come for the hiking, camping, beaches, boating, and tours of the Ozark Caverns.

(Below) **Meramec Caverns** is a cavern system in the Ozarks, near Stanton, Missouri. According to local legend, outlaw Jesse James once used the tunnels as a hideout.

(Left) **Mark Twain National Forest** encompasses 1.5 million acres of public land in 29 counties in Missouri. It contains several wilderness areas, natural areas, and the Eleven Point National Wild and Scenic River.

(Right) **Ozark National Scenic Riverways** is the first national park area to protect a river system. The park is home to hundreds of freshwater springs, caves, trails, and historic sites such as Alley Mill (shown here).

IOWA

Iowa State Fair

When it comes to state fairs, Iowa brings home the blue ribbon. You'll find concerts featuring chart-topping performers, acres of farm equipment, one of the world's largest livestock shows, and agricultural displays of all types. The food ranges from fair favorites such as funnel cakes, corn dogs, and cotton candy to chocolate-covered cheesecake on a stick, sweet potato fries, and fried ice cream.

The **Iowa State Fair** has more competitive events than any other state fair in the nation.

Amana Colonies

The Amana Colonies made up a historic utopian society in the gently rolling hills of Iowa's River Valley. Established shortly before the Civil War by German immigrants of the Community of True Inspiration sect, the colonies today are on the National Register of Historic Places. The Amana communities encompass 20,000 acres and 31 historic places. They were one of the world's longest active communal societies, lasting from 1855 to 1932.

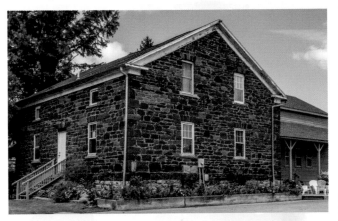

Almost 500 buildings once part of the communities have survived.

Bridges of Madison County

Robert James Waller's best-selling novel, *The Bridges of Madison County*, put Madison County, Iowa, on the map. The county at one time tallied 19 picturesque covered bridges; today just six of the original bridges survive, and five are on the National Register of Historic Places.

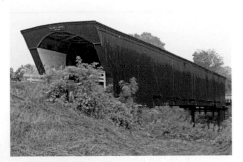

The **Holliwell Bridge** (left) is one of the six original bridges still standing in Madison County.

MINNESOTA

Boundary Waters Canoe Area Wilderness

The Boundary Waters Canoe Area Wilderness is the busiest wilderness area in the United States, drawing more than 200,000 visitors each year. The Boundary Waters stretch along almost 150 miles of the Canadian border in northeastern Minnesota. The region is a mass of marshes, lakes, and bogs on terrain once raked by glaciers at the edge of the Canadian Shield. Waterfalls plunge off cliffs, and you can catch a glimpse of native wildlife, such as otters, deer, moose, beavers, ducks, loons, osprey, and bald eagles. The wilderness is perfect for canoeing, fishing, and camping.

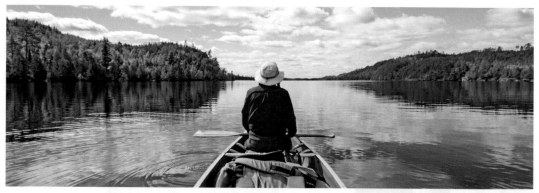

More than 1,200 miles of canoe routes weave through the wilderness of the **Boundary Waters**.

Minneapolis Sculpture Garden

Since opening in 1988, the Minneapolis Sculpture Garden has welcomed millions of visitors, showcasing more than 40 works from the Walker Art Center's collections, including the famous *Spoonbridge and Cherry*. After touring the Garden, take a stroll over to the Walker Art Center. It is one of the most-visited modern and contemporary art museums in the U.S.

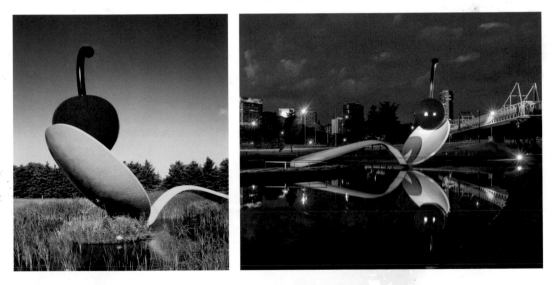

Spoonbridge and Cherry has become a beloved icon at the Minneapolis Sculpture Garden. Claes Oldenburg and Coosje van Bruggen designed it.

NORTH DAKOTA
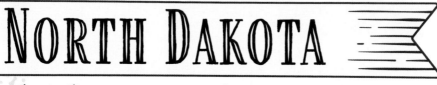

Theodore Roosevelt National Park

Theodore Roosevelt National Park comprises more than 70,000 acres including almost 30,000 wilderness acres. The history of North Dakota's badlands and prairie goes back at least 65 million years, after the Rocky Mountains arose over the Great Plains and just after the dinosaurs became extinct. For 50 million years streams and winds eroded the mountains, carrying their sediment across the plains. Then, between five million and ten million years ago, the Great Plains uplifted, and the Little Missouri River began to scour the Badlands and create the towering cliffs, twisted gullies, domelike hills, and

rugged pinnacles like needles, all daubed with colored striations that run on for miles. It is, as Roosevelt himself said, "a chaos of peaks, plateaus, and ridges."

This rugged landscape inspired Theodore Roosevelt's conservationist drive.

What to see at Theodore Roosevelt:
Elkhorn Ranch; Maltese Cross Cabin; Little Missouri River Badlands

What to do at Theodore Roosevelt:
Hiking; Camping; Horseback riding; Bicycling; Canoeing and kayaking; Cross-country skiing; Fishing; Snowshoeing; Wildlife viewing

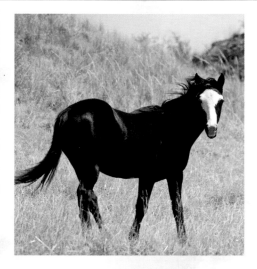

(Right) Feral horses have existed in the Badlands of North Dakota since the mid-1800s. Today, many live in Theodore Roosevelt National Park.

(Below) Little Missouri

North Dakota State Capitol

The North Dakota State Capitol, a 19-story building known as "The Skyscraper on the Prairie," towers over Bismarck. While the capitol stands only 241 feet and 8 inches tall, in winter, its upper stories often disappear in low-hanging clouds. The capitol complex and grounds have become the site for many memorials and museums, including the North Dakota State Heritage Center Museum and Fountain Garden, the Pioneer Family Statue, the Statue of Sakajawea, and the North Dakota Hall of Fame. Guided tours of the building, including a visit to the 18th-floor observation deck, are also available.

This art deco skyscraper replaced the original state capitol, which burned down in 1930.

SOUTH DAKOTA

Mount Rushmore

This presidential face-off of monumental proportions is a jaw-dropping feat of art and engineering. Blasted and chiseled out of granite, Mount Rushmore features four presidents: George Washington, Thomas Jefferson, Theodore Roosevelt, and Abraham Lincoln. The faces on the 5,725-foot-tall landmark tower over a majestic forest of pine, spruce, birch, and aspen trees in South Dakota's Black Hills. Sculptor Gutzon Borglum and his team carved the four 60-foot-high faces into the rock between 1927 and 1941.

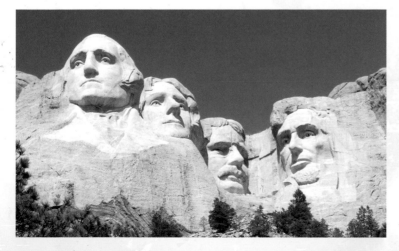

George Washington, Thomas Jefferson, Theodore Roosevelt, and Abraham Lincoln gaze over South Dakota.

Badlands National Park

The stark, uninviting terrain of the Badlands has been called a masterpiece of natural sculpture, of wind and rain that carves uncanny shapes, revealing colored bands in stratified layers. Rain comes rarely, washing away an average of an inch of sediment annually in South Dakota's White River Badlands. Some observers say one thunderstorm can create perceptible changes in the Badlands landscape, and this process has been going on for about 75 million years.

What to see at Badlands:
Big Pig Dig; Robert's Prairie Dog Town; the Wall; the Castle Trail

What to do at Badlands:
Hiking; Camping; Studying fossils

Rapid erosion of the plateaus of soft sediment and volcanic ash etched the Dakota Badlands.

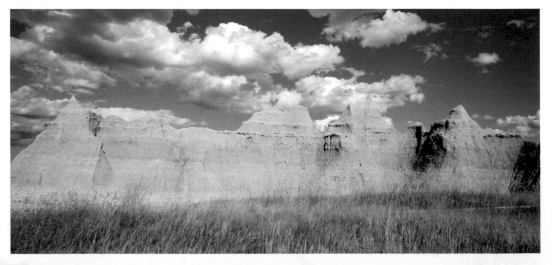

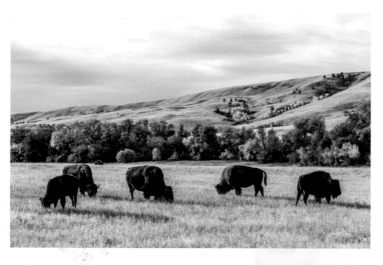

(Left) **Custer State Park** in southwestern South Dakota contains one of the nation's largest free roaming bison herds. The park is also home to bighorn sheep, antelope, deer, elk, coyote, and prairie dogs.

(Right) **Deadwood**, South Dakota, is a National Historic Landmark District with well-preserved Gold Rush-era architecture.

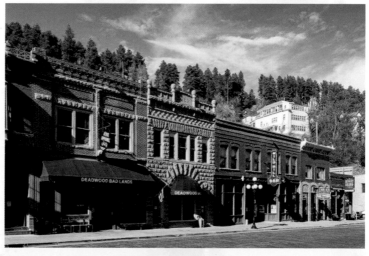

NEBRASKA

Chimney Rock

Chimney Rock rises to a spire almost 325 feet above the North Platte River Valley in Nebraska. It can be seen from miles away, so it was the ideal landmark for pioneers traveling the Mormon, California, and Oregon trails. Today, Chimney Rock is a National Historic Site that still marks the place where the plains give way to the Rocky Mountains.

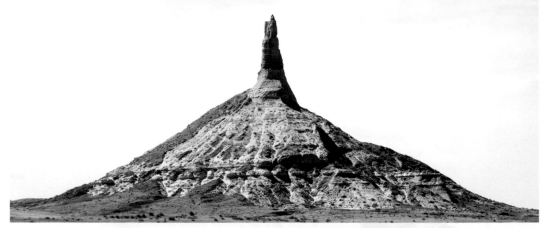

Chimney Rock is a distinct formation that can still be seen along the historic Oregon Trail.

Carhenge

Found in Alliance, Nebraska, Carhenge, the funky automotive version of England's mystical stone circle, emerged in 1987 from a plan that had as much to do with remembrance as it did with art. Built to memorialize the passing of artist Jim Reinders's father, Carhenge features a circle of 38 cars that were planted and balanced upon each other to precisely replicate Stonehenge. The end result is part Druid, part Detroit, and undeniably wacky.

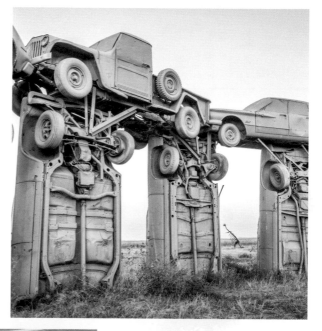

In keeping with the original monoliths, all cars have been spray-painted a stonelike gray. This produces the proper look even as it staves off rust.

Kansas

Dodge City

The lawless, gun-sling-ing reputation of this Kansas frontier town was well deserved. Beginning in the 1860s, Dodge City drew all sorts of people who traveled along the Santa Fe Trail (and later the Atchison, Topeka, and Santa Fe Railroad). Gambling and prostitu-tion ran rampant. With no law in town, disagree-ments often led to sud-den death. Today, Dodge City celebrates its past.

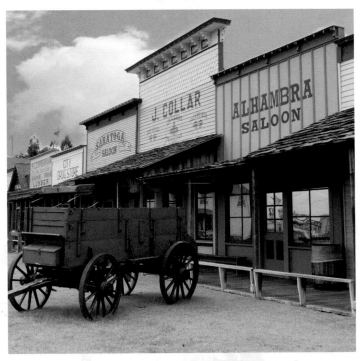

The notorious Front Street of 1876, the business district of Old Dodge City, has been recreated as a tourist attraction.

Keeper of the Plains

At the place where the Arkansas and Little Arkansas rivers meet, a 44-foot-tall statue stands proudly atop a 30-foot pedestal. Called *The Keeper of the Plains* and designed by Kiowa-Comanche sculptor Blackbear Bosin, the statue depicts an American Indian chief. It was commissioned to celebrate the United States Bicentennial and erected in 1974.

Some 30–60 million bison once roamed North America. By 1890, less than 1,000 remained. The **Tallgrass Prairie National Preserve** is now home to a growing bison herd.

Tallgrass Prairie National Preserve

Of the 170 million acres of tallgrass prairie that once covered North America, less than four percent remains today, mostly in the Flint Hills of Kansas. The Tallgrass Prairie National Preserve protects nearly 11,000 acres of the once vast tallgrass prairie.

OKLAHOMA

National Cowboy & Western Heritage Museum

The National Cowboy & Western Heritage Museum in Oklahoma City has a pretty broad mission statement: "To preserve and interpret the heritage of the American West for the enrichment of the public." But that all-encompassing spirit has led to the development of a world-class, 200,000-square-foot complex showcasing more than 28,000 Western and American Indian artworks and artifacts.

Skydance Bridge

Oklahoma City honored its state bird, the scissor-tailed flycatcher, with the design of the Skydance Bridge. Pedestrians can use the bridge to cross Interstate 40 and admire this massive public art project. The bridge's lights can be adjusted to celebrate events and holidays.

Construction began in 2011, with the bridge opening in 2012.

TEXAS

Texas State Capitol

Texas has the largest state capitol building in the country. Built in 1885, the Texas State Capitol building in Austin was declared a National Historic Landmark in 1986. Its builders were paid not by cash but with land in Texas that became the massive XIT ranch.

The distinctive reddish tint comes from rock quarried from the nearby Granite Mountain.

The Alamo

The Alamo is Texas's most visited site. The architecture of this historic mission church, now surrounded by modern downtown San Antonio, is hard to forget. Spanish missionaries established the mission in 1718 and worked to convert the local people to Catholicism. The Spanish secularized the mission in 1793. However, it was abandoned before it became the site of the legendary Battle of the Alamo in 1836. Today, visitors can tour the Alamo mission and a museum that recounts Texas's turbulent past, emphasizing the memorable two-week Battle of the Alamo.

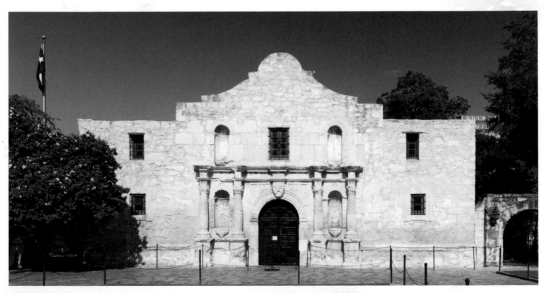

The Alamo remains an icon and reminder
of Texas's struggle for independence.

Big Bend National Park

More than 800,000 acres in all, Big Bend National Park encompasses a seemingly endless expanse of forested mountains, impossibly sheer canyons, and rugged desert wilderness just across the Rio Grande from Mexico in West Texas. Here the river winds south then suddenly veers north in a great horseshoe curve before turning southward again, thus the moniker, Big Bend.

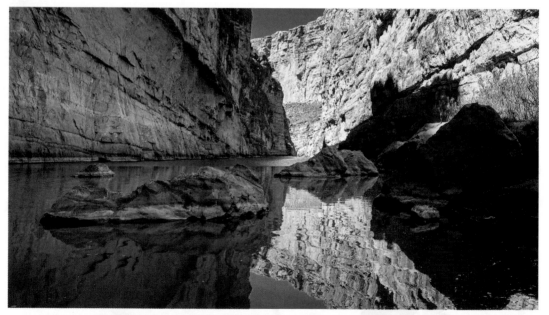

The chasms chiseled by the Rio Grande draw adventurous rafters to explore **Big Bend National Park**.

What to see at Big Bend:
*Santa Elena Canyon;
Castolon Historic District;
Sotol Vista; Sam Nail Ranch;
Window View Trail; Mule
Ears Overlook; Homer Wilson
Ranch; Tuff Canyon*

What to do at Big Bend:
*Hiking; Camping; Rafting;
Backpacking; Climbing;
Bicycling; Birding*

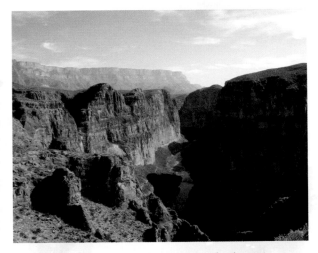

(Below) At lower-lying elevations, there are 70 species of cactus found in Big Bend, more than any other national park.

Winding through Big Bend, the Rio Grande has carved three of the continent's most striking canyons—**Boquillas** (above), Mariscal, and Santa Elena.

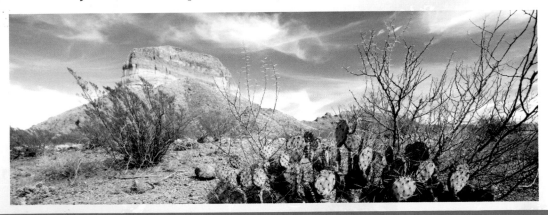

Padre Island National Seashore

The pristine beaches, wind-sculpted dunes, and saltwater marshes of Padre Island National Seashore stretch for 80 miles along the Gulf of Mexico off of south Texas. Both sea and land wildlife lure nature lovers from all over. Padre Island's major migratory bird flyway makes it ideal for bird-watching. Padre Island also offers speckled trout, black drum, redfish, and flounder for fishing enthusiasts. The saltwater lagoon between the island and the mainland is a perfect place to learn to windsurf.

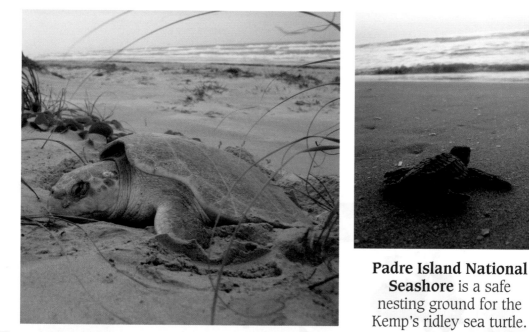

Padre Island National Seashore is a safe nesting ground for the Kemp's ridley sea turtle.

Big Thicket National Preserve

East Texas's 97,000-acre Big Thicket National Preserve is where the sultry swamps of the South, the verdant forests of the East, and the seemingly endless savannah of the Great Plains meet and mingle. Meadows are scarce. In Big Thicket's diverse biosphere, desert roadrunners live alongside swamp critters, such as alligators and frogs. And they coexist near deer, mountain lions, and 300 species of nesting and migratory birds. This is the only place on the planet where many of these species live side by side.

Big Thicket National Preserve provides a unique habitat of rich wetlands and thick forests that harbors diverse plant life.

NEW MEXICO

Carlsbad Caverns

This great cave system—consisting of 300 separate rooms—comprises one of the largest caverns in the world. The size and boldness of its huge vaulted underground chambers are truly awesome. The cave contains formations of such startling shapes and colors, and of such monumental proportions, that country humorist Will Rogers called this underground wonderland "the Grand Canyon with a roof over it" when he visited in 1931.

The vast **Big Room** at Carlsbad Caverns has a ceiling that arches 255 feet above the floor, and it contains a six-story stalagmite and the so-called bottomless pit, which is more than 700 feet deep.

Taos Pueblo

The Taos Pueblo in northern New Mexico is the oldest continuously occupied structure on the continent. Dating back to A.D. 1000, its adobe walls today house about 150 Taos Native Americans who maintain the ancient traditions of their ancestors, while about 2,000 Taos Puebloans live in the nearby area. The Pueblo is not a historical artifact or a re-creation; it is an actual town that offers a fascinating introduction to Native American life.

The Pueblo's distinctive style has influenced much of the region's architecture. It consists of two long, multistory adobe structures, one on each side of a freshwater creek.

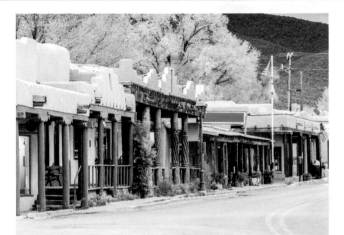

The nearby town of Taos (above) is home to a number of artists, art galleries and studios, and art museums.

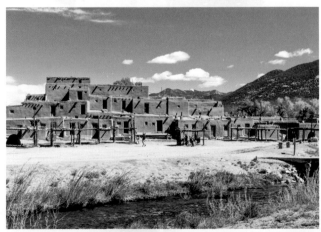

Albuquerque International Balloon Fiesta

In 1972, thirteen balloons gathered in the parking lot of a mall in Albuquerque, New Mexico, to celebrate the 50th anniversary of a local radio station. A few years later, almost three hundred balloons were gathered at the event. Today, about 600 balloons can be seen in the New Mexico sky over the course of a week in October. Events such as Balloon Glows at night, fireworks displays, and the Special Shape Rodeo™ draw hundreds of thousands of visitors to the popular festival.

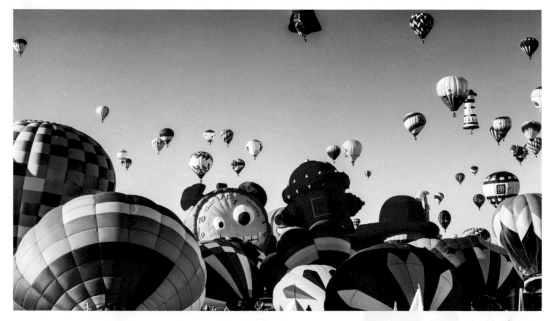

The **Albuquerque International Balloon Fiesta** is the largest balloon festival in the world.

ARIZONA

Taliesin West

In the late 1930s, Frank Lloyd Wright designed and built the Taliesin West complex in Scottsdale, Arizona, as the winter counterpart to his original Taliesin in Spring Green, Wisconsin. Taliesin West covers 600 acres of rugged Sonoran Desert at the foot of McDowell Mountain. The landscape is an integral part of the site: Wright employed rocks and sand on the property as key ingredients in his masterpiece.

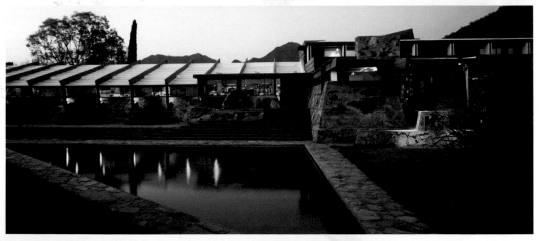

The organic design of **Taliesin West** blends perfectly with the surrounding arid landscape.

Grand Canyon National Park

Millions of years of erosion caused by wind and the Colorado River have carved and sculpted Arizona's Grand Canyon, truly one of the world's most dramatic natural wonders. At 227 miles long and 18 miles across at its widest point, this breathtaking abyss plunges more than a mile from rim to river bottom at its deepest point.

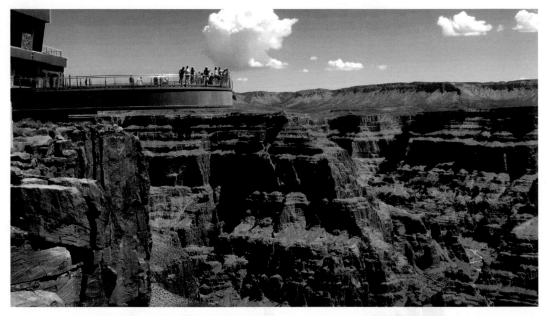

The Grand Canyon Skywalk is a horseshoe-shape, glass-bottom walkway that extends over the edge of the canyon and gives visitors the opportunity to look 4,000 feet straight down.

Horseshoe Bend (on left), shaped by the Colorado River, is found not far from Grand Canyon.

More than four million visitors come to see the **Grand Canyon** every year.

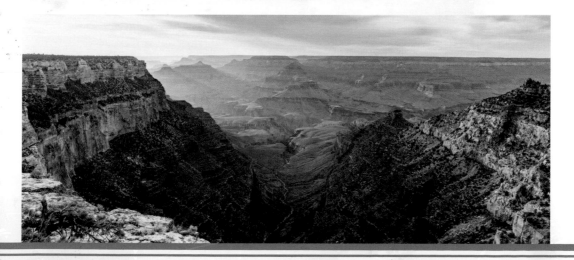

Havasu Falls

Havasu Falls was called Bridal Veil Falls until a flash flood in 1910 changed the appearance of the waterfalls. Havasu means "blue-green water." Havasu Falls are located on Havasupai tribal lands within the Grand Canyon, and administered by the Tribe.

Antelope Canyon

Each time a visitor goes through this narrow slot canyon, they might see something different. Wind, flash floods, and rain are constantly shaping the Navajo sandstone into unearthly beauty. Even going through the canyon at different times of day will reveal different views as the light plays on the rock.

Antelope Canyon is part of and administered by the Navajo Nation.

Petrified Forest

Some 225 million years ago, the arid desert of north-central Arizona was a lush tropical forest dominated by towering conifers. This era ended when catastrophic floods uprooted trees. Over millions of years, layers of silt, mud, and volcanic ash covered the spent trees and slowed the process of decay. Silica from the ash gradually penetrated the wood and turned to quartz. Minerals streaked the former wood with every color of the rainbow. Beyond the magnificent petrified wood, Petrified Forest National Park also contains one of the best fossil records from the Late Triassic period.

Over millions of years, ancient trees in Arizona were streaked with minerals and preserved as shimmering petrified wood.

NEVADA

Hoover Dam

In the Black Canyon of the Colorado River, 30 miles southeast of Las Vegas, sits the engineering marvel known as Hoover Dam. The dam was constructed between 1931 and 1935 and consists of 3.25 million cubic yards of concrete. The dam widens the Colorado into the vast waters of Lake Mead, a year-round recreation destination that attracts millions of visitors each year for swimming, boating, waterskiing, and fishing.

The Hoover Dam is a National Historic Landmark and has been selected by the American Society of Civil Engineers as one of "America's Seven Modern Civil Engineering Wonders."

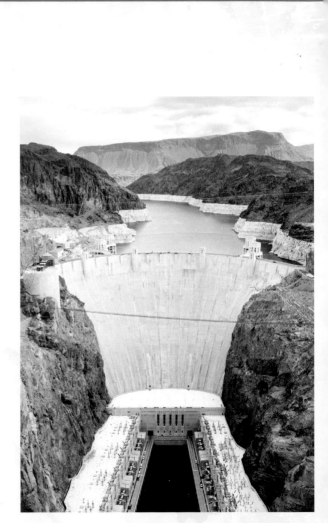

Las Vegas Strip

The Las Vegas Strip originated in 1938, seven years after gambling was legalized in Nevada. Bucking the trend of the downtown casino, an entrepreneur opened a gambling hall four miles south of Las Vegas's city center on U.S. Highway 91. In 1941, the Hotel El Rancho Vegas resort opened at the corner of San Francisco Avenue and U.S. 91. The hotel offered its guests an unprecedented slate of facilities and activities, including restaurants, live entertainment, shops, a travel agency, horseback riding, and, of course, a swimming pool. Gambling, nonetheless, remained the top draw.

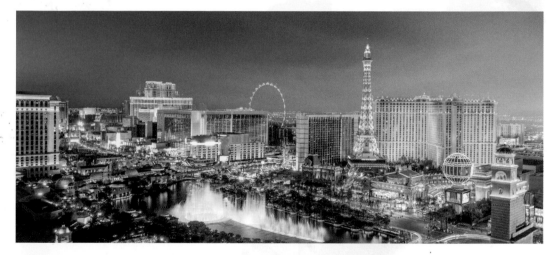

A visitor walking the **Las Vegas Strip** could see everything from replicas of the Eiffel Tower and the New York skyline to dazzling water fountains that dance to music.

COLORADO

Red Rocks Park and Amphitheatre

In Morrison, Colorado, Red Rocks Park and Amphitheatre is nestled in the stunning mountainside and natural red rocks. Its acoustics are superb, perhaps rivaled only by the beauty of its spectacular surroundings. The north and south sides of the amphitheatre are 300-foot geological masterstrokes named Creation Rock and Ship Rock, respectively. The seats stretch across the steep slope between the two.

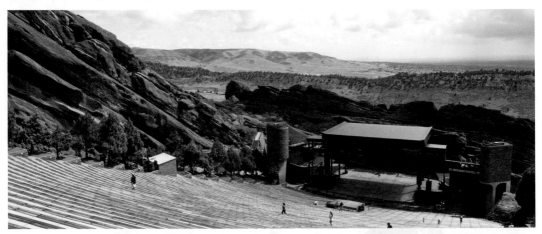

The dramatic red rock formations that give the **Red Rocks Amphitheatre** its name are both visually striking and acoustically ideal.

Air Force Academy Cadet Chapel

Completed in 1962, the Air Force Academy Cadet Chapel is a striking example of modernist architecture. In 1996, it won the American Institute of Architects' National Twenty-five Year Award. It contains several chapels devoted to different faiths.

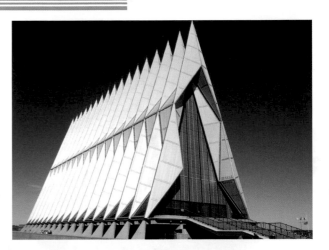

Air Force Academy Cadet Chapel in Colorado Springs

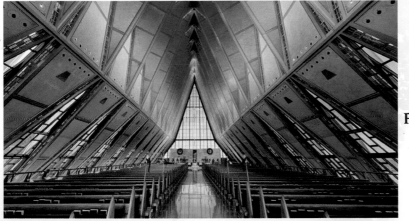

Interior of the **Protestant Chapel**

Great Sand Dunes National Park and Preserve

Great Sand Dunes National Park and Preserve in southwestern Colorado is home to the tallest dunes in North America, mountains of sand measuring 750 feet in height. The dunes were born about 440,000 years ago, the product of competing elements—wind and water—circulating and recirculating sand.

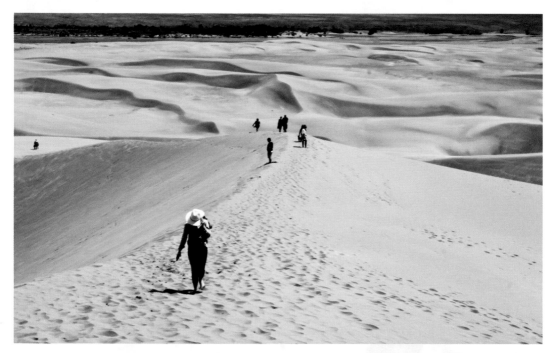

Masterworks of wind, water, and earth, the **Great Sand Dunes** reach heights of up to 750 feet.

What to see at Great Sand Dunes:
*Star Dune; High Dune; Medano Creek;
Medano Lake; Mount Herard;
Sand Ramp Trail*

What to do at Great Sand Dunes:
*Hiking; Backpacking; Sandboarding,
skiing, and sledding; Horseback riding;
Camping; Making sand castles*

The sandy habitats of the park provide refuge for a number of insects found only here. The predatory **Great Sand Dunes tiger beetle** (above) wanders the sand in search of ants, smaller beetles, and mites.

Rocky Mountain National Park

Perched atop the Continental Divide, Colorado's Rocky Mountain National Park is archetypal high country, offering a jaw-dropping panorama of daunting summits and alpine tundra in the mountains of north-central Colorado. Within the park are 78 peaks greater than 12,000 feet tall; 20 of them reach above 13,000 feet. Contrasting with this jagged terrain, meadows come alive in spring and summer as wildflowers poke their way through the tundra.

Crystalline lakes refilled by annual snowmelt are nestled at the feet of **Rocky Mountain National Park**'s awe-inspiring peaks.

UTAH

Arches National Park

Chiseled by the powerful, perpetual forces of wind and water, this surprising natural rock garden contains the planet's most remarkable collection of abstract sculpture. Arches National Park sits on a great plateau in southeastern Utah, encompassing a stark landscape of broken red sandstone. The park contains more than 2,000 natural stone arches. But these spectacular sandstone portals are only part of the stunning landscape here.

(Below) The park's most photographed attraction, **Delicate Arch**, is a famous icon seen on Utah's license plates.

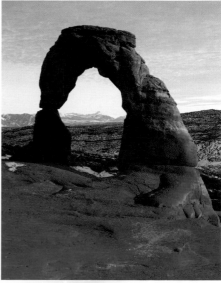

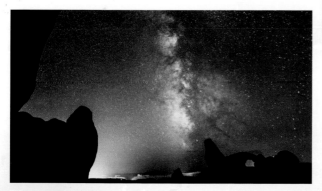

Most of the mammals that live in Arches are nocturnal, including kangaroo rats, skunks, foxes, and bats.

Canyonlands National Park

The wide-open wilderness of sandstone canyons in southeast Utah's Canyonlands National Park is the remarkable product of millions of years of rushing water. The Colorado and Green rivers have shaped this landscape of precipitous chasms and vividly painted mesas, pinnacles, and buttes.

What to see at Canyonlands:
Islands in the Sky; the Needles; the Maze; Chesler Park; Green River; Devil's Kitchen; Horseshoe Canyon; Colorado River; Butler Flat; Peekaboo Spring; Cataract Canyon

What to do at Canyonlands:
Hiking; Boating; Backpacking; Horseback riding; Climbing; Biking; Camping

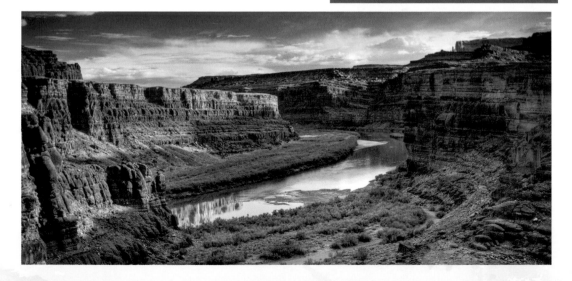

A wild array of arches, sandstone pillars and needles, canyon mazes, and scarps make up the otherworldly terrain of **Canyonlands National Park**.

The rugged landscape is one of deep-shadowed canyons, bright orange mesas, rust-colored pinnacles, and maroon buttes—an intense palette of natural colors that comes alive in the rays of the setting sun.

Bryce Canyon National Park

A maelstrom of rock figures of every size, shape, and color, sculpted by the elements over millions of years, Bryce Canyon National Park is one of the most amazing landscapes nature has to offer. The Bryce escarpment, with its thousands of geological gargoyles and castellated spires, is the product of the relentless strength of water and time.

These endless rock towers take on all kinds of shapes—resembling castles, bridges, towers, presidents, prime ministers, **Thor's hammer** (shown here), and even Queen Victoria.

What to see at Bryce Canyon:
Inspiration Point; Thor's Hammer; Riggs Spring Loop; Bryce Point; Wall Street Trail; Paunsaugunt Plateau; Sunrise Point; Paria View

What to do at Bryce Canyon:
Hiking; Horseback or muleback riding; Cross-country skiing in winter; Snowshoe hikes in winter

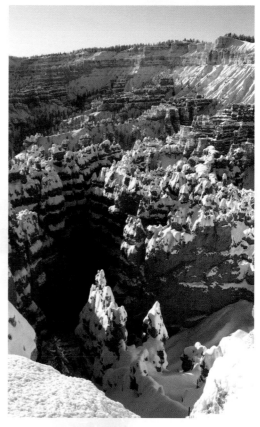

An intricately carved collection of vibrantly colored hoodoos populates the unforgettable landscape of **Bryce Canyon National Park**.

In winter, thousands of hoodoos take on the appearance of figures made of red and orange wearing white mantles of snow.

Temple Square

Temple Square in Salt Lake City is the most visited site in Utah. The striking Salt Lake Temple is at its center. This architectural wonder is a living legacy to 40 years of hard work and perseverance. Work on the Salt Lake Temple began in 1853, six years after Brigham Young led thousands of Mormons to the Great Salt Lake to escape persecution in Nauvoo, Illinois. During the next four decades, workers painstakingly carved granite blocks to create the temple. Master stonecutters fit the blocks perfectly into place—without the aid of mortar.

The granite for the **Salt Lake Temple** came from Little Cotton-wood Canyon, about 20 miles away. Each block weighed a ton or more, and many were transported by ox-drawn wagon.

IDAHO

Shoshone Falls

The 212-foot-tall Shoshone Falls is also known as the "Niagara of the West." Shoshone Falls is a few miles northeast of Twin Falls, Idaho, in the Snake River Canyon. It has long served as a tourist attraction—pioneers on the Oregon Trail were known to take a side trip to view the Falls as they traveled to their destination. Visitors today can picnic, hike, and swim in the area.

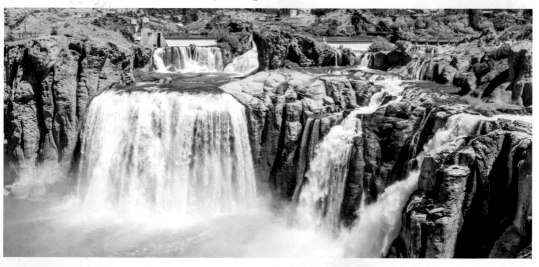

The rim of **Shoshone Falls** is nearly 1,000 feet wide.

Hells Canyon of the Snake River

A huge lake once covered the area now bisected by the Oregon–Idaho state line. The rocky bulge of the Owyhee Mountains kept the Snake and Columbia rivers separate until giving way roughly a million years ago. Then the Snake rapidly cut its way through as much as ten miles of igneous rock to join with the Columbia, chiseling out the chasm now known as the Hells Canyon of the Snake River.

Hells Canyon is North America's deepest river gorge and one of the continent's most dramatic landscapes.

Perrine Bridge

Ida Burton Perrine (1861–1943) was born in Indiana but moved to Idaho Territory, where he became a rancher and businessman. He became instrumental in the development of Idaho, credited with founding towns like Twin Falls and helping to develop a crucial irrigation system. The bridge named after him opened in 1976, in the location of an earlier bridge over Snake River Canyon.

The **Perrine Bridge** is a popular site for BASE jumping.

WYOMING

Medicine Wheel National Historic Landmark

Wyoming's Medicine Wheel is in a remote area of the Bighorn National Forest. It is one of the oldest active religious sites on the planet: For 7,000 years, this spot on Medicine Mountain has been sacred. Medicine Wheel is part of a larger system of interrelated religious areas, altars, sweat lodge sites, and other ceremonial venues, and it is still in use. The lasting artifact at the site is the actual Medicine Wheel, which is 75 feet in diameter and composed of 28 "spokes" of rocks intersecting in a central rocky cairn.

Originally built several hundred years ago, **Medicine Wheel** is now a National Historic Landmark enclosed by a simple rope fence. It is considered one of the best-preserved sites of its kind.

Cody

Named for its founder, William "Buffalo Bill" Cody, this is one town in the country where the West lives on. Cody, Wyoming, is a bit of a bug in amber, with wooden boardwalks fronting its historic storefronts on the city's main drag. The culture here still smacks of the Old West in many ways. The city bills itself as the "Rodeo Capital of the World." It's the only city in the country that has a nightly rodeo all summer long: the Cody Nite Rodeo, pictured below on the right.

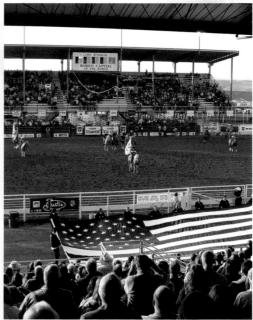

(Above) **Buffalo Bill Center of the West** is a complex of five museums (dedicated to Native Americans, natural history, Western art, firearms, and "Buffalo Bill" Cody himself) and a research library in Cody.

Yellowstone National Park

Here on Earth, Yellowstone National Park is as close to another planet as it gets. This alien landscape is home to more than half of the world's thermal features, an amazing variety of magma-powered plumbing that includes the archetypal thermal features of ferocious and majestic geysers, along with brilliantly hued hot pools, steaming fumaroles, and lethargically belching mud pots—about 10,000 in all, including more than 300 geysers.

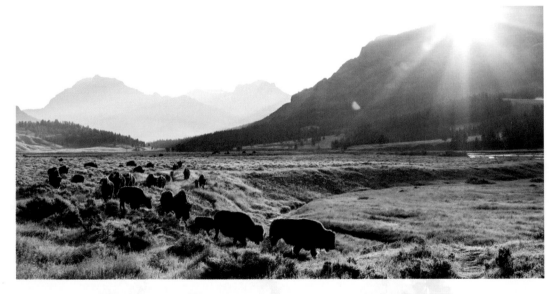

Yellowstone is home to bison, grizzly bears, black bears, wolves, coyotes, cougars, pronghorn, mountain goats, bighorn sheep, elk, moose, and many other animals.

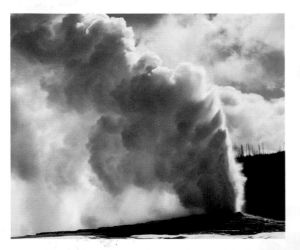

What to see at Yellowstone:
Old Faithful; Roosevelt Arch; Mammoth Hot Springs; Yellowstone Lake; Bridge Bay; Fountain Paint Pot; Morning Glory Pool; Continental Divide

What to do at Yellowstone:
Hiking; Camping; Horseback riding and llama packing; Boating; Fishing; Bicycling; Cross-country skiing; Wildlife viewing

(Above) Yellowstone's **Old Faithful** geyser erupts every 35 to 120 minutes. (Below) The **Grand Canyon of the Yellowstone River** is a geological masterwork punctuated by two dramatic waterfalls, 109-foot Upper Falls and 308-foot Lower Falls.

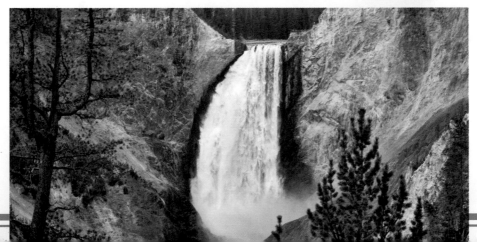

MONTANA

Museum of the Rockies

Long before grizzlies and bighorn sheep roamed the Rockies, Montana's claim to fame was wildlife of a different kind—dinosaurs. About 60 million years ago, the region was tropical. Local dinosaurs included *Tyrannosaurus rex*, *Apatosaurus*, and *Triceratops*. This rich prehistory is told at Bozeman's Museum of the Rockies, home to the largest collection of American dinosaur bones in the world, nearly all of which were discovered in Montana.

Exhibits at the **Museum of the Rockies** in Bozeman dig into dinosaur biology and behavior, as well as fossil recovery and paleontology.

Little Bighorn Battlefield National Monument

The Little Bighorn Battlefield National Monument memorializes the site where on June 25–26, 1876, Lieutenant Colonel George Custer and the U.S. Army's 7th Cavalry were defeated by a far larger Lakota and Cheyenne war party during what became known as Custer's Last Stand. Custer and more than 200 soldiers under his command perished in the battle, as did at least 60 Cheyenne and Lakota. Despite the outcome, Custer's Last Stand marked the end for the Cheyenne and Lakota people's nomadic way of life in the West.

The memorial on **Last Stand Hill** was built over the mass grave of 7th Cavalry soldiers, U.S. Indian scouts, and others who died here.

Glacier National Park

Northwestern Montana's Glacier National Park presents the Rocky Mountains as many have always imagined them: granite peaks with glimmering glaciers fitted into their gorges, fields run riot with wildflowers, lakes as deep and blue as the summer sky, cascading waterfalls, grizzly bears, wooded slopes, and miles and miles of wilderness trails.

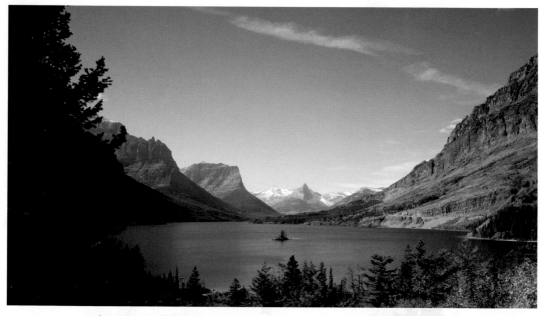

Glacier National Park, named for the rivers of ice that sculpted its dramatic alpine landscape, is the national park many people say they would most like to revisit.

What to see at Glacier:
Going-to-the-Sun Road; Logan Pass; Mount Logan; McDonald Lake; Sperry Glacier; Saint Mary Lake; West Glacier

What to do at Glacier:
Hiking; Backpacking; Camping; Horseback riding; Fishing; Cross-country skiing

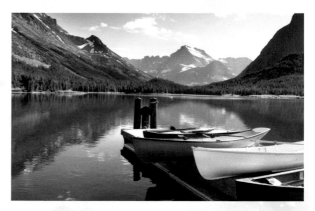

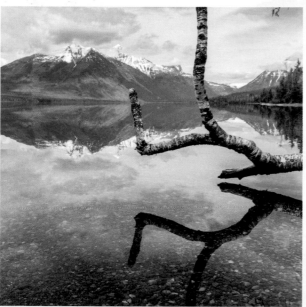

The Rocky Mountains rise to over 10,000 feet atop the highest peaks, then precipitously drop off to about 3,000 feet at **Lake McDonald** (above) in the park's southwestern quarter.

In 1850, Glacier had about 150 glaciers, and in 1997 there were about 50. By 2015, only 26 remained. If current global warming trends continue, scientists have estimated the park's last glacial remnant will melt away in the next few decades.

WASHINGTON

San Juan Islands

North of Seattle, Washington, in Puget Sound sits the San Juan Archipelago, a collection of 172 named islands and another several hundred rocky island outcroppings that appear at low tide. Although about 40 of these idyllic islands are inhabited, most people living here reside on the four that have ferry service: San Juan, Orcas, Lopez, and Shaw.

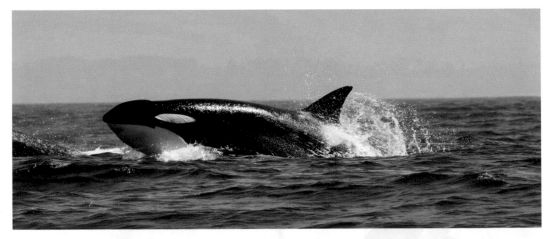

The **San Juan Islands'** sheltered waters are home to harbor seals, sea lions, sea otters, dolphins, and orcas.

Space Needle

Seattle's Space Needle is the most popular tourist attraction in the city, receiving more than a million visitors each year. Originally built for the 1962 World's Fair and still the defining feature on the Emerald City's skyline, the 605-foot Space Needle was the tallest building west of the Mississippi when it was completed in late 1961. The futuristic blueprints for the Space Needle evolved from artist Edward E. Carlson's visionary doodle on a placemat. His collaboration with architect John Graham resulted in a prototype space age design that looks a bit like a flying saucer balanced on three giant supports.

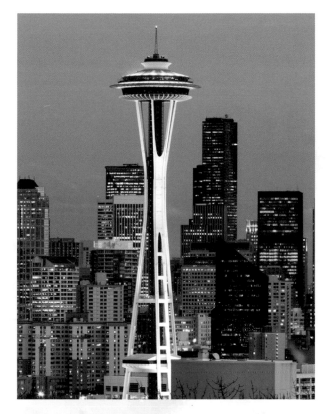

The **Space Needle** was built to withstand winds of up to 200 miles per hour. Wind does cause the needle to sway, but the top house has only closed once—for an hour-and-a-half in 1993 due to 90-mile-per-hour winds.

Museum of Glass

The Museum of Glass is Tacoma, Washington's splashy contribution to the contemporary art world. Its works in different media have one thing in common: They all incorporate glass. Visitors can browse permanent and temporary exhibitions of all kinds of contemporary glass art. The museum's Visiting Artist Collection is permanent, featuring works created on-site in the Hot Shop Amphitheater.

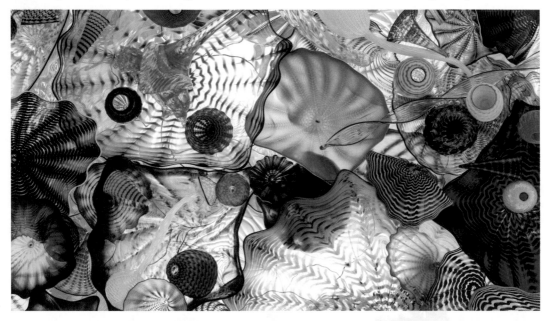

The **Museum of Glass** features a number of works from and influenced by noted artist and native Dale Chihuly, who was born in Tacoma.

Mount Rainier National Park

The world of snow and ice atop Mount Rainier never thaws. But below Mount Rainier's frosty covering, conditions are the polar opposite: Inside, the mountain is an active volcano, and it's the tallest one in the volcanic Cascade Range.

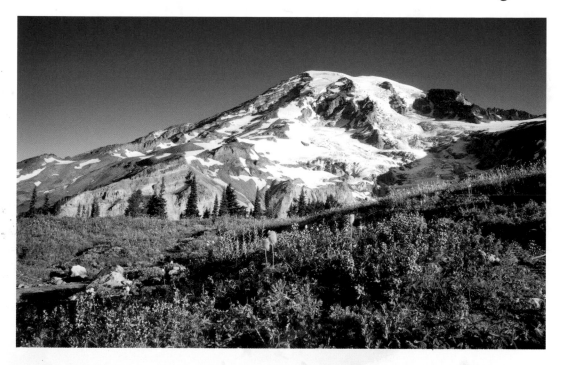

Come summertime, **Mount Rainier**'s subalpine meadows explode with color as lupines, monkeyflowers, asters, and myriad other species bloom.

OREGON

Multnomah Falls

Ancient Multnomah Falls is a sight to behold. Cascading from its origin on Larch Mountain, it highlights the picturesque Columbia River Gorge in central Oregon. At 620 feet, it's the second-tallest year-round waterfall in the nation. The falls are fed by an underground spring that provides a continuous flow of crystal-clear water that's enhanced by seasonal snowmelt and spring rainstorms.

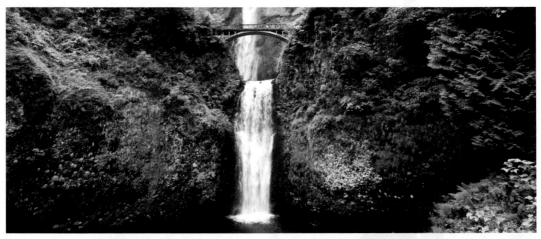

Many visitors take the foot trail up to **Benson Bridge** for one of the best spots to view the falls.

Heceta Head Light

Oregon's beautiful Heceta Head Light was built in 1894. The surrounding, near-vertical rock cliffs made construction particularly difficult. The white conical tower was raised on a flattened deck notched in the side of a mountain. Although the tower is only 56 feet tall, its actual height above the waves is 205 feet. The Heceta Head Light was automated in 1963 and is the brightest on the Oregon coast.

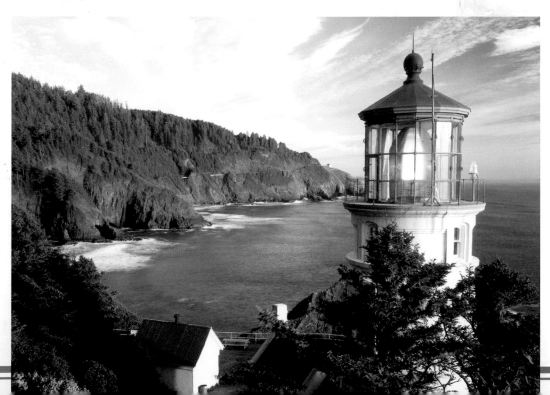

Crater Lake National Park

Southern Oregon's Crater Lake National Park, centered on the idyllic blue lake of its namesake, is one of the grandest sights on the continent. The distance from the surface of the lake to its bottom is 1,932 feet, which makes it the deepest lake in the United States. Water has accumulated here over centuries as rain and snowmelt filled in the huge caldera. Because no water flows into or out of the lake, its waters contain few minerals and almost no impurities.

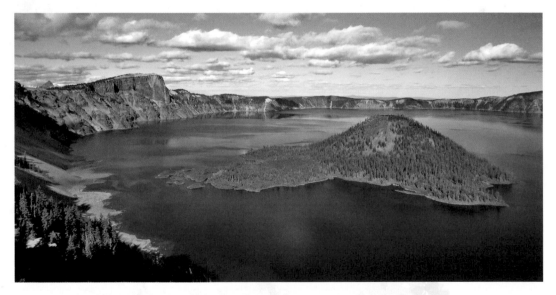

The vast and mirrorlike surface of **Crater Lake** is circled by steep slopes, mountains, and great cliffs. Wizard Island is a volcanic cinder cone that rises about 700 feet above the lake's surface.

Mount Hood

At 11,239 feet above sea level, Mount Hood is the fourth-highest peak in the Cascade Range. Like all of its Cascade brethren, Mount Hood is a volcano, and an active one. It erupted twice in the mid-1800s and has had at least four eruptive periods in the past 15,000 years. The volcanic cone atop the mountain is dominated by snow and ice, with glaciers and snowfields shrouding it year-round.

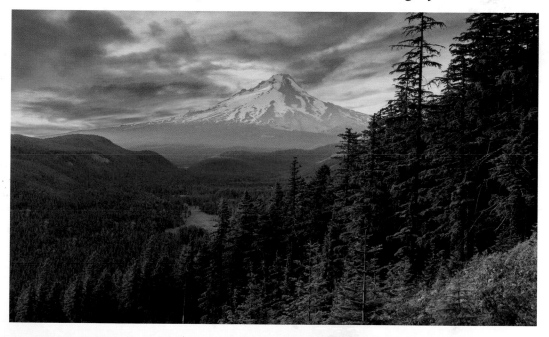

Oregon's **Mount Hood** is a recreational paradise, with popular ski resorts, hiking routes, and backcountry trails.

CALIFORNIA

Getty Center

Visitors to Los Angeles should be sure to check out this massive complex full of art, surrounded by beautiful gardens. Designed by architect Richard Meier, the buildings at the Getty Center opened in 1997. The Los Angeles site is also home to the Getty Research Institute. The art collections of the J. Paul Getty Museum are divided in two locations, the Getty Center and the Getty Villa in Malibu. The museum contains photographs, illuminated manuscripts, and paintings.

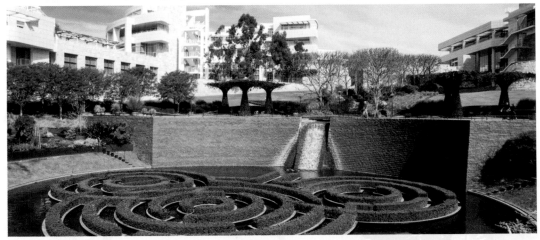

More than 1.5 million visitors flock to the **Getty Center** annually.

Hollywood

The rolling Hollywood Hills, clad in a lush layer of greenery, cradle neighborhoods of all kinds and feature a one-of-a-kind American icon, the Hollywood sign. Down below, on Hollywood Boulevard, the sidewalk sports 2,600 terrazzo-and-brass stars that immortalize giants of the entertainment industry. The street is also home to Grauman's Chinese Theatre, perhaps the most famous cinema in the world.

Located on the Historic Hollywood Walk of Fame, **Grauman's Chinese Theatre** was built in 1926.

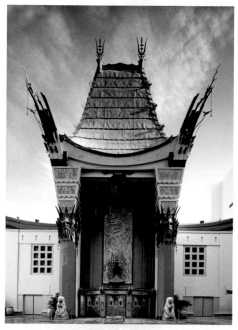

The **Hollywood sign** was put up in 1923.

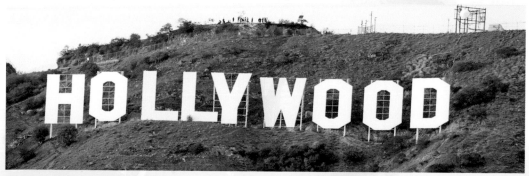

Yosemite National Park

Yosemite National Park is a showcase for the wonders of nature. This vast and varied domain includes giant sequoias, alpine meadows, peaks soaring above 13,000 feet, lovely alpine lakes, sparkling trout streams, grassy meadows, and glacial remnants. Within the park are four of the seven life zones found on the North American continent. The range of natural features is so diverse because of Yosemite's location in the temperate climate of central California and an unusually varied terrain, ranging from desert to high alpine.

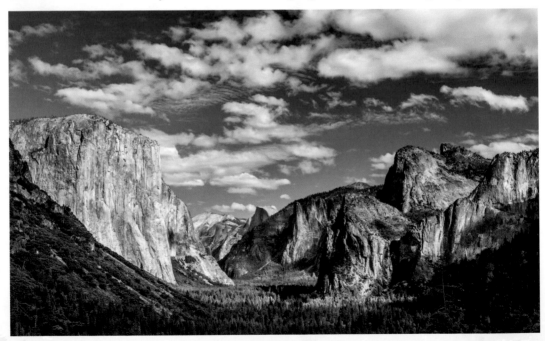

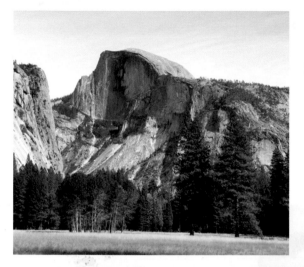

What to see at Yosemite:
Half Dome; El Capitan; Mariposa Grove of giant sequoias; Yosemite Falls; Glacier Point; Badger Pass; Yosemite Valley; Vernal Falls; Wawona

What to do at Yosemite:
Hiking; Rock climbing; Fishing; Horseback riding; Backpacking; Rafting; Downhill skiing and snowboarding; Biking; Bird-watching; Ice skating

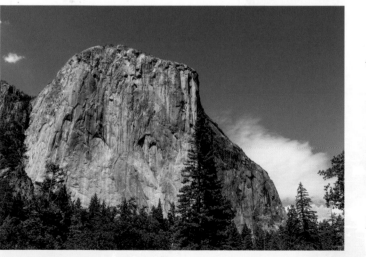

(Top left) The park's most famous landmark, **Half Dome**, with its great sheared-off face, rises 4,800 feet above the eastern end of the valley.

(Left) **El Capitan**, a monolith that rises 3,600 feet above the evergreens along the Merced River, stands at the western entrance.

Golden Gate Bridge

San Francisco's Golden Gate Bridge does for the West Coast what the Statue of Liberty and the Manhattan skyline do for the East: It welcomes newcomers while proclaiming the golden, youthful promise of the new world. The bridge was named not for its color (it's actually orange vermilion) but because it spans the Golden Gate Strait, named by explorer John C. Fremont. The beautiful bridge is also the centerpiece of the Golden Gate National Recreation Area. Golden Gate is the most popular destination in the national parks system, with more than 14 million visitors each year.

At 4,200 feet from tower to tower, **Golden Gate Bridge** reigned as the world's longest suspension bridge for 27 years.

Chinatown

San Francisco's Chinatown is the largest Chinatown on the continent, and it explodes with color every day of the year. Chinatown is one of the Bay Area's most visited tourist hot spots, but it also serves as an authentic neighborhood where people live, work, and play. If you're in San Francisco around the beginning of the year, you might be lucky enough to see the Chinese New Year Parade (a San Francisco tradition since just after the 1849 Gold Rush).

The **Chinese New Year Parade** is now the biggest illuminated nighttime parade in North America.

Huntington Botanical Gardens

The Huntington (Library, Art Collections, and Botanical Gardens) is located in San Marino, California. The Huntington's botanical gardens cover 120 acres and showcase plants from around the world. It was founded in 1919 by businessman and landowner Henry Huntington.

(Below) **Huntington Desert Garden** is one of the largest collections of cacti and other succulents in the world. The garden features more than 2,000 species of succulents and desert plants in 60 landscaped beds.

(Above) **Garden of Flowing Fragrance**, *Liu Fang Yuan*, is among the largest Chinese gardens outside of China. The garden features Californian oaks, Chinese architecture, a man-made lake, and pavilions connected by bridges. Limestone rocks from China's Lake Tai line the edge of the water.

Big Sur Coastline

This scenic stretch of coastline has a breathtaking beauty that invites many stops for pictures. One minute you're standing atop a high cliff looking down at a crashing sapphire sea, and the next you're hiking through a misty redwood forest. The Big Sur coastline begins just south of Monterey, California, where Point Lobos Reserve encompasses a group of headlands, coves, and rolling meadows. Between the months of December and May, migrating gray whales are a common sight.

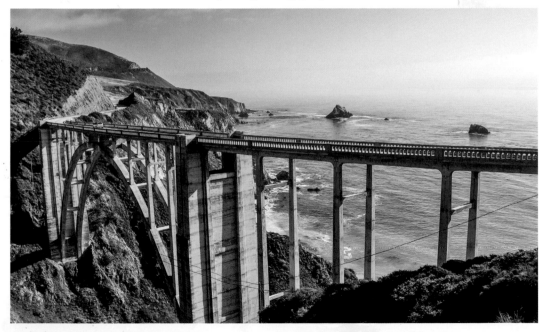

The **Bixby Bridge** on the Big Sur coastline of California

HAWAII

Waimea Canyon

Dubbed "The Grand Canyon of the Pacific" by Mark Twain, Waimea Canyon's sharply eroded cliffs reveal layers of vivid colors that seem to change in the sun. Unlike the Grand Canyon, plentiful rainfall keeps this canyon and its surrounding area thick with vegetation, and visitors are frequently treated to the sight of vivid rainbows.

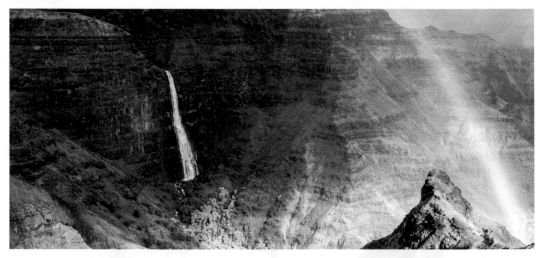

At ten miles long, one mile wide, and more than 3,500 feet deep, **Waimea Canyon** on the Hawaiian island of Kauai is the largest canyon in the Pacific.

Byodo-In Temple

The Byodo-In Temple is found on the island of Oahu. It is a smaller replica of a Buddhist temple of the same name that has stood for 900 years in Kyoto, Japan. Completed in 1963, the temple was dedicated to remember the centennial of the arrival of the first Japanese immigrants to Hawaii. The temple welcomes visitors of all faiths, and it is a popular places for weddings.

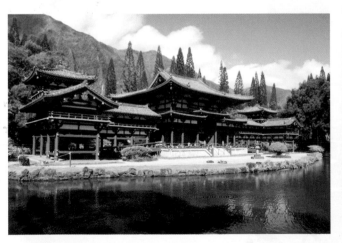

The **Byodo-In Temple** is located in Valley of the Temples Memorial Park, where thousands of Hawaiians of all faiths are buried.

Koi ponds are found on the extensive grounds.

Makapuu Point Light

In 1906, the U.S. Congress appropriated $60,000 to build a lighthouse at Makapuu Head, the easternmost point of Oahu Island. Because the site was nearly 400 feet above sea level, there was no need to build an extremely tall lighthouse. The lens, however, was enormous—eight and a half feet in diameter—so as to cast a strong beam far out to sea. The highland area around the lighthouse is popular with hang gliders, who take off directly from the rocky cliffs and soar above the lighthouse and sea.

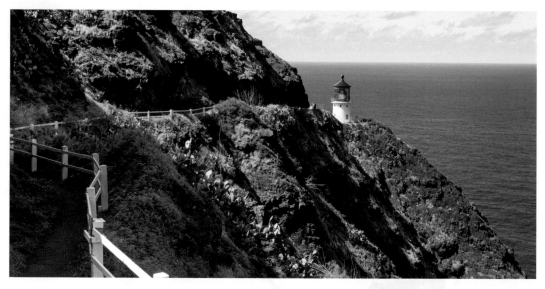

Panoramic views of the Pacific greet visitors to the **Makapuu Point Light**. During the balmy winter months, groups of migratory whales are often spotted.

(Above) When measured from the ocean floor, Mauna Kea is the tallest mountain on Earth. So it's appropriate that this massive giant hosts **Mauna Kea Observatories**—a giant complex of buildings and telescopes that form an "Astronomy Precinct."

(Right) **Waikiki Beach** is a famous two-mile stretch of sand in Oahu lined with beach hotels and all kinds of action-packed excitement. Waikiki is an excellent place to learn to surf, and lessons are available just about everywhere.

ALASKA

Saxman Native Village

This is the world's largest totem park, consisting of two dozen ornate totem poles in Saxman, near Ketchikan in southeast Alaska. Most of the poles are not dated and were reclaimed from abandoned Tlingit villages in the 1930s by the Civilian Conservation Corps and the United States Forest Service.

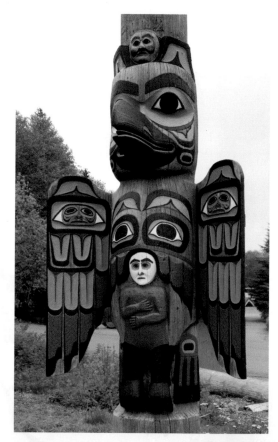

Each totem pole at **Saxman Native Village** is unique. The colorful carvings share the stories of their makers and the stories of the villages where they once stood.

Kenai Fjords National Park

The state of Alaska has a whopping 34,000 miles of shoreline, and many of its national parks are built along those coasts. Kenai Fjords National Park, found on the Kenai Peninsula near the city of Seward, includes more than 500 miles of shoreline, with glaciers flowing from Harding Icefield.

Humpback whales, orcas, sea lions, and seals are all seen frequently in the water around Kenai Fjords.

(Below) A Stellar sea lion sleeps on Kenai's rocky coastline.

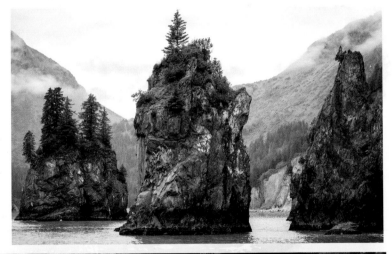

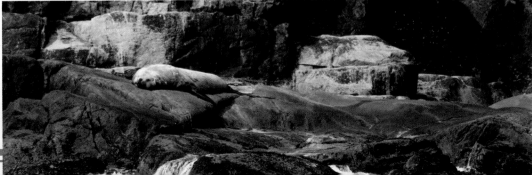

Wrangell–St. Elias National Park and Preserve

Wrangell–St. Elias National Park and Preserve in Alaska is the largest national park with more than 13 million acres. The park is six times the size of Yellowstone and larger than Switzerland. It has nine of the sixteen highest U.S. mountains—four of them are above 16,000 feet. Wrangell–St. Elias contains the nation's largest glacial system; glaciers cover more than one-quarter of the park.

This rugged region has been called the Himalayas of North America. **Wrangell–St. Elias National Park and Preserve** is so vast that it contains more unexplored terrain than the Himalayas, largely as a result of the short summers and long winters here.